Why Art Cannot Be Taught

University of Illinois Press

Urbana and Chicago

Why

ART

Cannot

Be

Taught

JAMES ELKINS

A HANDBOOK FOR ART STUDENTS

Library of Congress Cataloging-in-Publication Data
Elkins, James, 1955–
Why art cannot be taught : a handbook for art students / James Elkins.
p. cm.
Includes bibliographical references and index.
ISBN 0-252-02638-1 (cloth : alk. paper)
ISBN 0-252-06950-1 (paper : alk. paper)
1. Art—Study and teaching (Higher)—United States. I. Title.
N346.AIE44 2001
707'.1'173—dc21 00-011150

Contents

This little book is about the way studio art is taught. It's a manual or survival guide, intended for people who are directly involved in college-level art instruction—both teachers and students—rather than for administrators or theorists of various sorts. I have not shunned sources in philosophy, history, and art education, but I am mostly interested in providing ways for teachers and students to begin to make sense of the experience of learning art.

The opening chapter is about the history of art schools. It is meant to show that what we think of as the ordinary arrangement of departments, courses, and subjects has not always existed. One danger of not knowing the history of art instruction, it seems to me, is that what happens in art classes begins to appear as timeless and natural. History allows us to begin to see the kinds of choices we have made and the particular biases and possibilities of our kinds of instruction.

The second chapter, "Conversations," is a collection of questions about contemporary art schools and art departments. It could have been titled

Introduction

"Questions Commonly Raised in Art Schools" or "Leading Issues in Art Instruction." The topics include the following: What is the relation between the art department and other departments in a college? Is the intellectual isolation of art schools significant? What should be included in the first-year program or the core curriculum for art students? What kinds of art cannot be learned in an art department? These questions recur in many settings. In a way, they are the informal elements of our theory of ourselves, and the ways we talk about them show how we imagine our own activity. I don't try to answer them or even to take sides (though I also don't conceal it when I find one view more persuasive than another); rather I'm interested in providing terms that might help to clarify our conversations.

"Theories," the third chapter, addresses the title of the book. It may seem as if I should have called this book *How Art Is Taught*, but in general I am pessimistic about what happens in art schools. Whether or not you think art is something that can be taught, it remains that we know very little about *how* we teach or learn. Lots of interesting and valuable things happen in studio art instruction and I still practice it and believe

1

in it, but I don't think it involves teaching art. Chapter 3 introduces that idea.

The last two chapters, about art critiques, are the heart of the book. Critiques are the strangest part of art instruction since they are not like the final exams that nearly all other subjects have. They are more free-form, and there are few rules governing what is said. In màny cases, they are a microcosm for art teaching as a whole. The fourth chapter, "Critiques," considers a list of traits that can make critiques confusing and suggests ways to control some potential problems. The fifth chapter, "Suggestions," explores new critique formats that I have found useful in trying to understand how critiques work. They are not prescriptions for changing the curriculum but ways to observe what we do. Contemporary art instruction is not something that can be "fixed" once and for all, but there are ways to step back and analyze it. The final chapter collects my argument into four conclusions, and the book ends with a reflection about the very idea of trying to make sense.

-/-/-/-

Once, when I was a student in an M.F.A. program, another student showed an installation piece in his final critique. It was a table, and on it was a board, propped up like a piano lid. Between the board and the tabletop, the student had piled garbage he had found around the studios, including discarded sculpture by other students. From somewhere inside the heap a radio was playing a random station. Everyone stood around in silence for a few minutes. Then one faculty member said this (mostly while he was looking at his feet):

"Well, I'd like to be able to say this is an embarrassing piece. I mean, I'd like to be able to tell you I'm embarrassed because the piece is so bad. I wanted to say it's badly made, it looks bad, it's not well thought out, it's been done before, it's been done a million times, much better, with skill, with interest . . .

"But I realized I can't say that. I'm not embarrassed, because the work isn't even bad enough to make me embarrassed. Obviously it's not good, and it's also not bad enough to embarrass me.

"So I think that the piece is really about embarrassment, about the way you think you might be bored, or you might blush, and then you don't, because you don't care. About the way you maybe think about being embarrassed, when you're not. (Or maybe I am embarrassed because I'm not embarrassed.)

"So I think you should think about this: I mean, ask yourself, 'How

can I make a piece that will be just a little bit embarrassing? Are there different kinds of embarrassment?' Stuff like that."

When he finished, he sighed. He was just too overcome with boredom to go on—or perhaps he was affecting to be bored in order to drive his point home.

It may seem surprising to people who haven't been to art school that such things can happen. But they are not at all rare. At this particular school, critiques were held in front of all the students and faculty, and it was not uncommon to have the artist cry in front of everyone. One visiting student from another department called our critiques "psychodramas."

In general, critiques aren't anywhere near this negative. I use this example to show how wild they can get, and to underscore the fact that they do not have guiding principles that can address this kind of excess. Critiques are unpredictable, and they are often confusing even when they are pleasant and good-natured. When I was a student, I thought there must be something that could be done to make critiques more consistently helpful. After I graduated with the M.F.A., I switched to art history, but I retained my interest in the problem. I have almost twenty years' distance on this particular critique, and I have seen some worse critiques since then, but I have not forgotten what it is like to be on the receiving end of a truly dispiriting, unhelpful, belligerent, incoherent, uncaring critique. (And it's hardly better to have a happy, lazy, superficial critique.) The main purpose of this book is to make sense of all that.

I s there anything worth knowing about art schools in past centuries?[1] It is worth knowing that art schools did not always exist, and that they were entirely different from what we call art schools today. This chapter is an informal survey of the changes that have taken place in art instruction during the last thousand years. I have stressed curricula—that is, the experiences a student might have had from year to year in various academies, workshops, and art schools. It's interesting to think what a typical art student of the seventeenth or nineteenth century might have experienced. It shows how different art and teaching once were, and how we've invented much of what we take for granted.

The main development is from medieval workshops into Renaissance art academies, and then into modern art schools. Art departments, which are in the majority today, are less important from this point of view since they take their methods and ideas from art schools. Throughout this book, I refer to "art schools," but what I say is generally applicable to any art department in a college or university.

Histories ----- I

ANCIENT ART SCHOOLS

Though we know there were art schools (or workshops) in Greece and Rome, we no longer know what was taught. By the fifth century B.C. in Greece, art had become a complicated subject, and there were technical books on painting,[2] sculpture,[3] and music. According to Aristotle, painting was sometimes added to the traditional study of grammar, music, and gymnastics.[4] But almost all of that is lost.

In general, the Romans seem to have demoted painting within the scheme of "higher education," although it appears to have been something done by educated gentlemen. One text suggests a nobleman's child should be provided with several kinds of teachers, including "sculptors, painters, horse and dog masters and teachers of the hunt."[5] Thus the history of the devaluation of painting, which we will follow up to the Renaissance, may have begun with the late Romans, especially the Stoics.[6]

MEDIEVAL UNIVERSITIES

The idea of a "university" in our sense of the word—"faculties and colleges and courses of study, examinations and commencements and aca-

demic degrees"—did not get underway until the twelfth and thirteenth centuries.[7] There was much less bureaucracy in the early universities than we're used to: there were no catalogs, no student groups, and no athletics. The curriculum was limited to the "seven liberal arts": the *trivium*, comprised of grammar, rhetoric, and logic, and the *quadrivium*, which was arithmetic, geometry, astronomy, and music.[8] There were no courses in social studies, history, or science. Mostly students learned logic and dialectic. Logic is seldom taught now, except as an unusual elective in college mathematics or philosophy departments; and dialectic, the study of rational argument, has virtually disappeared from contemporary course lists.[9] Medieval students did not take courses in literature or poetry the way we do in high school and college. Some professors admitted—even boasted—that they had not read the books we consider to be the Greek and Roman classics.[10]

Before students went to a university, they attended grammar schools, something like our elementary schools, where they learned to read and write. When they arrived at the university, sometimes they were allowed to speak only Latin, a fact that panicked freshmen and prompted the sale of pamphlets describing how to get along in Latin.[11] As in modern universities, the master's degree took six years or so (students did not stop for the "college degree," the B.A. or B.S.). Those who studied at medieval universities meant to become lawyers, clergymen, doctors, and officials of various sorts, and when they went on to professional study (the equivalent of our medical and law schools), they faced more of the same kind of curriculum.

A typical course used a single book in a year. In some universities, teachers drilled the students by going around the class, and the students were expected to have memorized portions of the book as well as the professor's discussions of it. It is not easy to imagine what this regimen must have been like, especially since it involved "dry" texts on logic and little original thought—which is precisely what is required in modern colleges from the very beginning.[12] Today the medieval kind of rote learning occurs in Orthodox Jewish classes on the Talmud, in Muslim schools that memorize the Koran, and to some degree in law and medical schools—but not in colleges, and certainly not in art classes.

It is interesting to speculate about the differences between such an education and our own: certainly the medieval students were better equipped to read carefully and to frame cogent arguments than we are. From the medieval point of view, being able to memorize and to think logically are prerequisites to studying any subject: a student has to learn

to argue about any number of things before going on to study any one thing. That's very different from what happens in art instruction. The closest analogy, which I will consider a little later, is the strict copying of artworks, a practice adopted during the seventeenth century, essentially during the Baroque period. But in general, modern college curricula do not require memory training, rhetorical (speaking) skills, or dialectic (logical argument), and those omissions are not made up for in graduate schools. You don't have to be a conservative defender of "cultural literacy" or a Eurocentrist to wonder just how different education could be with the kind of rhetorical and dialectical training that was the norm in parts of the classical world and during the six or so centuries following the institution of medieval universities.

Artists were not trained within the medieval university system at all.[13] They went directly from grammar school into workshops, or from their parents' homes straight into the workshops. Students spent two or three years as apprentices, often "graduating" from one master to another, and then joined the local painter's guild and began to work for a master as a "journeyman-apprentice." That kind of work must not have been easy, since there is evidence that the young artists sometimes helped their masters in the day and spent their evenings making copies. Many of their tasks would have amounted to low-grade labor, such as grinding pigments, preparing panels, and painting in backgrounds and drapery. Eventually the journeyman-apprentice made a work of his own, in order to be accepted as a master.[14]

Though painting remained outside the university system, beginning in the twelfth century there were various revisions aimed at modifying or augmenting the *trivium* and *quadrivium*. Hugo of Saint-Victor proposed seven "mechanical arts" to go along with the seven liberal arts:

Woolworking	Hunting
Armor	Medicine
Navigation	Theater.
Agriculture	

Strangely, he put architecture, sculpture, and painting under "Armor," making painting an unimportant subdivision of the "mechanical arts."[15]

It is often said that Renaissance artists rebelled against the medieval system and attempted to have their craft (which did not require a university degree) raised to the level of a profession (which would require a university degree), a status they eventually achieved by instituting art

academies. But it is also important to realize how much medieval artists missed out on by not going to universities. They were not in a position to formally learn about theology, music, law, medicine, astronomy, grammar, rhetoric, dialectic, logic, philosophy, physics, arithmetic, or geometry—in other words, they were cut off from the intellectual life of their time. Though it sounds rather pessimistic to say so, much the same is true again today, since our four-year and six-year art schools are alternates to liberal arts colleges or universities just as the Renaissance art academies were alternates to Renaissance universities. The situation is somewhat better in the case of art departments, because students in liberal arts colleges have more classes outside their art major than art students in four-year art colleges; and at any rate modern art students aren't as isolated as medieval students were. But there is a gap—and sometimes a gulf—between art students' educations and typical undergraduates' educations, and it often delimits what art is about. (Conversely, it marginalizes art that is about college-level scientific or non-art subjects.) Much can be said about this, and I will return to it in the next chapter.

RENAISSANCE ACADEMIES

The first Renaissance academies did not teach art.[16] Instead they were mostly concerned with language, though there were also academies devoted to philosophy and astrology.[17] A few were secret societies, and at least one met underground in catacombs.[18] In general the early academies sprang up in opposition to the universities, in order to discuss excluded subjects such as the revision of grammar and spelling, or the teachings of occult philosophers.

The word "academy" comes from the district of Athens where Plato taught.[19] The Renaissance academies were modeled on Plato's Academy, both because they were informal (like Plato's lectures in the park outside Athens) and because they revived Platonic philosophy.[20] Many academies were more like groups of friends, with the emphasis on discussion among equals rather than teaching. Giovanni Giorgio Trissino, a poet and amateur architect who tried to reform Italian spelling, had an academy,[21] and so did King Alfonso of Naples, the philosopher Marsilio Ficino, and the aristocrat and art patron Isabella d'Este. After the Renaissance, Queen Christiana of Sweden described her academy in Rome as a place for learning to speak, write, and act in a proper and noble manner.[22] Poems were read, plays were put on, music was performed, and what we now call "study groups" got together to discuss them.

THE FIRST ART ACADEMIES

Leonardo da Vinci's name is associated with an early academy, proba-
bly a group of like-minded humanists. Academies became more popular
and more diverse after the High Renaissance.[23] (By 1729 there were over
five hundred in Italy alone.)[24] After the turn of the sixteenth century,
mannerist taste tended to make the academies more rigid, less "informal
and loose," and the idea of the academy began to merge with that of the
late medieval university. Academies specifically for art instruction began
in this more serious atmosphere, which lacked a little of the enthusiasm
and experimentalism of the earlier academies.[25] "Renaissance academies
were entirely unorganized," according to Nikolaus Pevsner, but "the acad-
emies of Mannerism were provided with elaborate and mostly very sche-
matic rules." Not only were there rules, there were odd names: the Acad-
emy of the Enlightened, of the Brave, of the Passionate, of the Desirous,
of the Inflamed, the Dark, the Drowsy.[26]

The Florentine Academy of Design (*Accademia del Disegno*) was the
first public art academy.[27] Its original purpose was rather morbid: to
produce a sepulcher for artists who might die penniless.[28] In 1563, three
years after it was founded, Michelangelo was elected an officer (one year
before he died). The setting was still informal—lectures and debates were
held in a Florentine orphanage, and anatomy lessons at a local hospital
(the Ospedale degli Innocenti and the Ospedale of S. Maria Nuova, re-
spectively; they can both still be visited). The Florentine Academy was
an early "urban campus," spread out among existing buildings rather
than cloistered in its own campus or religious compound.

(Incidentally, the distribution of buildings in an art school or univer-
sity inevitably affects the kind of instruction carried out there. I teach at
an urban campus, in a half-dozen buildings scattered around the Art
Institute in Chicago, and our instruction is decidedly more involved with
the art market and urban issues than the art instruction at the cloistered
University of Chicago—the site of the story I told in the Introduction. The
University of Chicago's studio art department is on the far southwest
corner of its campus, as if someone had tried to push it off into the sur-
rounding neighborhood. Cornell University used to teach drawing in the
Fine Arts Building and also in a building that was part of the agriculture
quad, and the instruction in those two places was quite different. Berke-
ley's studio art department shares a building with anthropology—an in-
teresting affinity for art students. Duke University's studio art department
is a small house set apart from other buildings, in a field behind one of

the campuses. If you're studying in a building remote from the rest of your campus, or remote from a big city, you might consider the strengths and limitations of your location.)

The teaching in the Florentine Academy was mannerist in inclination,[29] meaning students looked at statues (later called simply "the antique"), studied complexities of geometry and anatomy, and learned to make intricate, "learned" compositions. This was the opposite of earlier Renaissance taste; as we know from drawings, students in the fifteenth-century workshops drew each other, and it seems there was significantly less interest in drawing from "the antique" or in bookish learning.[30]

When they first entered the Florentine Academy, students learned mathematics, including perspective, proportion, harmony, and plane and solid Euclidean geometry. The idea was to get away from the empirical, haphazard kind of learning that artists had faced in workshops, and to substitute theories. Artists, it was thought, need a good eye and a good hand, but even before they develop those they need mental principles to guide them: so "measured judgment" and a "conceptual foundation" must come before manual dexterity.[31] This is our first encounter with an idea that was absolutely fundamental in art academies before the twentieth century: the notion that looking and working are not enough, that art requires a balance between theory and practice.[32] It is an idea worth pausing over. Often, I think, ideas in history are easy to understand—easy to write down or to explain—but difficult to "take to heart," as if they were your own. There are two aspects of this idea of theory and practice that I think are particularly alien to current ways of thinking:

1. The Renaissance educators had in mind a balance. Today we rarely conceive art as a matter of balance. Instead we look for extreme effects: the phrase "middle of the road" shows how little we care for works that try to blend properties we've seen before. Renaissance and Baroque academicians conceived art as a subject that inhabits the middle shades of gray rather than the black or white extremes. The operative word here is *decorum*, indicating a kind of art that does not stray too far from the middle for the sake of effect. It seems to me that modernism and postmodernism are so bound up with dramatic effects and innovations that the Renaissance way of thinking is nearly inaccessible. Imagine trying to make art that has no special effects and that achieves a measured calm and fluency by considering and balancing the moderate and compatible aspects of previous artworks. Harshness, stridency, excess, shock value, crudity, monotony, enigma, radical ambiguity, hermeticism, fragmentation,

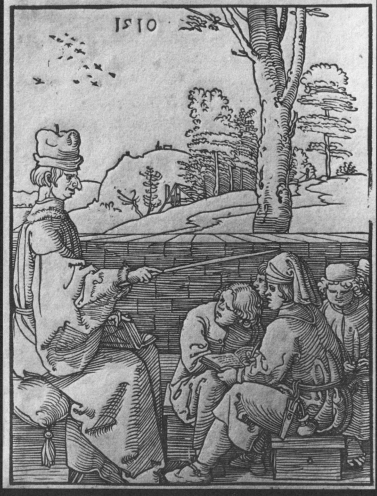

Wer recht bescheyden wol werden
Der pit got trum bye auff erden

1510

Albrecht Dürer, <u>The Schoolmaster.</u> 1510. Chicago, Art Institute, Department of Prints and Drawings. © 2000 The Art Institute of Chicago.

Dürer's woodcut doesn't show art students, but the scene wouldn't be too dissimilar from the setting of art instruction of the day. Dürer wrote several books that could have been used to teach the technical side of art—one on perspective, another on figure drawing. He compared the poor German students of his day to saplings growing up crooked. They need Italian art theory, he said, in order to grow straight. Here the instructor wields a sharp, straight pointer. Outside the wall (a very perspectival wall) are the asymmetric forms of nature, growing rulelessly, beyond the reach of systematic art instruction.

impatience: all the things we love were once excluded in the name of decorum. How could a well-balanced, moderate work of art possibly be more expressive than a weird, ambiguous, bizarre one? In today's art world, old-fashioned decorum would be essentially a waste of time.

2. **Academicians balanced the real and the ideal.** The two extremes that the Renaissance and Baroque academies sought to balance are alien to our thinking: they advocated that each painted or sculpted figure should display a knowledge of ideal forms, along with selected peculiarities of the live model. This concept of "ideal forms," derived from the Platonic Ideal, is not a concept that seems real today. When a contemporary artist looks at a model, she does not compare the model's body to a perfect form, seen only in her mind, and she does not contrast that imagined perfection against the imperfect, mundane form that the model actually has. In other words, we no longer conceive drawing as a mediation between the Ideal and the Real. The Platonic approach seems especially strange when we consider that the Ideal was colored with ethics and theology. The Renaissance Neoplatonists sometimes equated the Ideal with the highest ethical good, and called it "Venus," "love," or Christian love, *agape.* These ideas are easy to teach in a classroom—there are books on Neoplatonism, and translations of Renaissance Neoplatonic texts—but they are dead as ideas, because it is impossible to translate them into art practice. (It's always possible to invent classroom exercises that employ historical concepts. I can picture an assignment in which students drew Ideal and Real forms of objects and read texts on the Neoplatonic Ideal—but that would be artificial. Contemporary drawing practice no longer requires that kind of philosophy.)

After mathematics, the next subjects for the Florentine Academy students were anatomy and life drawing. Dissections were held once a year in the hospital, often in the winter so that the corpses could be kept around a little longer. Today teachers don't usually bring art students to see actual dissections (courses for that are available at some universities), and anatomy itself has become an elective. Typically, an art school has an art anatomy instructor or a doctor who teaches anatomy, though it is not always claimed that anatomy is indispensable for life drawing. Again the ideas behind the Florentine practice are unfamiliar ones. A primary goal of painting and sculpture was to express states of mind, and it was thought that artists such as Michelangelo had managed to do that by their knowledge of the hidden structure of the body. A person's nobility of the mind was thought to be mirrored and expressed by the nobility of his or her

body. Movements of the body were movements of the soul. In addition, Renaissance artists thought that the body's proportion and its "architecture" had something divine about them. The body had been made by the Divine Architect, and it repeated some of the harmonies that governed the universe. Hence proportions, articulation, and bodily movement were thought to be both expressive and divine.[33] Do we believe anything of the kind these days? I don't think so, and it seems to me that the loss of such ideas account for the marginal importance of anatomy in our art schools. For today's instructors, art anatomy is a dusty relic of old-fashioned teaching practices. Life drawing, as it is practiced today, has been emptied of much of its original meaning.

A third topic of study at the Florentine Academy was natural philosophy. The idea was that if an artist studied the body in order to express the "motions of the mind" or—to use the Renaissance phrase—"affects of the soul," then it made sense to have a theory about the soul, to explain how the soul works and what forms it can take. Until the late nineteenth century, "natural philosophy" meant physics, and the academy students learned whatever natural laws were relevant to artmaking. They studied "physiognomy," the science of facial expressions as signs of particular mental states; and they studied the "doctrine of the humors," which held that mental and physical well-being depends on a balance of four bodily "fluids." Too much blood, and a person becomes sanguine and jolly; too much "black bile," and a person becomes melancholic and depressed.[34] The doctrine of the humors sounds like medicine, but it was also physics since the humors were thought to be influenced by the planets. All the mistaken medicine and physiognomy was put to the purpose of understanding how the soul expresses itself in flesh. Since contemporary art instructors don't have doctrines like humoralism or physiognomy, art students are on their own if they want to communicate the idea that their model is in a certain mood. The result is that students don't often try to depict specific moods, or when they do, the moods are expressed by obvious symbolic gestures—an arm over the eyes for sleep, a hand over the eyes for grief. It no longer seems interesting to try to express specific mental states—anger, torpor, humiliation, humility—by studying the typical poses or expressions that accompany each state.[35]

Two further topics completed the academy curriculum. One was the study of inanimate objects such as drapery.[36] Students were required to draw drapery twice a week, and the seriousness with which they took those classes is attested to by beautiful drapery studies done by Leonardo and others. To some people, drapery is the most typical academic

13

subject, since it is reminiscent of the yards of drapery in Renaissance and Baroque painting and sculpture. But it is important not to forget that drapery study came *after* the more essential classes in theory (mathematics) and in the human soul (dissection, life drawing, natural philosophy). Drapery was an "inanimate form," quite different from the body and face. Today it is the other way around: students draw live models as if they were "inanimate forms," and they talk about drapery, fiber arts, and fashion in terms of deeper significance.[37]

The other advanced subject was architecture, and the reason it was placed last may have to do with a famous demand made by the Roman architect Vitruvius, who said that architects should know drawing, geometry, optics, arithmetic, history, philosophy, physics, astronomy, law, music, ballistics, pipe organs, medicine, and philology.[38] Buildings were thought of as analogies to the proportions of the human body, so it was reasonable that an architect should master everything a painter knew and more. In terms of education, architects were to painters as psychiatrists are to doctors: they knew the rudiments of their art, and also a number of more specialized fields, especially anatomy, geometry, and musical harmony (to help them construct harmonious proportions). From a twenty-first-century perspective it's odd to think of architecture as a required "advanced" course in an art school curriculum. Architectural theory has expanded tremendously since the Renaissance, but in this sense we think less of architecture than we once did.

THE CARRACCI'S ACADEMY

The late Renaissance painters Agostino, Ludovico, and Annibale Carracci began the best-known Renaissance art academy at the end of the sixteenth century.[39] They were reacting against the decades of mannerism and attempting a return to the standards of the High Renaissance. Specifically, they wanted to synthesize three High Renaissance styles: the drawing of Rome (meaning Michelangelo's and Raphael's), the color of Venice (principally Titian's), and the aristocratic style of Lombardy (meaning Correggio's). They did not admire naked realism, such as Caravaggio was then painting, and they did not want to continue the Mannerists' habit of neglecting drawing from nature. As in the Florentine Academy, they valued work that mediated the Ideal and the Real: work that was neither a fantastical invention nor a slavish imitation of natural forms.

There have been debates about the value of the Carracci's program. Art historians have come to appreciate what the Carracci did,[40] but it seems to me that Carracci-style painting is entirely off the radar screen

of contemporary painting. If it appears at all, it appears as a dead end—a long-past, wrongheaded experiment in academic thinking.[41] One of the differences between art students and art history students is that the former always care about whether they like what they see, and as a result styles like the Carracci's get taught a little less in art schools than those of other periods. The time of the Carracci is one of the dead zones in art instruction, along with the line of styles and artists the Carracci admired, including Hellenistic sculpture and Raphael, and along with the Baroque art the Carracci academy inspired. This kind of prejudice, which seems so alien to art historians, needs to be carefully weighed when it comes to studio artists.

Nevertheless the Carracci did something unusual with history: they looked beyond their recent past, back to a period that had already ended, where they found models for their own work. They *used* history as a kind of buffet table, picking and choosing the best work. That quintessentially *academic* frame of mind is what makes their academy, if not their art, important for anyone interested in how art is taught. Many of the Carracci's choices echo in the later activities of European and American academies. In a short list, the Carracci's choices include the following:

- rejecting contemporary art
- looking to a certain "golden age" when art was better
- taking only certain elements from artists
- putting those elements together into a new art.

These are simple ideas, and they might seem unproblematic. But each entails a certain way of imagining the past, a way that can be called "academic," and they often occur together as symptoms of academia. I will return to them when I examine the concept of academic art in chapter 2.

BAROQUE ACADEMIES

Even in the Baroque period, there were still many "academies," "schools," "societies," and informal "studio-academies" in which instruction essentially followed the medieval guild system.[42] Yet for the most part, the Baroque is the period in which the large, well-organized academies began.[43] The most important were the French Academy, founded in 1655, and the Royal Academy of Arts in London, founded in 1768,[44] and there were dozens of others throughout the eighteenth century—though America did not have an academy before the nineteenth century.[45] (The Pennsylvania Academy of the Fine Arts, in Philadelphia, was the first in

America. It opened in 1805, though it had been preceded by an art school.) In non-Western countries, art academies were still being set up early in the twentieth century. The first Chinese academy opened in Nanjing in 1906, following the Tokyo Art School by seventeen years.[46]

Some of the Baroque academies had aristocratic antecedents. As early as the sixteenth century, drawing was one of the things that polite gentlemen or ladies might do in their spare time. Once painting had gained its new status as a liberal art, it became a suitable aristocratic pursuit. The odd result, however, is that in a way it was demoted again, this time into an "amateur" activity: one text lists painting along with other pastimes appropriate to a gentleman, including fencing, riding, classical learning, and coin collecting.[47] Other sources suggest that gentlemen should learn to draw in order to know about maps, or in order to acquire a good calligraphic handwriting, or to be better able to appreciate art.[48] Various sixteenth- and seventeenth-century authors also mix art and aristocratic education.[49] It is necessary to recall this aristocratic, amateur tradition when considering academies in general. Though we've lost most of it, some lingers. Anyone who travels to London should see the cast sculpture gallery in the Royal Academy, which still breathes the dark, serious air of the Baroque.

In many respects the Royal Academy of Painting and Sculpture in Paris is exemplary. It was the largest, most influential, and best-organized of the seventeenth-century academies. From 1656 onward, classes were held in the Louvre.[50] Like most other academies, the French Academy taught only drawing. The purpose was again to provide theoretical instruction to go along with the practical knowledge that could be gotten in studios. Students were expected to learn painting, carving, and modeling in workshops, where they were apprenticed to masters, somewhat in the medieval fashion. As time went on, the workshops became less important, and by the later seventeenth century, the academies had broken the monopolies that the guilds once had on commissions and teaching.

The curriculum at the French Academy was divided into lower and higher classes, but it supported essentially a three-step process: first, students were allowed only to draw from other drawings; then they drew from plaster casts and antique sculptures; and finally from live models (from six to eight in the morning in the summer, according to one schedule).[51] In the eighteenth century, beginning students did not even draw from *original* drawings, but from lithographs of drawings. Often enough the originals were done by teachers at the academy rather than Renaissance masters, and the "Raphaels" and "Michelangelos" the students

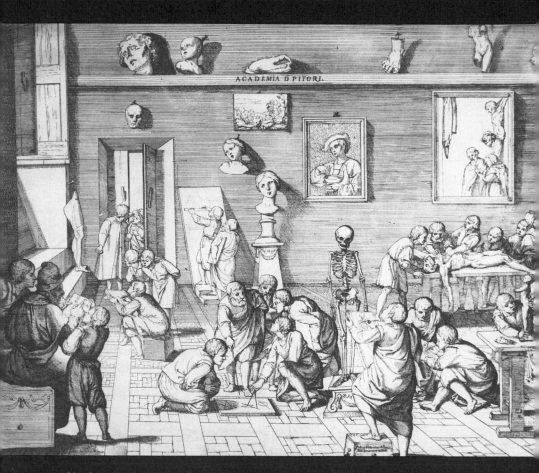

ACADEMIA D PITORI.

Pierfrancesco Alberti, <u>Painters'</u>
<u>Academy.</u> **Early seventeenth cen-**
tury. Bartsch XVII.313.1. Photo:
author.

Here is an eighteenth-century
European academy where the
teaching methods are systemat-
ic. In the middle ground on the
left, a student draws an <u>écorché</u>
leg (a plaster cast of a flayed
limb, used to study muscles). In
the center, a group discusses
geometry, one of the rudiments
of all art. They haven't pro-
gressed to perspective yet, be-
cause they're still using calipers

and drawing basic geometric
shapes. In the right background,
a group dissects a cadaver. (It
could be fresh, or perhaps it's
been preserved by being soaked
in honey and spices.) The genres
of painting are represented on
the wall: landscape, portraiture,
religious painting, in order from
least to greatest. This kind of
instruction must have been very
reassuring: you knew where you
were at every step.

17

copied were contemporary lithographed versions of originals. And the first-year course was even more dismal than that, since in the first stages students didn't even copy lithographs of *entire* drawings, but lithographs of drawings of parts of bodies: ears, noses, lips, eyes, feet, and so forth. The idea of disassembling the body in this way appears to have begun with Leonardo, and it was practiced at the Florentine Academy.[52] Broadly speaking there were two kinds of body-part illustrations: proportional studies, meant to show what ideal noses looked like, and physiognomic studies, intended to teach how noses reflect a person's soul—how, for example, the nose of a virtuous man might differ from the nose of a sinner. In the Berlin Academy, these "first rudiments" included lithographs of flowers, ornaments, and "ideal foliage."[53] Students worked their way from plants to small body parts, and from there to larger parts of bodies, whole figures, and then compositions of more than one figure.

The academies maintained collections of life-size plaster casts of famous sculptures and also casts of body parts. Many drawings of ideal Greek sandaled feet survive. The results of studying them can be seen in paintings such as David's *Death of Socrates* in the Metropolitan Museum, where the foot of Socrates displays the anatomy of the classical, Roman-style sculpted marble foot. Even Picasso drew from such casts, and several of his drawings survive. Students from all over Europe learned from the same array of plaster figures: the Belvedere Torso (called simply "The Torso"), the Farnese Hercules, the Spinario (a boy pulling a thorn from his foot, from a Roman bronze statue), the Apollo Sauronctonus (Apollo with a lizard), the Discobolus (discus thrower), the Apollo Belvedere, and the Laocoön. Most of these are unfamiliar today, but they were deeply ingrained in the imaginations of students who drew them and lived with them every day. (A life-size plaster cast can be an intimidating presence, well worth a visit. In America, these casts can be seen at Cornell University and at the Carnegie Museum of Art in Pittsburgh. The latter museum as well as museums in London and Paris also have full-size plaster casts of architecture.) In addition the French Academy had *écorchés*, plaster casts of flayed figures, used to study anatomy. Some of them were casts of flayed versions of famous sculptures, and others were designed by academy members and modeled on actual dissected bodies.

This silent population has almost vanished from schools.[54] A typical art school or large art department may have one or two battered *écorchés*, where once it may have had dozens. The Art Institute of Chicago threw away its collection in the 1950s, and by the early 1990s, the School of the Art Institute had only a single remaining *échorché*, a famous one designed

by an artist at the French Academy.[55] An upper floor at Harvard's Fogg Art Museum has a cast of Michelangelo's *Giorno.* Cornell University has a large collection of casts, scattered in various places: a small library room houses a copy of the Discobolus, a coffee shop has an entire pediment from Olympia, and a small art gallery has the Laocoön and the Pergamon Altar. Plaster casts of antique sculptures have only limited importance in contemporary schools, and their ghostly presence—added to the fact that no one knows their names—is strange and a little sad.

It's hard, these days, to recapture the effect that the casts (and, in some cases, the originals) had on artists' imaginations. The closest influence on the public consciousness that we have is in sculptures like Rodin's *Thinker,* because everyone knows it; anytime you draw or photograph someone in a pose remotely like that of the *Thinker,* you're reminded of it. Still, it's not a close parallel, because artists seldom use the *Thinker* in their work, and students are not required to draw it. I doubt many people are even sure of details of the pose. (Is the thumb out or in? Which knee does the elbow rest on?) By contrast the painting and sculpture of the sixteenth through nineteenth centuries would be unthinkable without references to famous Greco-Roman sculptures.

One of the principal aims of this sequence of academic instruction, and one that is virtually forgotten today, was to enable students to draw from memory. It is seldom appreciated that Michelangelo, Titian, and other Renaissance artists could invent poses and arrange entire compositions in their heads, with relatively little reliance on models. (One of the reasons we do not pay much attention to this is that it is not easy to say which figures and compositions were imagined and which real.)[56] Invention (*invenzione*) was a Renaissance goal that included this ability, and academies through the nineteenth century included classes in invention. Vasari, Leonardo, and Cellini all advocated drawing from memory,[57] and remnants of the doctrine still persist.[58] There's a simple exercise that can be done in life-drawing classes to give some feeling for what Renaissance and Baroque artists could do: draw the model, omitting one arm. Then invent a position for that arm, add it to the drawing, and re-pose the model so his or her arm corresponds with what has been drawn. That way you can compare the model to what you invented. The exercise can be made progressively harder by inventing more and more, until you're beginning by drawing *just* the arm, and inventing the whole body to go with it. Students trained in the French Academy and other Baroque academies were expected to be able to invent whole compositions of figures without models; models were used to fill in details but not to build compositions.

Though Renaissance artists including Leonardo and Squarcione had advocated the same basic three-step sequence from copying drawings to drawing casts to drawing from life, they could not have imagined the sober rigor with which it was implemented by the French Academy, or the academy's absolute exclusion of media other than drawing. French Academy students were judged for criteria that now sound alien or repellent:

1. **The drawings were required to have perfect proportions.** Baroque academies didn't place any value on inventive elongations or other distortions of the figure. Bodies had to be represented in the heights and breadths in which they appeared, or in slightly idealized versions of their natural proportions. These days that kind of restriction would seem absurd, and more to the point, we would probably find it very difficult. Students often say, "I'm not very good at that kind of thing," when they see an academic figure done in flawless "photographic" proportions, and people outside the art world assume that few people can make such figures. But the academies proved that everyone with a modicum of talent can make an impeccably proportioned figure, if they are trained to do so. The tens of thousands of drawings by Baroque academy students, held in museums throughout Europe and America, show that basically anyone can learn to draw a figure with reasonably correct proportions. A proportionally correct drawing is not really a matter of skill, and only marginally a question of training. Everything difficult about drawing begins *after* proportions are not longer an issue.

One of the keys to the academies' success in producing accurate drawings was their long life-drawing sessions. Typically, in the "atelier system," students looked at one model (or cast or drawing) for four weeks, and they made only a single drawing in that time. One of the students, designated *massier*, set the model's pose each morning, making sure it exactly matched the day before. Later, when the Romantic aesthetic began to hold sway, students found this way of working "petrified, immobile, and artificial and commonplace," if not "hopelessly dead."[59] Another convention that allowed art students to make drawings with precise proportions was the hierarchy of *kinds* of drawings, from "first thought" to thumbnail sketch to composition drawing to anatomic study to oil sketch to full-scale monochrome underpainting.[60] Students trained in the use of different levels of sketches could more easily produce impeccably proportioned studies, because they used their first drawings (which were normally done from imagination, without models) to begin thinking about proportions, and then gradually refined them by working up detailed studies from life.

2. **The students were required to observe decorum.** As in the Renaissance, decorum meant moderation in all things. Drawings could not be too large or small, and they couldn't be made too quickly or too slowly. The speed of the chalk or the *crayon* (that is, the pencil) on the paper could not be excessively rapid, nor the pressure too heavy or too light. These days teachers tend to encourage drawings and paintings done very rapidly, or with a tense hand, or very loosely and weakly. There is nothing particularly wrong with pictures that are uneven, or disunified, or otherwise quirky. The idea is to find interesting effects. In the Baroque academies, the purpose was to avoid *bizarrerie* and abnormal excesses, in order to practice the most broadly and effectively expressive style.

3. **The students were not asked to be original.** Creativity in the modern sense, in which each student is helped to make something that is his or her own, was not important in these stages of academy instruction. It was as if students in a life- drawing class were to be asked to conform to the teacher's way of drawing: there was little question of individual interpretation; the idea was to bring whatever was peculiar to the student's own manner under the control of the accepted style. Today that is exactly what teaching is *not,* or to say it the other way, virtually all our instruction goes into fostering individuality. It's hardly possible to imagine an art classroom at the beginning of the twenty-first century—at least in Europe and America—where students are encouraged *not* to try to find individual voices and styles.

Even though the Baroque academy's curriculum was more restricted than the Renaissance curricula, it did address other subjects, typically perspective, geometry, and anatomy. Periodic lectures, called *conférences* and modeled on the less widespread Italian Renaissance lectures (*discorsi*), were the most important addition to the student's education.[61] Some of the lectures were published, and there were books that came out of the academy environment.[62] (The present book is in that tradition: it is a theoretical treatise, concerned with education, that belongs to the school environment.)

In English-speaking countries, the most famous of these books of lectures is Sir Joshua Reynolds's *Discourses.* Among his first duties as president of the Royal Academy in London was to begin a series of lectures setting out, among other things, the academy's goals. The fifteen *Discourses* are still read, though their ideas are not often applied to contemporary art.[63] In France there were a number of such books,[64] and they

helped give that country the first independent body of art theory since the late Renaissance.[65] Today such books are mostly read by art historians. But the *idea* of having public lectures to define a curriculum is not a bad one for any art school or art department. If it is rare, that may be because it requires an administrator who is also an art theorist—but there is no reason not to have a symposium on the organization and purpose of a school or department even if the school has been around for some time. I recommend this to any school or department: it's always interesting to see what faculty produce when they're asked about the purpose of their institution, and the paper trail that results can be helpful to the next generation of teachers and administrators (as well as to historians trying to understand how art instruction has changed).

The books produced in Baroque academies seem stilted today. They sometimes had a formulaic way of discussing paintings: a book by Roland Fréart, for example, evaluates all pictures according to their invention, proportion, color, expression, and composition.[66] The categories entailed rules, *préceptes positifs*, which determined how best to treat each subject. Another author, Roger de Piles, rates painters on a scale from one to eighty on the basis of composition, expression, design, and color. Some results:

Raphael and Rubens (a tie)	65
Carracci	58
Poussin	53
Rembrandt	50
Michelangelo	37.

Today we might invert this order (and add other artists that de Piles neglected). Baroque academic theorists also rated paintings by genre. The so-called "hierarchy of the genres" determined which subjects were worthy of serious attention. One hierarchy reads, from lowest to highest:

Still life
Landscape
Animals
Portraits
Histories.[67]

Practices like these are valuable to the extent that we might define ourselves in relation to them. Here again are ideas that are easy to read about but quite difficult to take seriously. Can portraits really be more

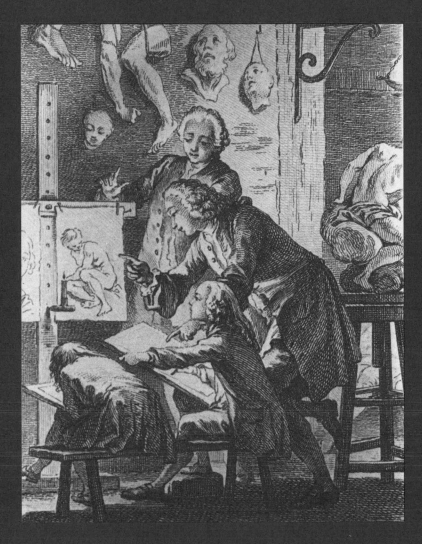

Charles-Nicolas Cochin, <u>Drawing School,</u> detail. 1763. From Denis Diderot et al., <u>Encyclopédie</u> (Paris, 1751–57), v. <u>Dessein,</u> pl. 1. Photo: author.

This is a detail of a plate that appeared in Denis Diderot and Jean Le Rond d'Alembert's <u>Encyclopédie,</u> one of the biggest publishing efforts of the eighteenth century. The plate accompanied the essay on "Drawing." The students drew from their teachers' drawings, not from nature; that was the first step in their art education. Later they would graduate to drawing plas-ter casts like the ones on the wall. Everything in drawing, like everything in art education—and everything in the whole <u>Encyclopédie</u>—is rationally arranged. As in modern art schools, the academy was a substitute for a university education. Notice how young the students are.

23

worthy than still lifes because they are inherently more noble? In contemporary parlance, "noble" is a word that most often occurs in speeches by politicians. The view in the early twenty-first century is decidedly anti-hierarchical: "Men think they are better than grass," as the poet W. S. Merwin says.

In the French Academy, beginning students were called *élèves.* They had a reasonably good life; they were exempted from military service and were well positioned to compete with apprentices outside the academy. There were monthly examinations, designed to weed out inferior students, but the major goal, from 1666 onward, was to win two all-important prizes: the Grand Prix (Grand Prize) and the Prix-de-Rome (Rome Prize) scholarship.[68] The Grand Prize was not easy to attain. First, students had to pass an examination by executing a satisfactory drawing in the presence of an instructor. If they passed that test they could submit a sketch, and if that sketch was accepted, they were invited to make a picture or relief from the sketch while locked in a room (to make sure they weren't cheating by copying other drawings). All the pictures that had been made that way were put in a public exhibition, and eventually a panel chose a single Grand Prize winner.

The subjects were often set beforehand, and they were usually taken from Greco-Roman mythology. Imagine an art competition today that required artists to pick from the following subjects:

Hannibal Looking Down on the Italian Plain

Albinus and the Vestal

Papirius and His Mother

Alexander and Apelles

The Death of Caesar

Achilles and Thetis

Venus Leading Helen to Paris

Hector Leaving Andromache

Ulysses and Diomedes Carrying Away the Horses of Rhesos

Achilles's Fight with the Rivers

Achilles and the Daughters of Lycomedes.[69]

Part of the student's work was to research such subjects, even though Greek and Roman myths were more or less common knowledge until the mid-nineteenth century. It's ironic that one of the few modern artists who makes pictures with titles like these is Joel-Peter Witkin—his work is strongly academic in that sense, and infused with art history, even though

it would have been unthinkable to the French academicians. (It would have seemed mad.)

The Rome Prize was much more generous than today's grants and fellowships. Winners went to the French Academy in Rome for four years, and when they returned they had a choice of careers.[70] They could either set up shop in some small town or else try for the next step up in the academy. After being an *élève* and taking part in the Grand Prize competition, a student could apply to be accepted as an *agréé,* which involved finding a sponsor and submitting another painting. *Agréés* then had to pay a fee and complete a third work, this time specifically for the academy's permanent collection; and if it was accepted, they became *académiciens,* the highest normal position, something like our full professors.[71] This three-stage system was adopted from the medieval sequence from apprentice to journeyman-apprentice to master. The correspondence with the medieval system is therefore:

MEDIEVAL GUILDS	FRENCH ACADEMY
Apprentice	*Élève*
Journeyman	*Agréé*
Master	*Académicien*

The Rome Prize and the other competitions put tremendous pressure on students to produce a winning work, a "masterpiece," which would launch their careers. The closest modern analogy I know is the large music competitions such as the Tchaikovsky competition, which use a merciless weeding-out to find a single winner. That winner is then offered concert dates and an opportunity to build an international reputation. The large public competitions for buildings or monuments are not quite the same, in part because they generally attract people who are already professionals. (The same could be said for the MacArthur "genius" grants, which are often given to people who are already established.)

Another consequence of the Rome Prize system was that art students had to be single-minded: they had to think of each of their classes as preparation for a single painting. In fact, the entire curriculum of the Baroque academies was geared toward the production of a single work. Art historians who study these academies ask about what kinds of work were most likely to win the prize, and they note that the Rome Prize and similar competitions fostered uniformity and discouraged experimentation. It is also important to see it from the students' viewpoint: everything they did, from taking drawing lessons to reading the classics, would have

fed into the production of their competition piece. It was a blinkered curriculum, and it must have encouraged obsessive students. What would it be like if one of today's art schools offered a single prize so lucrative and prominent that the winner would be virtually assured of making a living? The whole school, I think, would become obsessed with the prize, and suddenly the noncompetitive atmosphere of postmodern practice would evaporate.

The early French Royal Academy perpetuated and legitimized a number of customs and ideas that are still with us. One worth reiterating is the idea that an academy exists for the sake of *theory*, rather than menial practice. The academy's exclusive attention to drawing, even at the expense of color,[72] came from Renaissance ideas about design (*disegno*), though the Baroque academies narrowed the Renaissance meanings of *disegno* into an unyielding pedagogic demand. The idea that theory belongs in academies and "mere" technique belongs elsewhere still has influence, even though the majority of contemporary art schools and departments also tend to provide some market-oriented, technical, "industrial" and engineering instruction. (This is not to say that there was an obvious connection between the theory that the students learned and the paintings they made. Then as now, theories often had little to do with the work.)[73]

Another seminal idea was the dissective manner of talking about pictures that got underway in the seventeenth century. Before that, for example, in the Renaissance, systematic art theory was not common, though there are examples of it. Instead people wrote appreciations mixed with snippets of biography and other anecdotes, technical information, and descriptions of what the pictures were about. It was mostly very informal. Forms and categories of art theory got underway at the end of the Renaissance, however, and flourished in the ambience of the French Academy. Today, although pictures are no longer divided into "invention, proportion, color, expression, and composition," they *are* divided. When students now complain that there is too much icy intellection at art school, too much jargon and theory-speak, they are complaining about something whose seeds were planted in the early Baroque in France and Italy. The phenomenon has always been academic.

There is no better way to appreciate the atmosphere of a Baroque academy than to put yourself through some of the exercises the students of that time had to master.[74] It is fairly easy to find at least a second-rate, anonymous academic drawing from eighteenth-century France in a local museum; and many museums allow drawings to be copied in their

departments of prints and drawings. If that is not possible where you live, then you can try drawing from reproductions of seventeenth- and eighteenth-century drawings and casts of sculptures. (That wouldn't be so different from the activity of first-year students at the academy, with their lithographed books of drawings.) Or you could draw from the plaster statues that ornament downtown buildings—Cézanne did that in the south of France. The three-part regimen of the academy (drawing from drawings, from casts, and from life) can be duplicated in three day long sessions. This may sound like an odd suggestion, but the experience is informative no matter what you end up producing. It will give you a sense of eighteenth-century artists' physical exactitude and mental constraint, and you'll remember it long after you've gone back to the freer exercises that are done in today's studio classes.[75]

NINETEENTH-CENTURY ACADEMIES

Inevitably, there were revolts against this pedantic and artificial way of teaching. In general, the rebellion is associated with the Romantic movement, especially in Germany in the last decades of the eighteenth century and the first decades of the nineteenth. One leading idea, held by the young artists who came to teach in the late 1700s, was that the subjective, individual vision of each artist is more important than any sequence of classes or standardized theory. Routine and requirements were thought to be wrong; freedom was all-important. The artists spoke out against uniformity and in favor of the "special qualities" and "particular talents" of each student. Teaching, they thought, should be "natural," "unaffected," and "liberal." One aspect of codified Baroque instruction, the analyses of paintings according to fixed categories of color, expression, and so forth, seemed particularly offensive. Art was conceived as an "organic entity," something "living" that should not be dissected.

These sentiments led to sweeping rejections of art academies. It was said that all academies do more harm than good. Academy students were compared to maggots, feeding on a rotting cheese; academy drawing was compared to masturbation; academy rooms were compared to coroners' rooms full of corpses; the academy was imagined as a hospital for sick art.[76]

There are tempting parallels between the early 1800s and the 1960s, even though the kinds of art produced in the two periods are completely different.[77] Both periods shared a surplus of idealism and a shortfall of practical curricular change. It is one thing to rebel against a bureaucracy and another actually to change a curriculum. On 11 November 1792 Jacques-Louis David voted to close down the French Academy. In 1795

it was split in two (becoming the Institut de France and the École des Beaux-Arts),[78] but both branches quickly reverted to very conservative positions. The new academies were, in a word, antidisestablishmentarianist.[79] Some educators in European academies tried to get rid of the first years of the Baroque curriculum, but typically the old ways of teaching remained in place, and nineteenth-century students continued to draw from drawings and casts. The Romantic emphasis on drawing from nature instead of from the antique usually meant even more life drawing, instead of trips into the countryside.[80]

German Romantic artists did not rebel the way late-twentieth-century artists did, and their works look strange by our standards. Yet the Romantic rebellion has had lasting impact on contemporary art schools. Five notions are particularly important:

1. **We still devalue the intensive investigation of meaning.** Most of what is taught in studios is loose and informal—a whole mix of criteria and judgments without pattern or consistency. (This is the subject of chapter 4.) Contemporary instructors avoid the kind of formulaic, compartmentalized analyses that the Baroque academicians promoted. Even professional art critics, who can seem downright nasty, are tender toward artworks in that they rarely try for a "complete" analysis the way Roger de Piles did; instead they work impressionistically (another nineteenth-century term), going from one image or allusion to another. All that is a lasting heritage of the Romantic rebellion.

2. **Artists should be independent of the state.** Baroque academies were a little like modern businesses, since they served the aristocrats who needed artists to build and decorate their houses. After the French Revolution that source of income dried up, and in the wake of Romanticism artists tended to proclaim their independence from any class of patrons. Today there is a spectrum of opinions about the relation between artists and their society, but there is a nearly universal consensus that artists should not primarily serve the state.[81] There's a simple thought-experiment you can do to measure your distance from your society. In the seventeenth and eighteenth centuries, the great majority of academicians would have been happy and proud to be commissioned to do a portrait of their king or queen. But how many art students these days are motivated by a desire to paint the president? Artists *caricature* the president, and critique him, but I don't know any who admire him enough to want him to commission their painting.

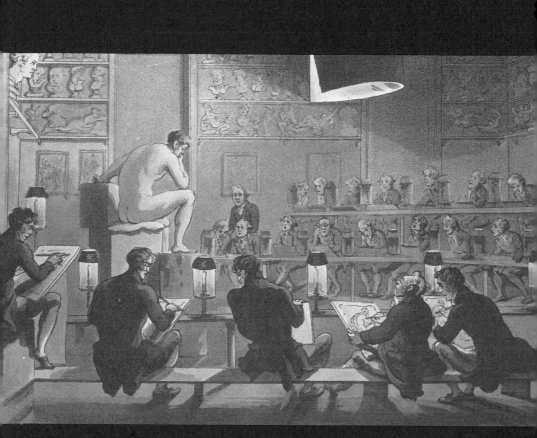

Rowlandson and Pugin, <u>Drawing from Life at the Royal Academy.</u> From <u>The Microcosm of London</u> (London: R. Ackermann, 1808–10), vol. 1, plate following p. iv. Photo: author.

This is an unusually well-ordered classroom. That is because it would have doubled as a lecture hall, and perhaps as an "anatomical theater"—a place where doctors wheeled in cadavers and dissected them in front of an audience. By the early nineteenth century, drawing was becoming a pastime for the leisure class as much as a profession for young men—notice how many of the students are middle-aged. Some in the far row even have curled wigs. The sad-looking instructor stands against the back wall, presiding over the production of yet more identical-looking drawings, to be followed by yet more identical-looking sculptures like the ones on the shelves up above.

3. **We retain the Romantic re-invention of the "master class."** In order to foster individuality and freedom (and in part, to return to what they thought of as authentic medieval workshops), the Romantics expanded the advanced levels of instruction. Students worked under masters, who helped them to develop their "individual genius." Contemporary teachers adhere to this in that they do not try to foist a uniform standard on each student they advise. Instead they try to feel their way to an understanding of what each student is all about. Teachers acknowledge that everyone has different ideals, directions, talents, and potentials. That sense of individuality is quintessentially Romantic.

do this necessary or even good?

4. **We still think—sometimes—that art cannot be taught.** Some Romantics thought that only techniques could be taught in art school. Hermann Grimm (son of one of the brothers Grimm) held that art was "altogether unteachable." Later in the century Whistler said, "I don't teach art; with that I cannot interfere; but I teach the scientific application of paint and brushes."[82] These ideas are extreme, but they follow directly from the less radical idea that artists are individuals: if everyone is different then there's no telling how art can be taught. The Romantics were the first to explore the idea that art cannot be taught, and some of their reasons are also my reasons in this book.

5. **It is possible to study painting in art school.** Because the Romantics thought individual vision was so important, nineteenth-century students could study art from beginning to end in their classrooms. They no longer had to learn painting, sculpture, and other arts outside the academy, by apprenticing themselves to independent masters. In the Royal Academy in London in the nineteenth century, some teachers specialized in painting, ornament, and even coach decoration. The huge range of techniques and media in current art schools is due to the Romantics, who took the essential first step of bringing painting into the academy.

MODERN ACADEMIES AND THE BAUHAUS

The history of modern academies begins in the middle of the nineteenth century, with the Great Exhibition of 1851 in London. Nineteenth-century exhibitions were more like national trade fairs than the world's fairs we think of today, and this one was particularly driven by manufacturing, since one of its purposes was to showcase and improve industrial and manufacturing skills. These days people like to complain about how

WHY ART CANNOT BE TAUGHT

"cheap" manufactured goods are. At the turn of the century, people complained about the poor quality of architecture and furniture (why don't we complain about furniture outlets anymore?), and in the mid-nineteenth century people complained about the poor quality of everything that was manufactured, as opposed to being handmade. Each generation has thought it was the first to notice the disappearance of skilled craftsmen and the first to see that industrialization was the cause. Perhaps to future generations the late twentieth century will seem like a utopia of skilled apprentices.

The Great Exhibition inspired a number of books on the subject of the loss of the workshop tradition. The nineteenth-century architect Gottfried Semper thought that the crafts had degenerated so far that the best decoration was to be found on the objects that needed it the least, such as weapons and musical instruments.[83] Museums were set up for people to study examples of good craftsmanship; the Victoria and Albert Museum in London is the most prominent instance. Educators began to think that what was needed was a single curriculum for "fine art" and "industrial art"—meaning whatever is made with the help of machines, from hammers to iron staircases. Others thought that the principles of "fine art" were of prime importance, and these precepts needed to be applied to decorative and industrial arts (hence the term "applied arts").[84]

The most influential nineteenth-century worker along these lines was William Morris. Like many others, he associated the unity of arts and crafts with the pre-industrial age, specifically with the Middle Ages. His shop, called Morris, Marshall and Faulkner, Fine Art Workmen in Painting, Carving, Furniture and the Metals, founded in 1861, made things only by hand. The phrase "Fine Art Workmen" is telling, and so is the art movement that Morris enlisted: the Pre-Raphaelites, who wanted a return to higher, and nonacademic, standards of production.[85] A number of schools followed Morris and the Arts and Crafts movement. Birmingham had a school for jewelers and silversmiths in 1881, and various schools incorporated crafts such as printing, goldsmithing, and embroidery into their curricula.[86] Part of the impetus for this was purely economic; students at the state-run academies objected to being given worthless degrees. Who needed academic painters when Courbet, Degas, Renoir, and others were challenging the status quo, and who needed a degree in painting when there was so much demand for skilled craftsmen?

If there was a downside to Morris's ideas, it was that only the rich could afford handmade objects. Mass production and industrial techniques could not be avoided if the goal was to disseminate the arts rather than just im-

proving them for a minority of customers. The most famous solution to that problem was Walter Gropius's school, the Bauhaus, which taught a range of subjects—even if it was not entirely singleminded in its integration of "industrial" and fine arts. Students at the Bauhaus went through a three-stage curriculum, which I'll list in detail because the Bauhaus is by far the most important influence on current art instruction:[87]

1. **The first-year course.** A six-month preparatory class was taught originally by Johannes Itten,[88] and it has been extraordinarily influential in modern art instruction. Itten divided the course into three topics:[89]

(a) Two-dimensional instruction: Training the senses. The first exercises were to train the senses and the hand. (Sometimes Itten had his students get ready by doing special breathing exercises.) Students were asked to draw fine rows of parallel lines, pages of perfect freehand circles, and spirals. Some of this still survives in postmodern curricula. I have assisted in classes taught by a student of a Bauhaus artist, in which the students drew long series of fine parallel lines across long sheets of brown butcher paper. Each line had to be a little darker than the one before, and then a little lighter, so that the paper looked like it was buckled in waves. The object was control of the hand, the arm, and the eye. I remember it as difficult, exhausting, and apparently irrelevant to any other kind of artmaking. The first portion of Itten's course also included exact drawings from models and the study of different textures and materials.

(b) Two-dimensional instruction: Training the emotions. Here students were given emotional themes (anger, sorrow, pain) or emotional subjects (a thunderstorm, a war) and told to represent them graphically. Sometimes an abstract approach was required, but more frequently the surviving drawings show a high degree of abstraction that includes realistic elements.

(c) Two-dimensional instruction: Training the mind. The intellectual side of art was promoted by exercises in the analysis of Old Master paintings, color schemata, and simple formal oppositions (light/dark, above/below, motion/rest). Live models and abstractions were both used to teach the analysis of rhythm.

These same three principles—training for the senses, the emotions, and the mind—were then applied to three-dimensional objects, including some arrangements of junk that Itten brought into the studio to test the students' capacity to render unusual textures and forms. This final por-

tion of the six-month introductory course was meant to lead into the studio work of the next stage.

2. **The undergraduate curriculum.** Next in the Bauhaus curriculum came a three-year program in which students specialized in an area of their choice (stone and marble, textiles, "wall-painting," ceramics, glass, woodworking, and so forth). The entire Bauhaus was open to students so they could learn new disciplines, but they were expected to remain in one area and apprentice themselves to two masters. (That was a compromise between the master class of the German Romantics and older academic instruction, and it still survives in the contemporary system involving two or three "advisors.") Bauhaus students were instructed in materials, geometry, construction, model-making, and some history of art.[90]

3. **Assistant work.** At the end of the three years, students took a standard municipal trade examination and got a journeyman's certificate. That in turn enabled them to enter the third course, which was something like being an assistant in an architectural firm or doing postdoctoral research in science. The graduates helped with Bauhaus commissions and sometimes did work in local industries.

The specific agendas and organization of the Bauhaus have been superseded, but a number of Bauhaus-inspired exercises are still common today. As often as not, they form the basis of the first-year or foundation programs in art schools and art departments. Some of the more common exercises include:

— **Textures.** Students gather different textures and try to depict them in pencil or charcoal.
— **Materials.** Students learn about different materials by making carvings, molds, and so forth. Sometimes the object is to make as many different objects as possible out of a single material.
— **Value.** Students are asked to arrange small newspaper clippings into a continuous scale from white to black or to reproduce a scene or still life in shades of gray.
— **Rhythms.** Students arrange objects into a rhythmic composition or making a complex drawing using simple forms.
— **Concrete to abstract.** Beginning with a still life or a painting, students analyze "lines of force" or "points of equilibrium" and eventually arrive at an abstraction.
— **Collections.** Students collect objects that seem to have little in common, or else similar objects (e.g., red things), and see how they are related.

33

— **Emotions.** Students make abstract or concrete drawings or con-
structions that express given emotions.
— **Color.** Students are sensitized to color relations through a wide
range of experiments.

There are many more, and they can be found in Albers's and Itten's books and in books on the Bauhaus written by former students. Though the Bauhaus instructors did not originate all these exercises, they were unknown in Baroque or Romantic instruction. The list I've given is fairly typical, and versions of it are nearly universal. Yet it should provoke some questions:

1. **Is there a tabula rasa?** Some Bauhaus instructors used exercises like these to erase bad habits inculcated by the society and the state of the arts. Itten spoke in these terms: he wanted to return students' minds and muscles to a tabula rasa, a blank slate.[91] Yet as time passes, it becomes more apparent that Bauhaus exercises weren't aimed at a timeless blank slate, but were closely related to the styles of the day. Some Bauhaus students' works look expressionist, and others show the influence of international abstraction. This is well known to historians, but it is not often noted in contemporary art instruction. When exercises like the ones I've listed are done today, teachers don't usually talk about the tabula rasa, and their goals remain similar to Itten's: to do something rudimentary, without the influence of current art styles or art history. But I think it makes sense to think of art history and the styles that inevitably creep into the exercises—after all, an exercise that looks "timeless" today (say a sheet of butcher paper, covered with straight lines) will look very much of its time to future viewers. In other words, there is no tabula rasa.

2. **What is the relation between sensitivity and work?** Many of the Bauhaus exercises are aimed at increasing sensitivity to colors, values, textures, and compositions. Itten's idea was to bring out the individual's capacity to respond to phenomena. Albers's book on color is a sequence of "scientific experiments" in color perception intended to provoke new ways of thinking, to shake up the students' confidence in their sensory knowledge. Yet it's an open-ended sequence because the purpose is primarily to increase sensitivity. (Albers says you probably will never get to be as good at seeing color as he is.) Albers's "experiments" are still popular because they increase the enjoyment of everyday life: if you go outside after a session with Albers's book, you will probably notice more colors, shapes, textures, and compositions than you had before. But

Woman student painting. c. 1945. Chicago, School of the Art Institute. Archives of the Art Institute of Chicago, folder 8250FF1B. Used with permission.

By the mid-twentieth century, the demanding and systematic methods of the Baroque academies had been virtually forgotten. This woman was free to paint in just about any style—she might have been thinking of Titian, Rembrandt, Toulouse-Lautrec, Matisse, Augustus John, or even Norman Rockwell. But she couldn't have gotten tips in the ways Titian or Rembrandt painted; that knowledge was lost well before the twentieth century. She might not even have been able to get instruc-tion in proper proportions or the mixture of paint: there is no telling, these days, what a studio instructor might know. I remember a life class when I was a student: a number of other students were out sick, and the instructor decided to have some fun. He set up his own easel and tried drawing the model for an hour. At the end he had a picture that looked like scrambled eggs, and he said, "Boy, this figural stuff is harder than I thought."

the same reactions may not be helpful in the studio. Is Albers's artificially high level of color sensitivity really necessary to painting? Some kinds of art require nuance and others don't. Sensitivity can be irrelevant, and Bauhaus-style exercises can be more like meditation than like making art.

3. What is rudimentary? The exercises were concentrated in the "preparatory" course. The study of "rudiments" has a much longer history, going back before the Baroque academies. The earliest post-medieval Western art text is Alberti's *Rudiments of Painting*, written in the early fifteenth century. His "rudiments" are geometric forms and constructions.[92] In the Baroque period the rudimentary discipline was drawing. Both Alberti's geometric exercises and the Baroque drawing books make good sense for their respective periods: the Renaissance did base much of its picturemaking on geometry, and the Baroque practice was founded on certain conventions of drawing. But it should not be accepted without question that the Bauhaus's miscellany of exercises is our "rudiments." Do we really think that materials and textures are the basis of our practice? Is postmodern art practice well served by the formal agendas of the Bauhaus?

The Bauhaus curriculum contained the seeds of the 2-D, 3-D, 4-D sequence that is common today. That sequence is open to the same objections as the study of "rudiments." Why assume that 3-D should come after 2-D? If you're a teacher, and you have some latitude in the curriculum, you might consider rearranging the 2-D, 3-D, 4-D sequence. Why not teach 4-D, then 3-D, then 2-D? (Start first-year students with time arts, work down through painting to drawing, and end up in the spring with lines and points.) Does it makes sense to start art with sequences of "D's" at all? Should there be *any* "fundamentals"? After all, postmodernism prides itself on not believing in foundations, and the remnants of Bauhaus teaching look more out of place with each passing year. At the same time, I am not so sure there is any such thing as a post-Bauhaus method of elementary art instruction. The Bauhaus notion of rudiments and the 2-D, 3-D, 4-D sequence are the *only* workable alternatives to the academic model. It can seem as if contemporary art departments and art schools have done away with the Bauhaus by intermixing all sorts of new things in their first-year courses—digital video, multimedia installation, biology, ideology and politics, and even pornography—but the mixtures only obscure the ongoing belief that art *does* have rudiments, and that they have to do with seeing, making, and the tabula rasa.

4. **The resistance to theory.** There is an interesting parallel between the first-year course at the Bauhaus and the children's exercises advocated by Friedrich Froebel, the inventor of the kindergarten. Froebel gave children woolen balls, blocks, laths, paper, and hoops. He encouraged them to draw, to compare sizes, make patterns, investigate texture and color, weave, and model clay. The rationale was that learning takes place best in nonutilitarian interaction with materials. Like the Bauhaus instructors, Froebel held that theory—what he called "mind"—need not, or cannot, develop before activity.[93] These ideas have been held by a wide range of theorists, from Johann Heinrich Pestalozzi through John Dewey.[94] It is worth considering that the kindergarten and the Bauhaus first-year course share an interest in nonverbal, ahistorical learning, and that such learning may not correspond with artmaking that is done in later years. How many subjects in elementary school are prepared for by kindergarten exercises? How useful are the various remnants of Bauhaus pedagogy?

One last point about the Bauhaus. Like some instructors in the French Academy, teachers at the Bauhaus made statements and wrote pamphlets, lecture notes, and books. Several students wrote about their experiences. That, more than any single factor, accounts for the importance the Bauhaus continues to have. Students still read Albers, Klee, Mies, Itten, and Kandinsky, and that makes all the difference in our estimation of the school. Today teachers who write about successful classes they have taught publish in journals like the *Journal of Aesthetic Education* or in the various regional teachers' journals—where their articles are immediately lost. Most art schools have no formal histories and few archival documents. This is a note more for instructors than students: consider writing at length about the school where you teach, to define it and your teaching.

ART SCHOOLS BEYOND THE BAUHAUS

Art academies were very slow to catch up to contemporary styles. In the late 1930s, when Nikolaus Pevsner was writing his history of art academies, the École des Beaux-Arts still had three departments (painting, sculpture, and architecture), and the Royal Academy was still teaching a nineteenth-century curriculum of five classes (the antique school, school of painting, life drawing, life modeling, and architecture). Only the London Central School of Arts and Crafts, Frank Lloyd Wright's Taliesin Fellowship, and the Royal College in London—originally an industrial arts school—are mentioned by Pevsner as progressive, and mostly they

were following late nineteenth-century ideas about the unification of the arts and crafts and the return to medieval apprenticeships.[95] A utilitarian kind of art education flourished in the United States in the nineteenth century, stressing the practical value of visualization, handwriting, and accurate drawing. Though such instruction pertained mostly to elementary and high school curricula, it found its way into art schools, where it mingled with the academic strains inherited from Europe.[96] (Thomas Eakins is an example of an artist strongly influenced by such academic training.)

Art schools in the contemporary sense did not arise until after the Second World War.[97] They are marked by an absence of almost all restrictions on the kinds of courses that can be taught, and on a radical increase in students' freedom to choose courses. The educational reforms of the 1960s removed even more restrictions, sometimes including letter grades and basic or "core" course requirements. Many American art schools were reorganized in the sixties and seventies to remove from their names or course rosters such older-sounding terms as "applied art" and to substitute inclusive categories such as "communications" and "art and technology." The tendency to lump subjects continues today.[98] At the same time schools and departments tend to disavow any overarching purpose in favor of pluralism and the independence of different courses or departments. The result is a curiously free "learning environment," in which students have a large say in what they will learn and when they will learn it.

What I want to stress here is not how we are connected to the past but how strongly we are *disconnected*. For practical purposes current art instruction doesn't involve a fixed curriculum, a hierarchy of genres, a sequence of courses, a coherent body of knowledge, or a unified theory or practice. In large art schools, any two students will be likely to have very different experiences of their first-year program, which is supposed to be the common foundation for further work. They will have been in different classes and had different teachers. In art departments, students' experiences differ widely year by year. Since instructors are generally free to devise their own class plans within the general guidelines of the school or department, the same core course can be very different in different hands. (Art history surveys are restricted by the textbooks, but they vary too.) It is as if modern art schools are a different *kind* of school, as different from the French Academy as it was from medieval workshops. Contemporary art instruction does have a past. But what is done at the beginning of the twenty-first century is strongly different from what was done in the preceding centuries. Yet art instruction has invisibly reinvent-

WHY ART CANNOT BE TAUGHT

Ask students about this. Perhaps he's thinking primarily of places with the ... Most of these but to don't seem correct ..?

ed itself, creating the impression that nothing has changed. It looks as if art is being taught in all sorts of ways—in any established way—but what is done in studio classrooms is often either the determined *opposite* of the customs and habits of the older academies or else the lingering, nearly inaudible echo of the Bauhaus.

And is there anything beyond the Bauhaus? I have seen bits and pieces of post-Bauhaus teaching that are free of the ideas I discussed above— the tabula rasa, the rudiments, sensitivity training, resistance to theory, the sequence from 2-D to 4-D. I've seen postmodern exercises intended to demonstrate how *little* can be understood about art: that's certainly a post-Bauhaus mentality. The Bauhaus that exists today has itself adopted a post-Bauhaus curriculum; students design "sociological experiments"—essentially public installations and performances—and take courses to build up whatever skills they may need.[99] Any first-year program that stresses ideology and politics over media and skills is certainly post-Bauhaus. But any introductory course that focuses on seeing, on visuality, on textures, colors, motions, value, weight, emotion, assembly and composition, or sensitivity, is working in the shadow of the Bauhaus. Contemporary art instruction has moved far beyond the Baroque academy model, without even noticing it. At the same time we have moved only baby steps away from the Bauhaus.

My topic in this chapter, conversations, concerns the subjects that are raised among students and teachers when they talk about how art is taught. It is a kind of complement to the histories of the first chapter, because it offers a way of thinking about current instruction. It might have been possible to write this chapter by drawing on the literature of art education, but I find that literature does not describe the issues the way that they occur in classrooms. Rather than saying art education is out of touch, or claiming that day-to-day studio talk has logical precedence over the discipline of art education, I would rather say art education is a different language, one that is aimed at objective knowledge, research, policy review, and curricular development. Art education speaks the language of statistics, of "purpose," "method," "evidence," and "conclusion." Sometimes, to be sure, the art education literature is intimately tied to the conversations that take place in the studios and classrooms, and certainly what I will say here is more formal than what is usually said over lunch: but in general, I think that it is

(as previous and recent day art teaching, vs -)

Conversations ----- 2

important to try to organize and express the ordinary informal conversations of people trying to learn and teach art. By adopting the language of the social sciences, art education enables itself to ask and answer different kinds of questions. When teachers or students sit around a table and talk, they rarely pursue one topic right to its conclusion. The very open-endedness of our normal conversations is centrally important, and I want to acknowledge that here. At the same time, I want to show what might happen if the conversations are pushed a little—if they are kept on one track a bit longer than usual.

Our informal ways of talking, I will argue, are ways of *not* coming to terms with a number of fundamental difficulties. It's not polite to press too hard on an issue, since a lunchtime conversation or a studio chat is not supposed to be a formal debate, and it is also a way of acknowledging that the issues are not easily resolved. This is a healthy attitude toward difficult problems—one that the journals of art education often cannot accommodate—and it allows students and teachers to make continuous adjustments to their sense of what art and art instruction are all about. The issues I will be considering in this chapter are "our issues,"

(as college-level art teaching)

41

things that we air, and their irresolution is part and parcel of the experience of teaching art. Wittgenstein might say that the incomplete nature of the problems is an illusion, caused by seeing them from the point of view of philosophy, and that art world issues *are* truncated issues—that they do not exist as fully worked-out philosophic positions.

It is widely assumed that extensive debates on some issues—such as whether or not political art can work to change society—would be possible, and sometimes desirable, but would end in irresolution. I agree that such subjects can't be solved once and for all, and that they are better treated informally or in parts and pieces; but I think the kind of irresolution that would result from a concerted, prolonged effort to elucidate the subjects would be different from the kind of pluralist lack of concord that might be expected. Instead of a conflict of interpretations—in which one group would argue in favor of political art, and another would oppose it—I think art world issues would end in conflicts that are *internal to each point of view.* Most of the topics discussed in the course of art instruction become entangled in self-contradiction if they are pressed much beyond the places they're usually left.

My purpose is not to show some underlying weakness in art world discourse. I want to show how the level, intensity, and duration of our accustomed conversations provide whatever sense of purpose that we need to carry on—to continue to think that teaching or learning art is a minimally coherent thing to do. By pressing the issues a little unnaturally in this chapter, I want to try to see art instruction as a very unusual activity, one that sometimes lacks even the minimal or contingent sense that would allow students to speak of learning, or teachers to speak of teaching, at all. This leads naturally to more pessimistic conclusions, which I'll be introducing in later chapters.

A surprisingly small number of themes come up in discussions about studio art instruction. Those themes gather, I think, around three basic uncertainties: the meaning of academic freedom, the question of what is teachable, and the difference between visual art and other disciplines. I will start with some themes that connect with the previous chapter: the nature of academic art, the survival of the "system of the arts," and the recent question of the validity of the core curriculum. Then I will turn to the general question of the place of the art school in society, the issue of teaching mediocre art, and what kinds of art can and cannot be taught in art schools and departments. The chapter closes with a consideration of two more specific subjects: the relation between decoration and fine art, and the social and gender issues involved in drawing from life.

IS CONTEMPORARY ART INSTRUCTION ACADEMIC?

Since the 1960s, the art market has developed an interest in older academic art, and even third-rate student works from the nineteenth century are now admired and exhibited.[1] The people who like academic art are almost exclusively well-to-do patrons, gallery owners, and curators on the margins of the "serious" avant-garde art world. Journalists love revivals of academic painting because it relieves them of the burden of contemporary art and assures them that kitsch and the avant-garde are happily interchangeable. In these debates and misunderstandings (which Clement Greenberg diagnosed over a half-century ago) there is general agreement that academicism isn't a problem in current studio art instruction. (In America, journalists continue to poke fun at studio art instruction because it isn't grounded in academic values.) There is not much sign of old academic art in *Artforum, Parkett, Flash Art,* or other contemporary journals, and it is usually taken for granted that current art instruction is not academic. But could that conclusion be a little too sanguine? Is there a sense in which contemporary art is academic?

It depends on how "academic" is defined. One study of Baroque and nineteenth-century painting reduces the concept of academic art to four ideas: (1) nature is defective and must be improved upon; (2) compositions should be inventive, but unified and harmoniously organized; (3) there is a science of gesture and physiognomy to help artists communicate emotions; and (4) artists should research dress, ornament, religious narrative, and myth so that their scenes are appropriate.[2] That list, which is culled from the histories I surveyed in chapter 1, certainly doesn't seem to fit contemporary art instruction.

Other writers have argued that academicism is still around, because the word "academic" can mean anything that "tends to solidify, gain momentum, perpetuate itself and eventually become rigid."[3] If "academic" is whatever is entrenched, stereotyped, or unoriginal, then most art movements do become academic. This is what is meant by saying that abstract expressionism, cubism, or minimalism had academic phases. There's a lot of modern academic art in this sense, but it isn't quite what I am looking for because it pertains to the successors and imitators of earlier styles and not so much to contemporary instruction.

It has also been suggested that the huge provincial would-be avant-garde is academic. Small art schools and rural liberal arts colleges inevitably lag behind major centers, and inevitably what they produce partly echoes and imitates cutting-edge art. This has been true since the

beginnings of Western civilization, and it is still true today, though it has gotten harder to recognize as the time lag between the provinces and the centers has narrowed.[4] (The time lag also isn't much publicized or studied: after all, it hurts civic pride to be told that your town or college makes only pallid, slightly out-of-date copies of works done in large cities.) Much of modern art, which is about art and artmaking, is academic in this sense because most people, even in big cities, lag a little behind a minority of innovators. (That's another dynamic Greenberg worked out.) The only problem with defining "academic" as "provincial" is that the term is vague and universal, and it doesn't have much to say about the varieties of actual practice.

There are more senses to the word "academic" that go beyond "provincial" to describe what happens in studio art classes. For one thing, academies have a tendency to reimagine the past in a particular way.[5] (Recall the Carracci's rejection of their recent past in favor of the High Renaissance.) Academies emphasize some art and marginalize other art so that it seems that art develops in a line, leading from the past straight to the present. They think art progresses, an idea modernist historians tend to vigorously reject.[6] Contemporary artists wouldn't usually see themselves as academic in this sense; after all, the art world is full of unclassifiable interests and movements, and they don't progress in a linear fashion from Lascaux to the latest biennial.[7] Naïve art, advertising, junk, kitsch, and outsider art are valued as much as the Old Masters or the canonical sequence of modernism that runs from Cézanne through Picasso and Pollock. It would almost seem as if contemporary art instruction is as far from academic, in this sense of the word, as it's possible to get. But the art made in colleges and art schools continues to be primarily fine art, much more closely tied to Cézanne than, say, to aboriginal bark painting or the "starving artist" work at the local Holiday Inn. Students may take their forms and subjects often from popular culture, but their strategies still derive largely from European and American masters. Though we do not often find reasons to admit it, a great deal of what is made in studio classes is made possible by, and expressed in, the traditions of post-Renaissance Western art. To the extent that students and instructors remain tied to the canonical Western past, then at least that one thread of academicism is still alive, and our art is academic.

So I think contemporary art instruction is academic in the sense that despite all its wild experimentation, it still owes final allegiance to the canonical sequences of artists who were also valued by the academics of

past centuries. (A good example is graffiti, which seems to be detached from the academy and from the art world, but depends on a whole battery of very academic devices: chiaroscuro, perspective, glazing, composition, and even lettering—which as I mentioned was taught in turn-of-the-century American art academies.) Art instruction is also academic in the sense that it depends on the idea that art is a systematic, intellectual pursuit.[8] Renaissance and Baroque academies were based on the theory that theory is important; and although people would no longer say that art has a single coherent theory, it is treated as an intellectual pursuit. M.F.A. programs teach students to deploy a formidable range of interpretive methods, and art criticism cannot be written these days without some acquaintance with feminism, deconstruction, psychoanalysis, queer theory, or postcolonial theory. In comparison to what Piero della Francesca or even Vasari could say about their work, we are monsters of eloquence, and that is testimony to a decidedly academic strain.[9]

A third reason to think academicism is still with us is the fact that so many artists have advanced degrees. Artists, like composers, poets, and novelists, are usually people who have been to college. Many have graduate degrees. It's nearly impossible to get a job teaching art in a college without an M.F.A.; compare that to the fact that at the end of the nineteenth century, Harvard had 189 professors, of which only 19 had Ph.D.'s.[10] This may be the strongest sense in which studio art instruction is an academic pursuit, though I think it is also the least meaningful. The four- and six-year programs that lead to the M.F.A. have little resemblance to the Baroque academies, and the M.F.A. itself is a mid-twentieth-century invention.[11] It is unclear whether it makes sense to say current art departments are "academic," if that means "like Baroque academies." But certainly M.F.A. programs—and the handful of Ph.D. programs in visual arts and poetry—are academic institutions.

I've listed six meanings of "academic," of which three apply reasonably well to current art instruction. The fourth and the fifth—academic as an unnoticed connection to the Old Master past, and academic as the privileging of theory—are especially problematic. To some critics, "academically taught art has in fact been defeated," but it may be prudent to weigh such claims.[12] A teacher of mine once said that all art is academic, and all that students are taught is "a description of their prison bars." Perhaps the question should really be, "What is *not* academic in modern art?" That's not an unanswerable question, but it cannot be addressed until students and teachers stop resisting the notion that academicism is still a strong part of what happens in the classroom.

WHAT IS THE RELATIONSHIP BETWEEN THE VISUAL ARTS?

In a small college, the art department might offer only painting, ceramics, and photography, and in that case the arts wouldn't need to be classified or arranged—there would simply be three choices. In a large art school it becomes necessary to impose some sort of order on the dozens of departments and media. In past centuries the issue was solved by organizing the arts into more and less fundamental media. Drawing typically came first, because it was understood as the basis of other media; but there were many *systems of the arts,* some of which we have seen in chapter 1.

These days people reject such systems. According to one view, there should be no organization whatsoever. Painting should just be on a list of media, in alphabetical order somewhere between "marble" and "stained glass." When dozens of media are taught side by side, they are usually simply listed—each one separate and independent of the others. So ceramics, wood, bronze, iron, and aluminum sculpture could all be separate departments in an art school. Borrowing a term used in evolutionary theory, this way of thinking can be called *splitting.* The opposite is *lumping:* put ceramics, aluminum, iron, wood, and bronze together in the sculpture department. Of course, lumping immediately leads to problems. Should ceramics really be under sculpture? Is holography 2-D because holograms are pictures, or 3-D because they have strong spatial illusion, or 4-D because they invite viewers to walk around them? Is holography a kind of picturemaking like painting or photography, or is it ultimately just a kind of installation art? Art schools get more disorganized every time a new department is added. From a student's point of view, the disorganization can be both inspiring and confusing. Small art departments aren't any less confusing, because their relatively small number of classes don't add up to any coherent picture of artmaking.

Today it seems that the number of arts and media are indeterminate. By and large, art schools and departments remain disorganized because postmodern pedagogy has made it seem as if systems of the arts are irrelevant or even pernicious. That has not always been so. Ever since the seven medieval liberal arts, there have been attempts to organize and number the arts, and the habit of thinking up systems still guides people's thinking. In contemporary art schools, media-based departments (sculpture, photography) mingle with idea- or discipline-based departments (visual studies, criticism, liberal arts), making it seem as if the whole idea of classifying the media is outmoded. But it isn't: remnants of the idea that the arts comprise a system still haunt instructors and guide

administrators. The arts have become productively disorganized, but they aren't free of all organization. The problem of the system of the arts is relevant because it's the great excluded topic wherever a large faculty has to get along together, pretending everyone else's department or specialty is just equal and different from their own.

The system of the arts has gone through a number of variations. In the late Middle Ages, the Renaissance, and the early Baroque period, what are now called the "fine arts" were mixed in with what are now called crafts, mechanical arts, and sciences. For example, one seventeenth-century author proposed this scheme for the arts:

Eloquence	Painting
Poetry	Sculpture
Music	Optics
Architecture	Mechanics.[13]

It wasn't until the middle of the eighteenth century that the fine arts were at last separated from crafts and sciences. One important early formulation separated arts that are strictly for pleasure from those that have a use (and the author added a third category for arts that were both pleasureful and useful):

Arts whose purpose is pleasure
 Music
 Poetry
 Painting
 Sculpture
 Gesture or dance
Arts whose purpose is both pleasure and use
 Eloquence
 Architecture.[14]

The eighteenth century codified the idea that there are exactly five fine arts:

Painting
Sculpture
Architecture
Music
Poetry.[15]

Once these five seemed graven in stone; now it is difficult to name them from memory. Sometimes other arts were added to this scheme, without erasing it:

Painting	Engraving
Sculpture	Stucco and the decorative arts
Architecture	Military strategy
Music	Dance and theater
Poetry	Opera
Gardening, including layout, arboriculture, and fountains	Prose literature.[16]

And occasionally there have been fewer divisions: the École des Beaux-Arts in Paris was divided into two parts, one for architecture and the other for painting and sculpture together.

In the late twentieth century, the five fine arts were overwhelmed by a tide of new entries:

Performance	Industrial design
Video	Fashion
Film	Artists' books
Photography	Printmaking
Fiber	Kinetic sculpture
Weaving	Computing
Silkscreen	Neon
Ceramics	Holography.
Interior architecture	

And, as I mentioned, the mix is enriched by "academic" departments based on ideas or disciplines imported from universities:

Liberal arts	Visual theory
Art history	Anthropology
Critical writing	Computer science
Visual studies	Languages.

Recently it's even become common to find "transdisciplinary" or inter-disciplinary initiatives, concentrations, committees, and majors, making the mixtures even more impure. I'm going to concentrate on studio de-

partments, not academic or technical or support departments, because I think the illusion that all fields are potentially equal is rooted in artistic media.

Studio departments continue to proliferate. All the recent nonstudio additions to art curricula only obscure the problem. Now it's taken for granted that art schools will have separate departments of film and photography, but few art schools taught those subjects before the Second World War. When silkscreen was first taught in the 1930s, it was intended for commercial uses (it was a cost-efficient way to make napkins, tablecloths, wallpaper, and toys). Performance art, as a department, is largely an innovation of the last decade of the twentieth century, though some departments were started in the 1970s. The School of the Art Institute of Chicago, where I teach, did not offer courses in abstract art until 1944. Outside of large cities and outside the West, the profusion of media is still held at bay by the five fine arts. The Academy of Fine Art in Sofia, Bulgaria, still does not teach abstract painting, though it has abstract painters on its faculty. Computer-assisted art is virtually unknown in the academy in Bucharest, Romania (on a visit in 1999, I saw three old computers in operation). At the School of the Art Institute, we have over one hundred graphics workstations with commercial and proprietary software. Economics and geography influence the growth of media in every college and school—but wherever the budget allows it, new media grow like weeds with no form or limit.

The list of media could be longer, but not, I think, too much longer. Let's say you are studying at a school with a Department of Neon Art, and you notice that some students are making wall pieces à la Dan Flavin, and others are using neon in their video installations and performances. Could the neon art department be split into several departments? Perhaps there could be a Department of Free-Standing Neon, a Department of Flat Neon, and a Department of Installation-Art Neon. Would the instruction be significantly different in each? If so, then there might be good reason to divide the department. In many studio art departments painting could be divided into any of its styles, so that you could major in all-over painting or hard-edged abstraction. (Or, in an art school there would be a Department of All-Over Painting and a Department of Hard-Edged Abstraction.) This kind of fantasy is useful for showing just how many possibilities each medium seems to have: it is not an infinite number, and in some cases the number is not much greater than the number of departments that already exist.

Some of the many media I listed above can be lumped together. Per-

formance art goes with theater, and fiber and ceramics seem to have a natural affinity with sculpture. Installation art is a new multiple category that covers several entries on the list. The fact that it's at least conceivable that ceramics goes with sculpture, or performance with theater, shows that we retain a sense of underlying order—a pale ghost of the Baroque system of the arts. I think that, although we really don't spend much time thinking about it, a modern system of the arts would look something like this:

Fine arts

a) Visual arts	b) Music
Painting	c) Writing
Sculpture	Poetry
Architecture	Prose.
Film	

Contemporary artists and critics don't care very much what is counted as an art and what isn't, and they are likely to accept anything (billboards, miniature golf) as a visual art. If someone says ceramics really belongs under the rubric of sculpture, no one is likely to object except the faculty members who teach sculpture (who might feel their turf is being invaded). Basically, when it comes to ordering the arts, no one seems to care.

The pluralist notion is divided between two alternatives that I think are nearly equally unsupportable. On the one hand, people say that there's no sense in dwelling on classifications of the arts, because what's important is how they are used, not what they are. In that view the arts are separate just because they happen to use different technologies, so it is sensible to house them in different rooms and buildings. What matters is entirely different: meaning, production, context, intention, politics. Systems are just outmoded and narrow ways of conceiving the arts. Other people—just as strongly pluralist—say that each medium is its own message, unique and incomparable. In that view every art, every department, is important in its own way, and comparisons are unfair or incoherent.

I think there's truth to both versions of pluralism, but both go on the assumption that the centuries-old impetus to compare and classify the arts has simply vanished. Even today students in the visual arts tend not to know about the histories of their "sister arts." That in itself is evidence for the lingering effect of the system of the fine arts, and it's especially telling when it comes to the *kinds* of information students have about other arts. In my experience music students are not taught much about

contemporary visual art, and few painters and sculptors that I have taught have known names like Pierre Boulez, Karlheinz Stockhausen, and Elliott Carter—among the most famous late twentieth-century composers. Fewer still recognize the name Paul Celan, arguably the greatest poet of the second half of the century. Composers such as Carter and poets such as Celan work with forms that are disjunct, dissonant, and fragmentary, much like the forms of some contemporary art. Yet the contemporary art world remains more connected to popular music: far more art students know the current bands than the current composers (with a few exceptions, like Philip Glass). Naturally it is difficult to sustain an argument at this level of generality, but I think that by and large, students who study painting know contemporary popular music, and those who study poetry know older painting. That's odd simply because songwriters like Madonna are in many ways more strongly tied to late Romantic theater than to contemporary visual arts culture. There are separate subcultures for painting, poetry, and music—a deeply entrenched remnant of the system of the arts.

There are other signs that we are living among the invisible ruins of the five fine arts. Curricula are still organized as if music is separate from painting and poetry. Despite the fact that visual artists work with sound (in video, in film, and in sound installations), music departments are still separate from studio art departments. Architecture, too, is often a separate department or even a separate school. The five fine arts are still largely distinct: painting and sculpture are usually together, but music, architecture, and poetry are off in the music, architecture, and English departments.

Certainly artists mix and match indiscriminately, so much so that it is said multimedia art is a principal direction of postmodernism. But the postmodernist's fascination with multimedia art is the exception that proves the rule. Students go from department to department in an art school, but they still have to leave one department to get to another; that is, the classifications remain in place. Only a few departments, such as time arts, media studies, or art and technology, are interdisciplinary from the outset. Universities try to solve this problem by allowing interdisciplinary majors and Ph.D. dissertations, but it's up to the individual students to build their own bridges.

It follows that the current way of thinking about the arts is self-contradictory, since we believe both in systems and in mobile or unorganized lists of co-equal arts. The principal dangers of not acknowledging our investment in classifications, and the reasons why I think that the sys-

tems of the arts is an important subject, are the two limit-cases of pluralism I mentioned earlier. Either we come to think that the very idea of talking about differences between departments is a relic, and that it should be replaced by more radical transdisciplinary concepts of making and thinking, or we say that each department has its own "language," its own way of dealing with its particular medium.

The problem with the first case is that it smears historically grounded differences in the name of a theory that has no historical grip—a theory that tends to weaken as the traditional media continue on their largely separate paths.

The problem with the second approach—in which it's said that each medium has its own language—is that it may be based on wishful thinking. It's tempting to think that any imaginable medium has its own language, but I suspect there are only a few basic ways of thinking about media. In the nineteenth century, photographs were hard to reproduce and so publishers who needed illustrations had photographs copied as wood engravings. (The lines of the engravings were easier to print than the grain of the photographs.) So the first generations of wood engravers did not pay attention to their medium. Instead they were thinking of photography and trying to reproduce the look of photographs. In the twentieth century, wood engraving "came into its own," and now it has a "look," meaning recognizable conventions that spring from the quality of the ink, the boxwood, and the specialized wood engraver's tools. Early wood engraving therefore had photography as its *ideal method.*

Many other media originally borrowed their ideal methods from pre-existing media, until artists discovered their medium's specific "language" or "intrinsic potential." The ideal method of early etching was engraving, because etchers based their techniques on the known conventions of engraving. The ideal method of Japanese woodblock was ink drawing, and the ideal method of Michelangelo's early pen drawing was marble sculpting. My point is that this is the normal state of things: there are only a few ideal methods, and all the dozens of techniques look to them for guidance. Now that there are so many media, artists can be seduced into thinking that each medium is independent of its predecessors, when it may take decades for that to happen.

Teachers may turn their backs on their medium's ideal methods, in order to concentrate on what seems unique and fruitful about their chosen medium. Yet in doing so, they lose sight of their medium's ideal methods, and those methods don't get taught. Students can end up in departments that are intellectually cut off from their originating ideas. If you're

Daniel Clowes, "Fortunately, talent really isn't the issue." From <u>Eightball</u> 7 (1991). © 1991 Fanta-graphics Books, Inc. Used with permission.

Talking is all-important. In undergraduate classes it helps students figure out what they're doing. In M.F.A. classes, it's practice for real-world situations. As an artist, you have to be able to keep up a steady, intriguing patter while the potential customer wonders whether or not you're worth as much as you say you are. "Artspeak" can be learned by reading maga-zines or books like Julian Schnabel's <u>CVJ</u> (New York, 1987), but the best way to learn it is to practice during critiques.

a student, this means it is good to be careful that the right people are advising you. In a Department of Computer Graphics, it is very likely that the ideal method is still painting or photography. Photoshop and other software tools descend directly from styles and strategies that were originally applied to painting, drawing, and photography. The palettes and the filters were all inspired by effects in other media.[17] Though it is often said that drawing on a computer is different from drawing by hand, it is far from clear what that difference might be. Most of the things that happen differently on computers are simply a matter of greater efficiency and ease. David Hockney noted that it is possible to cover a blue field with a red stroke on a computer and have the blue entirely effaced. But the same is possible in oil or tempera, if you have enough time and patience. Large rectangular pixels are a trademark of computer illustration, but they are arranged and printed in ways that depend on the history of painting, and especially cubist painting. It is not easy, I think, to point to something in computers that is different from painting in kind rather than in degree. Hence it makes sense to have a painter or a photographer advise you, because computer graphics' ideal method is still very much nineteenth- and early twentieth-century painting. Otherwise you may get only technical advice about Photoshop or your particular computer configuration.

The same holds true in holography, video, and other new media. A student in my fictional Department of Flat Neon might be best off choosing her advisor from the Department of Hard-Edge Abstraction, since her neon work might lean on that kind of painting for its strategies. Some media are on the verge of developing their own ideal methods: screenprinting and ceramics come to mind, because each has some strategies and interpretive methods that belong to it alone, and each also borrows heavily from the aesthetics of neighboring media. Other media are so new that virtually everything they do, except the technical components, is borrowed without acknowledgment from other media. (Here I think of virtual reality and cyberspace, which are almost entirely dependent on earlier histories of immersion and bodily dispersion. They are as entrancing as they are pedagogically narrow, because teachers have to concentrate almost exclusively on technical issues.)[18] From the teacher's standpoint, the paucity of ideal methods means that all departments are not created equal, and that some thought should be given to the seemingly old-fashioned idea of putting painting, drawing, sculpture, and architecture instructors on every student's critique panels and advisory boards. In this way especially, the five fine arts are still with us.

I think there are only a half-dozen ideal methods, perhaps fewer, and they determine the number of ways artists can deal with objects. Hence all departments are not created equal, nor is every medium a message. And given that, it pays to think seriously about the systems of the arts and decide how you think they are related. Is drawing really fundamental? Do 3-D arts depend on 2-D arts? Should ceramics be in the sculpture department? Those are questions for each student and teacher to decide.

THE CORE CURRICULUM PROBLEM

What should be taught in an art school aside from visual arts? Do artists need a core curriculum of classics, like the courses student have to take in large universities? Or is visual art important enough, and different enough, to warrant four years of undergraduate study? The same questions can be asked of students who are majoring in studio art in college: How many non-art courses should they take? What beside art is necessary?

It is helpful to compare this issue with the core curriculum debates current in liberal arts colleges. Core literacy problems were not new to the second half of the twentieth century, although they were often presented as if they were. They came from concepts of academic freedom that were current in German universities in the late nineteenth century. "Freedom of learning" (*Lernfreiheit*) and "freedom of teaching" (*Lehrfreiheit*) were the mottoes of the day, because German educators wanted to replace classicizing and medievalizing courses with more "modern," Romantic curricula. The German reforms influenced American universities, which in turn influenced American art schools.[19] Beginning in the 1960s, core curriculum debates have focused on ethnocentrism and gender issues. For example, some people hold that Plato and Aristotle are dispensable, that Western white males have had their say, and that alternate traditions need to supplant them.[20] The fact that faculty members concerned with the core curriculum in universities spend much of their time talking about issues of gender and politics is only the most recent form of revisionism.

The core curriculum debate suffers somewhat from a lack of attention to its history, but the discussion is also less coherent than it might be since it does not draw on several underlying philosophic issues. One is the difference between absolutist and relativist theories of education. The former holds that education should be the same for all people—or all Western people—and the latter that education needs to be relative to each decade or social group.[21] The Great Books program at the University of Chicago

was an example of the absolutist approach. Robert Maynard Hutchins, one of the program's developers, looked to the Middle Ages as the model of institutionalized learning and believed that all modern universities should have three "faculties": metaphysics, social science, and natural science. Metaphysics comprised many of the subjects of the medieval *trivium* and *quadrivium:* logic, dialectic, grammar, and mathematics (meaning principally Euclid), with the addition of the Great Books. Anything that did not fit that scheme was to be banished to "technical schools."[22]

Relativist learning, in contrast, would seek to revise the curriculum every so often in order to keep it responsive to the surrounding culture. Democritus, Isocrates, or Cicero, orators who addressed issues specific to their cultures, might be replaced by Vaclav Havel, Malcolm X, or Martin Luther King Jr., who addressed issues specific to ours. It might be argued that art schools are among the least absolutist of institutions of higher learning, and their lack of absolutist theory should be food for thought. Curricula in art schools are radically relativist: classes are changed as quickly as possible, to reflect each change in the art world's fashions. What is missing in art schools and studio classes is the conversation between relativism and absolutism that energizes so many universities.

A second issue that can help clarify core curriculum debates is what the philosopher John Dewey called "the case of Child v. Curriculum": whether or not the students' interests should determine the methods and content of the instruction. Educators who take the child's side try to adjust teaching at all levels in order to let children be children and adolescents be adolescents. From the curriculum's point of view it is a question of when educators should listen to students' demands.[23] The same argument (without Dewey's title) has also been applied to gender difference: it has been urged that teachers should listen to their female students in order to learn what kind of instruction suits them best.[24]

The case of Child v. Curriculum is especially relevant to art schools, because teachers sometimes scramble to adjust what is taught to fit the special requirements of art students. A large fraction of full-time art students is dyslexic, and in my experience many believe in right-brain/left-brain differences, despite growing scientific evidence against the popularized versions of that idea.[25] Should such students be taught differently? Should they have a version of art history or liberal arts tailored to their needs? In general, the child wins out in art schools, and the curriculum is adjusted to fit. That makes sense if the school's purpose is to help inspire students to make new art, but it doesn't make sense if interesting art depends on an awareness of the deeper history or wider culture that is found,

ideally, in the core curriculum. It's not an easy question to decide. In the last decade of the twentieth century, many students felt they couldn't make interesting art without knowing how to make virtual environments or do real-time video editing. Where I teach there was high demand for courses on Lacan, film theory, and Photoshop. A few people went on teaching premodern art, literature, and philosophy. Were those teachers right, or should they have followed the child's lead and abandoned deeper history in favor of the subjects the students felt they needed?

These two principles—absolutism versus relativism, and Child v. Curriculum—can help clarify some disagreements about the core curriculum. The debate in art schools is arguably more complex than in liberal arts colleges, since there are three distinct areas in which the concept of core curriculum applies to studio art. The first, which I have already introduced, concerns which classics ought to be read by art students. Should artists know about Dante's "visual imagination," or about written works that are "nonvisual," such as Joyce's *Ulysses* or Aristotle's *Poetics?* The second pertains to the visual art that ought to be seen by art students: do art students need Michelangelo or Picasso? And the third concerns which techniques and media should count as classics: that is, which procedures, concepts, and materials are indispensable to a basic education as an artist. I'll consider required reading, seeing, and making, in reverse order.

The idea that some techniques are indispensable is the commonest concern of core curricula in studio art. The "canon of techniques" usually takes the form of a first-year program or a series of introductory courses with titles such as "Concepts of Space and Light." As we saw in considering the Bauhaus first-year curriculum, there is little agreement about the content or the purpose of such programs. But this kind of core is fundamentally different from the other two. It does not teach "classics" in any sense: instead it is more like grammar. A college English department does not teach spelling or grammar. Instead it teaches what can be accomplished once the basics are mastered—that is, everything from Parmenides to Pynchon. So although it is important for teachers and students to discuss which techniques are essential, the problems of a core curriculum of techniques or media isn't on a par with the other two kinds of core curricula (those pertaining to texts and artworks). Both philosophically and in terms of teaching, the choice of essential media comes before the choices of classics, visual or otherwise.

The second sense of core curriculum, concerning which "classics" of visual art should be seen, is no less problematic. At first it may seem that

studio art instruction has entirely abandoned the classics of visual art. Studio art teachers don't introduce Praxiteles, Raphael, and Rembrandt in their elementary studio classes. The architecture and interior design departments no longer begin with the five orders of architecture (Tuscan, Doric, Ionic, Corinthian, Composite). The terms and achievements of Greco-Roman sculpture are largely absent from introductory classes. If there is a visual core curriculum at all it is the art history survey, which is usually required in colleges and art schools. But that is a curious kind of core, since it is not about indispensable classics but about everything that can be packed into one year's course. The survey implies that an aggregate of people and works is indispensable. It's not a matter of choosing bell hooks over Plato, or *Tom Sawyer* over *Paradise Lost,* but of trying to mention as many works as possible. The large art history survey books are like E. D. Hirsch's "cultural literacy" dictionaries, which also have thousands of entries. So the question of the canon never really comes up. No one in studio art has to worry whether there is a short list of essential works, "masterpieces" that must be in all students' imaginations in order for them to be able to create. In this sense, studio art instruction is weirdly free of the problem of the core curriculum.

By comparison with other departments in a university, studio art is astonishingly free of interest in its essential cultural heritage. English and comparative literature departments teach the latest literary theory, but they also offer courses in the classics—Chaucer, Ariosto, Cervantes, Milton, Keats. Even architecture departments teach the classics—Vitruvius, Alberti, Serlio, Palladio, and so on. There is a similarity between the way studio art instructors deal with Old Masters and the way that Mendeleev and Mendel are brought into introductory chemistry and biology courses: the Old Masters are treated as venerable curiosities or sidelights. The newer science textbooks mention history in "boxes" (that is, typographically isolated paragraphs), and the main story winds its way past with a brief nod in their direction. In studio art instruction, the Old Masters— Giotto, Masaccio, Leonardo, Raphael, Bernini, Tiepolo, and so forth— may be mentioned in passing, but only inconsistently and only as illustrations. Studio art is not centered on the Old Masters any more than physics is centered on Galileo or Newton, or mathematics on Euler and Gauss. But of course the parallel to science isn't exact. Within the humanities, no departments are as radical, as far removed from the common concern with classics, as studio departments.

So much for the core curriculum of essential techniques and the core curriculum of essential visual works. There remains the original sense of

"core curriculum": the *written* material that might be essential for every person's education. In this respect it is instructive to look at an especially extensive core curriculum, the one required at St. John's College in Annapolis and Santa Fe. The 1990–91 catalog listed the following books that freshmen were to read in whole or in part:

Homer	*Iliad, Odyssey*
Aeschylus	*Agamemnon, Chorphoroe, Eumenides, Prometheus Bound*
Sophocles	*Oedipus Rex, Oedipus at Colonnus, Antigone, Philoctetes*
Thucydides	*Peloponnesian War*
Euripides	*Hippolytus, Bacchae*
Herodotus	*Histories*
Aristophanes	*Clouds*
Plato	*Meno, Gorgias, Republic, Apology, Crito, Phaedo, Symposium, Parmenides, Theatetus, Sophist, Timaeus, Phaedrus*
Aristotle	*Poetics, Physics, Metaphysics, Nicomachean Ethics, On Generation and Corruption, The Politics, Parts of Animals, Generation of Animals*
Euclid	*Elements*
Lucretius	*On the Nature of Things*
Plutarch	*"Pericles," "Alcibiades," "Lycurgus," "Solon"*
Nicomachus	*Arithmetic*
Lavoisier	*Elements of Chemistry*
Essays by:	*Achimedes, Torricelli, Pascal, Fahrenheit, Black, Avogadro, Cannizzaro*
Harvey	*Motion of the Heart and Blood*

FRESHMAN READING LIST, ST. JOHN'S COLLEGE

Things continued at this pace through the next three years and into graduate study.[26] On the other end of the scale are universities that have made substitute lists. At Stanford in 1990, a student could also learn about Chinese, Japanese, African, and South American literature, as well as poststructuralism, lesbianism, and "pornographic culture."[27]

From a studio art standpoint, the choice between the St. John's commitment to the classics and Stanford's revisionism is curiously irrelevant. The issue in the visual arts is not, Should we teach non-white, non-Western, non-male authors? but rather, Should we teach writers at all?[28] In a curriculum like those at St. John's or Stanford, as in any liberal arts college, studio art is surrounded by, informed by, and based on a program of broader cultural readings. The situation is different in art schools, where liberal arts departments are small or absent. (In studio departments, the liberal arts and art history requirements are similarly minor.)

There are two opposed possibilities: either studio art majors could study the humanities (liberal arts, English, art history) and take a minority of studio courses, or they could take mainly studio art courses and have minor requirements in liberal arts and art history. The second possibility is quite common: think of any small art school, with its minimal complement of art history and liberal arts. Such a case is the opposite of what happens in colleges, where the humanities and other requirements take most of the credit hours and studio is in the minority. But what's best for a studio art major: to be grounded in studio practice, with some help from the humanities, or to be grounded in the humanities, and let them illuminate a smaller selection of studio courses? Which is the core, the studio courses or the classes that study texts?

Perhaps I am proposing a false choice, and the two sides should be balanced and play against one another. Dante might help a student who wants to paint Hell; or it might be that the experience of painting Hell helps in reading Dante. Teachers in literature, languages, philosophy, anthropology, history, art history, and other "support" disciplines could tailor their own classics to fit the needs of artmaking. But if mutual help is the goal, and if disciplines are watered down to let them speak to studio art, *then* where is the core curriculum? It seems to me that the coherence of any claim for a core curriculum rests in part on the idea that the core curriculum is the *foundation*, the place where knowledge begins. The idea is basically that knowledge and ideas begin from one place and proceed to another. You learn to think about concepts by reading the original texts of Aristotle or Heidegger, and you learn to think about mathematics by reading Euclid or Frege. Then, so the assumption goes, you can be a citizen in the fullest sense and let your participation in the world inform your artmaking. The opposite claim would be that reading Aristotle and Euclid might not ever help you make your art, and teaching them takes up valuable credit hours that could be filled by texts with proven bearing on modern art production. Disciplines, in other words,

should be bent and even broken a little so they can enter into dialogue with artmaking. The price that's paid for diluting disciplinary boundaries is that the core curriculum of indispensable classics quickly vanishes. In the 1990s, for example, Lacan, Baudrillard, Foucault, Derrida, Heidegger, Deleuze, Irigaray, Fanon, Benjamin, Hélène Cixous, bell hooks, Judith Butler, Martin Jay, Rosalind Krauss, and Hal Foster would replace Homer, Aeschylus, Sophocles, Aristotle, Plato, Euclid, Dante, Boccaccio, Chaucer, Ariosto, Cervantes, Montaigne, Milton, Lavoisier, Pope, Kant, Keats, Frege, Joyce, and even Pynchon. The core, as students in colleges and universities know it, would vanish like last year's snow.

These are three primary options: humanities could take the majority of a student's time, or the minority, or they could be balanced and blended with studio classes. There is one other possibility, more radical than the first three. Art schools could choose to teach no liberal arts at all, so that there would be no core curriculum of texts. (Some would argue that art schools, and even some colleges, essentially do that anyway by requiring so little reading that it is negligible.) It could be urged that there is so much to be learned in visual arts that even artists with M.F.A. degrees need more visual education. There's a comparison to be made with law and medicine, which have demanded the full attention of their students— that is, no liberal electives—since the twelfth century. The same could be said of a typical graduate education, in science or in the humanities: the four- or six-year Ph.D. is a cloistered, specialized activity with little room for comparison shopping. Art schools aren't really that different from medical schools, law schools, and Ph.D. programs, because they also virtually exclude the humanities (although less strictly, to be sure). In doing so, art schools are essentially saying that studio art is nearly broad and deep enough to require full-time study. Hence by teaching a relatively small number of academic "supporting" courses, art schools involve themselves in a contradiction: they imply that studio practice is *nearly* self-sufficient, but that there is a need for some of the distribution requirements and core curriculum typical of universities. Why not just omit humanities courses altogether and concentrate exclusively on visual art?

It seems to me that studio art is in a radical, almost ahistorical position in regard to the questions of the core curriculum. I am not arguing that there need to be core curricula of techniques, texts, or visual materials—I do not agree in this respect with the agendas of writers such as Allan Bloom or E. D. Hirsch. And I'm not at all sure that artists need rigorous or thorough understanding of fields outside their own. I just mean to say that questions surrounding the core are even more interesting and

difficult in studio art than they are in the much more widely publicized cases of large research universities like Stanford. As in so many other respects, studio art is at the very edge of college life: the edge of educational theory, the edge of historical awareness, the edge of incoherence.

DOES ART REFLECT THE SOCIETY IN WHICH IT IS MADE?

Art students naturally wonder about the education they are receiving: about the difference between an art major and a physics major, or between art schools and liberal arts colleges. A good way of resolving those doubts is by getting to know people from outside the art world. Artists I know who also know lawyers and business people tend to say there are no real differences between art-world people and people outside the art world. But the question nags: as undergraduates, the doctors, lawyers, and business people had four years of distribution requirements in subjects like biology, chemistry, math, physics, anthropology, sociology, political science, English, French, and history. Does their education make them different from people with B.F.A.'s, M.F.A.'s, and B.A.'s in studio art? In other words, does the core curriculum make a difference?

At the heart of the art world there's an assumption that art is somehow universal: it expresses the society in which it's made, even if it is not intended to, and even if the wider society outside the art world seems not to understand it. If any question is troubled, this one is. To begin, it sounds like an echo of the old Hegelian concept of a *Zeitgeist*, the idea that a culture is unified, so that the components of society are like the spokes of a wheel. One spoke is art, another is religion, another is politics, and they are all attached to the hub, which is the spirit of the times. In Hegel's account, artists do reflect their entire society, even if they try not to.[29] Most people don't mean anything so specific when they say that art expresses its surrounding society. No one would claim that early twenty-first century American society is a unity, but I think artists often behave as if the society were at least coherent enough so that art can have a broad significance outside the world of galleries and openings. On the one hand, students and teachers have a stake in the significance of what they do, but on the other hand they don't sit down, as Hegel did, and work out how the connection between artists and their society actually functions. I haven't heard a student say of his own work, "I want this to express the spirit of contemporary America," but I have heard students say, "I want this to express a kind of American feeling." Either way—explicitly or implicitly—the idea is that products of the art world can speak to a very broad public who might not even be aware of what's happening in that world.

Behind this assumption is the idea that what artists do is different in kind from what electrical engineers or physicists do: in theory everyone can understand art, but only some people can understand engineering or physics. And in the end, everyone *needs* art, while only some people could be said to need the expertise of an electrical engineer or a physicist. Art is ideally or potentially universal: it has to do with the people's feelings and inner lives, and so it isn't a specialty known only to a few individuals.

If you believe some version of these ideas—and in my experience, everyone in the art world does—then it's sobering to consider what people who have no traffic with art think of artists. There is certainly a feeling among the non-art public that artists are a little nuts. They are likely to be liberal, anarchic, undependable, or mentally unstable. If they are great artists, then they are also incomprehensible and gifted, worthy of a reverent trip to the museum. There are dozens of ways of describing this. Sometimes people think artists are likely to be manic-depressive, or learning-disabled, or homosexual. Much has changed since the Renaissance, when artists were first thought of as a special kind of person, a little mad, prone to melancholy and flights of imagination denied to ordinary people. Michelangelo and the mannerists acknowledged and sometimes cultivated the idea that they were "geniuses."[30] In early modernism, people like Kurt Schwitters, Tristan Tzara, and Marcel Duchamp were still cast in that mold: they were considered opaque, infuriating, and even dangerous. Today the situation is significantly different. According to the newspapers, artists are something of a blemish on society—or, more strongly, they are parasites on public largesse, or just jerks.[31] The general attitude of the public, as it is reflected in the media, is *annoyance*. Artists are seldom described as geniuses, or even as talented workers. Publicly visible artists, like Jeff Koons, Robert Mapplethorpe, Joel-Peter Witkin, Damien Hirst, Andres Serrano, Richard Serra, and Chris Ofili, are not at all essential members of society, expressing thoughts that everyone can share: they are useless parasites, ticks clinging to their society and drinking public tax money.

There is a gulf between the art world and people outside it, and people inside the art world may sometimes fool themselves about that world's significance. Public perceptions of artists tend to be described as "misunderstandings," as if journalists and the general public just need more information or a better education in art to comprehend what is being done. Perhaps—so it's said inside the art world—the public is miseducated to think that art is mostly about money, and artists' works are stunts

intended to make a profit. When people in the art world do notice the gap, they tend to think it can be solved by educating the public.[32] The notion is that art *could* reach a larger public, if only more people had taken more art courses in college and gotten accustomed to going to galleries. Driving those prescriptions is the conviction that art *does* have relevance to the society as a whole, and that what artists make expresses our time and our culture. It's only a matter of adjusting people's educations so they can appreciate the best art.

These, I think, are dangerous mistakes. It may be that people in the art world make them because they do not want to think about another possibility. Let me put it in the boldest possible terms: it may be that the community of art students and teachers is genuinely, importantly different from the communities of business students, pre-med students, and pre-law students. And if that is true—no matter how it is true, or why it's true—then what gets made in art school and afterward may only express the minority community of artists, teachers, students, gallery directors, critics, and consumers. In that case, art could no longer be said to express our culture. Even the word "our" would be suspect.

This theory also explains why the public sometimes finds artists annoying rather than intriguing, and why the expressive content of some art is invisible to the press. It's not because the public isn't educated. It is because *we* aren't educated. Artists are educated differently, typically with fewer non-art subjects, and that contributes to the fact that artists make art that expresses their own minority subculture and not the culture as a whole. In the opening chapter I suggested medieval artists were "cut off from the intellectual life of their time" because their education was so different from that of doctors, philosophers, lawyers, and clerics. Even if it could have made sense for a medieval artist to address the intellectual concerns of the time, it wouldn't have been possible. Medieval artists formed a separate class outside of educated people, and to a lesser degree that is what is happening today.

Needless to say, this isn't a popular topic among art teachers. As long as I've pursued it this far, let me also suggest that there may be measurable differences between "types" of people who end up in colleges and in art schools. I once had an opportunity to teach in an exclusive private high school, and I noticed the split of the types I'm describing here. It is not that the students interested in art careers were always poorer at academics, it is that students interested in science and mathematics were bright in a different way. They were quick thinkers, but not always patient thinkers. Their particular kind of brilliance and inquisitiveness,

Daniel Clowes, "Don't hold any false notions." From Eightball 7 (1991). © 1991 Fantagraphics Books, Inc. Used with permission.

In the Renaissance and Baroque, the human figure was still associated with divinity and perfection. Artists drew from imperfect bodies only when they were working on paintings with elderly or fat people in them—and even then the artists always idealized what they saw. That began to change starting with Romanticism, when some artists put deliberately horrifying figures into their works. Now that the equation of the human form and divinity is entirely discredited, it doesn't matter if the models are good-looking or not: in fact it would be strange to worry about such a thing. The model is a difficult shape, and nothing more; so the more wrinkles, the better.

65

which every science and mathematics teacher knows, is exceedingly rare in art, art criticism, and art history. Whether by proclivity or choice, my students were already receiving very different kinds of education. The French theorist Michel Serres describes those who belong to disempowered "literature," as opposed to the exact sciences, in the same way: "such a person does not know how to demonstrate, measure or count, does not know how to manipulate, does not speak the right languages, does not present credentials to any power whatsoever. Reason has no need of paupers; power has no need of songs."[33] It's a power difference, but it's also a temperament difference. In my high school class, and when I was an undergraduate student at Cornell University, the distinction between arts people and science people was immediately obvious. I've scarcely seen the science-types since my years as an undergraduate student, and people who have spent their entire lives in the art world tend to doubt the distinction: I've been told it's just a prejudice of mine.

I won't push this any further. Volumes are written about educational aptitudes and learning types, just as volumes have been written about the stereotypes of artists from the Greeks onward. Both kinds of evidence, I think, support the hypothesis that artists create only for a small portion of their society. I do not think it is possible to take this too seriously. We continue to believe that art is universal in a way that tax accounting or pig farming are not. Art is still said to express things of general human interest. And it is still thought that art schools and art departments train people to do things everyone might be interested in, while technical schools train specialists. The oscilloscope repairman still needs some sort of art, but artists don't need to know how to repair oscilloscopes. What if these notions aren't true? In that case, studio art students are being trained to live in intellectual ghettos.

The disconnection between art students and their society also emerges when students set out to make political art. The results, which are often scandalous, prompt educators to say that art students should be trained to make more responsible, effective, interesting political art. Politically charged art, like Andres Serrano's, Komar and Melamid's, or Hans Haacke's, can appear awkward or strident. In response, there are intermittent calls for renewed integration of artists and their society, and critiques of the ways artists fail to handle political issues except as radical polemicists.[34] The assumption in such writing is often that the solution entails improved education: artists must know the history of political art, and they must be taught politics and economics. But it is possible that the situation is bleaker than that. It may be that the retreat of the arts

into the ivory tower is a deeply rooted and pervasive phenomenon, one that cannot be cured by improving artists' educations. I argued in chapter 1 that the separation of artists and society began in early Romanticism, and it has been increasing for almost two hundred years. Seen in historical perspective, artists and their society are widely divergent, and pedagogical initiatives are not likely to have any consistent effect. Historically speaking, the two sides—artists making alienated works, educators bemoaning the artists' isolation—have been in place for some time, and one might argue that it is best to study and understand the phenomenon rather than attempting to change it.

There's a more subtle question here as well. Art has never been a dependable reflection of its society. In China, the political scene was relatively uneventful during the life of Tung Ch'i-ch'ang, one of China's most innovative artists; on the other hand, the transition from the Ming to the Ch'ing Dynasty, one of China's most disruptive events, left hardly a trace in painting. The art historian E. H. Gombrich has pointed out that in the West, "both Mannerism and the Baroque have been claimed to express the spirit of the Counter Reformation but neither claim is easy to substantiate."[35] It seems that important art has seldom expressed its immediate political surroundings, which makes it even more difficult to know how to train artists to make interesting political art.[36]

Does contemporary art reflect its society? Yes, in all sorts of ways. But there is also a fraction of artists who have been educated in relative isolation from people in other professions. The general lack of understanding of science, business, law, medicine, and other fields is clear in such art, and it may be best not to assume that such art expresses the lives and feelings of the society in general.

TEACHING AND LEARNING MEDIOCRE ART

Out of a thousand art students, maybe five will make a living off their art, and perhaps one will be known outside her city. That's not a condemnation. It's the nature of fame, real quality, and genuine influence to be rare. In addition the mechanisms of fame are strongly random. Many interesting artists don't make their work at the right moment or show it to the right people. A bad critique, or bad weather on opening night, can be enough to topple a career. No one will agree on what's great or important or worthwhile, and in the second half of the twentieth century the avant-garde became notoriously evanescent and hard to locate.

Yet beyond those problems of luck and history, it is still true that most artists do not make interesting art. And it follows that most art students

do not make the kind of art that they study and admire. Some people would say they make art that imitates "better" art, so that art schools at any given time are filled with people making art that is roughly emulating more successful art being made elsewhere. The graduation shows at art schools can look impressively diverse, as if each student were pioneering an art unique in history. Seeing such shows, it can seem as if virtually all the art has value, and only the vicissitudes of the market stop each artist from being successful. A look at earlier graduation exhibitions belies that assumption. Art school catalogs from the turn of the century are filled with reproductions of student paintings that look like slavish copies of John Singer Sargent or Henri Toulouse-Lautrec, and exhibition catalogs from the 1950s show hundreds of students works that emulate abstract expressionism. The lesson I draw from looking at older art school catalogs and graduation exhibitions is that fifty years from now even the most diverse-looking work will begin to seem quite homogeneous. Works that seemed new or promising will fade into what they really are: average works, mediocre attempts to emulate the styles of the day. That's depressing, I know: but it's what history teaches. (If you doubt it, you need only find a large library that collects the catalogs from institutions like the Royal Academy in London. In the oldest catalogs the students' work seems to be all done by one person, and in the newest, each student seems to be a lone innovator. The passage of time smoothes differences down to uniformity.)

The impending mediocrity I am describing is invisible in the present. If you're an art student now, you may not even be aware of the influences on your art. The overwhelming similarity that will become apparent to later generations is hidden. For that reason it wouldn't be right to call contemporary works pastiches or pale imitations: they aren't perceived that way, either by students or teachers. That's a happy fact, but it doesn't mean that your work won't eventually *become* a pale echo of someone else's work. The majority of artworks, like the majority of works in any field, are average and uninventive.

At the same time that art classes continue to produce normal, average works, museums continue to privilege unusual, adventurous, strong, challenging work. The National Gallery in Washington tends to exhibit works that are large in scale as well as ambition: in the early 1990s it was hanging Rauschenbergs, large Diebenkorns and Pollocks and Gottliebs and Rothkos, and there was a room dedicated to Anselm Kiefer's *Zimzum,* a gigantic painting on lead sheets. Among the few smaller works were Jasper Johns's flag and target pieces, though they were also strong, challeng-

ing, and adventurous. The large scale of many of the paintings was typical of abstract expressionism, which the museum—as America's "national" museum—wanted to showcase. (A museum featuring surrealism would have had much smaller works.) Overall, however, what stays in museums is powerful, aggressive, uncompromisingly avant-garde, and statistically unusual. It's the cream of the crop, no matter how it's chosen.

It's a very simple contrast that I am drawing here. Average people—average art students—are not innovative, challenging, aggressive, adventurous, or strong. Most art students do not spend their lives in intense dialogue with their work, and few are reliably challenging or provocative. Whether or not you care about the criteria that museums like the National Gallery promote, the fact is that most work produced in most studio art classes is bound to be utterly normal and low-energy. Few of us master the cutting edge or come to terms with the most radical work in our field.

Average people have average energy, and that means they may be significantly different from those few that find a voice for more urgent, passionate, timely, "essential," or "profound" thoughts. This is only melancholic if every artist wants those qualities. The very fact that most art students are not depressed shows this is not so, and there are writers who critique museums for their historical and gender-related biases. (The National Gallery, for example, tends to favor dead white males who had world-scale ambitions and a penchant for huge canvases.) Most of us are relatively contented with our level of energy and our mastery. Everyone is a little discontented, but few people are *strongly* discontented. Most of us are not profound and we have obvious limitations. We may not feel anything too deeply, and we may not be capable of creating work that has intense feeling or striking intellect.

Average art students produce art with different values than the art they admire or are taught. Average art is less challenging, less aggressive, more conciliatory and inviting, more immediately comprehensible, and less troubling than exceptional, historically important art. What is done in art classes is *necessarily, unavoidably* more complacent, retiring, and even timid than the "monuments" of culture and the "masterpieces" of art history survey texts. And this finally brings me to what I want to say: teachers should consider teaching average kind of art in addition to the famous models that are always taught. It would be both realistic and honest to teach studio art without emphasizing artists or qualities that are rare in school settings.

What's needed is a way to talk about common, everyday virtues in a

positive fashion. Some people are timid, and teachers would have to try to speak about timidity as a positive achievement. Other people are retiring, and they want their art to show the distance between themselves and the world; they would have to be praised and encouraged not to emulate well-known artists. The problem is that the languages of art criticism and art history are deeply biased against timid and retiring art. "That's a beautifully timid piece!" sounds sarcastic, and "That piece is quite successful in its unadventurous way" sounds condescending. At times, "timid" can be an outright accusation. (Perhaps "intimate" could serve as a more productive synonym.) Words like "kitsch," "failure," "boredom," and "mediocrity" would have to be rethought.

I am not saying weakness is necessarily less interesting than strength: on the contrary, I find derivative, provincial, incompetent, and outdated art very interesting.[37] Most artists are not Rembrandts or Kiefers, and I don't know any artists who want to be pale echoes of Rembrandt or Kiefer. One of the ways to avoid being a pale echo is to begin to see virtue in what is average: to admit to mediocrity, and try to comprehend its particular nature.

Of course, not all mediocre art is timid, unadventurous, retiring, unoriginal, safe, or easy. But a teacher can either inspire students to do "better," or she can appreciate students' works for what they are. Some teachers try to help students by naming famous artists, and one often hears their names in art classes. Instructors may question the choice of artists to emulate or critique, and they may try to suggest alternates if they think a student has picked the wrong model. All teachers try to change their students' art in various ways; that's the purpose of teaching. But consider what teaching would be like if its purpose were not to improve or even change the student's art, but to appreciate it and to help students to understand what they already do. This kind of teaching would have *self-awareness* as its goal rather than change of any sort. It would accept the fact that mediocre art has its own virtues, and it would not seek to change mediocre art into something that it is not. Later in the book I will revisit this idea, describing it as the difference between *descriptive criticism*, which seeks to understand what has been made, and *judicative criticism*, which seeks to expand, improve, and advise.

I like the idea of trying to be realistic about what actually takes places in ordinary classrooms, and I am especially attracted to the strange conversations that result when teachers and students try to work on everyday, mediocre qualities. Here is such a conversation, between a student and a teacher who is thinking of the virtues of mediocrity:

— That's a very nice, timid drawing. It repeats a lot of what you've done in the past, and it looks pretty much like the work you did last year.

— Do you think that's bad?

— No, no: I think you should do more of the same. I mean it shows you think of the same set of ideas, almost like you're swimming in them. It's nice . . . it's friendly to see the same things again.

— Here I was trying to draw the books more accurately. I think they are a little weightless.

— They don't seem to be really part of your imagination, or at least not so much as the lamp or the pencils.

— No, I guess not.

— Sometimes in your pictures I get the impression that you don't really care, that the pictures are a kind of daydreaming. You might want to be careful about that: if you start worrying about that, they might become kind of artificial. They are like dreams, the drawings are like dreams.

— Sometimes I think so.

— Some of your most satisfying pictures are ones that are done without much thinking, like you were looking out the window, or watching TV, while you were drawing.

— Thank you, it's true, I do.

I am not suggesting that this is a good idea for any artist or teacher. I mean the example, which I have partly invented (it comes from fragments of conversations I've had), to sound strange, so that it can throw normal studio conversations into relief. Average art teaching is aimed at something other than average art. It is aimed at improvement, strength, unity, power, challenge, radicality, newness, voice, power, and any number of other common and debatable terms. It's aimed, in short, at the masterpieces that hang in museums. Average student art may be haunted by those ideas, but it seldom achieves them, and it doesn't always even aim for them. Mediocre art is what we do. Can we admit that, and still make art instruction a worthwhile experience?

There's also the matter of how well students get along with one another. Very conservative and unambitious students tend to hide their work. Teachers may be more aware than students that most classes harbor some conservative artists. Several times I've had the experience of seeing work in private that would be unacceptable to the majority of other students and teachers: small delicate watercolors, naïve dreamscapes, pastels in the style of Matisse. Some work is too unashamedly or too obviously mediocre to be effectively critiqued in art classes. Perhaps if mediocrity could come out of the closet it would be possible to find new virtues and sources of interest.

Now that the restrictive Baroque-style academies have virtually disappeared (many still remain, in rural schools and in places like South Korea, Singapore, and eastern Europe), it may seem as though art students can learn virtually any kind of art. If you want to study figurative painting, you probably won't go to UCLA or Cal Arts, and if you want to work on expensive graphics workstations you probably won't enroll in a small liberal arts college. Each department and art school has its special emphases, but with a little shopping around, it appears that you can find a place to make just about any kind of art.

At least that's the self-image of many studio art programs: art has broken open, and anything is possible. But I am not so sure that studio art education is as catholic as it seems. I can think of nine kinds of art that cannot usually be made in art school. If you're interested in one of these kinds of art, you might be better off learning and working on your own:

1. **Art that involves traditional techniques.** The practices that are now called painting and drawing are entirely different than what they were in past centuries. Painting has died—its central techniques have been lost—four times in the history of Western art: once when the Greek paintings and textbooks were lost, again in the sixteenth century when Jan Van Eyck's method was lost, again in the late eighteenth century when Venetian Renaissance technique was forgotten, and a fourth time in the early twentieth century when painting *all prima* (wet in wet) definitively replaced the more systematic Baroque techniques. Renaissance painting was done in many stages, with each layer drying before the next coat, and the images were constructed: that is, planned in advance and brought to completion in a more or less systematic and deliberate manner. Different emulsions were used within a single painting (a typical sequence was tempera, followed by oil, and then glazes and varnish). Nowadays artists paint all at once, *all prima*, in a single thick coat. Even Romantic painting, at the beginning of the nineteenth century, was definitively different from what is done now. The change happened as early as Manet and the Impressionists.

It does not help to look in old texts, because Jan and Hubert Van Eyck kept their methods secret, and there is no Renaissance source that says how Titian executed his glazes. Nor does it help to turn to contemporary chemical analyses, because what is important about the techniques—such as ultra-thin paint layers—cannot be adequately studied in infrared, X-

ray, or thin section. Some German texts, written around the turn of the twentieth century, record attempts to recapture Renaissance methods—but even they have become hard to interpret as the traditions of reconstruction have died out.[38] The fact is that oil painting is a lost art several times over, and what we call oil painting bears very little resemblance to what past centuries knew by that name.

It's worth contemplating these losses, because the general feeling is that oil painting is oil painting, and that modern pictures look different from old ones because contemporary painters are interested in different things. Painters these days no longer care about religious narratives or historical pageants or moralizing allegories, and they are not as fastidious about realism as the Old Masters were. Modernism and postmodern have certainly brought radical changes, but it wouldn't be prudent to lose sight of the fact that the *technique itself* has also been lost, so that what happens, minute by minute, in the classroom is entirely different from what once happened.

The same applies to drawing, which was also done in stages. The contemporary, post-Bauhaus way of drawing is intuitive, quick, and ruleless; by contrast, drawing from the mid-fifteenth century to the mid-nineteenth century tended to be rather rigid, and it sometimes had its own sequences of steps and even its own specialized technical vocabulary.

So I think oil painting, in any of the older senses, is something that cannot be learned in studio classes, and so is drawing. Even though art departments advertise courses in "Painting" and "Drawing," what they mean is "Painting since 1850," and "Drawing since 1850." Painting and drawing belong on a list of lost or nearly lost techniques—a kind of Sierra Club endangered media list:

> Oil painting (the Van Eycks', Venetian Renaissance, Baroque, Romantic)
>
> Tempera painting (according to medieval instructions)
>
> Drawing (Renaissance, Baroque, Romantic)
>
> Marble sculpting, without the air drill
>
> Copper engraving and steel engraving
>
> Wood engraving on Turkish boxwood, and finer woodcuts of all sorts
>
> Fresco (done with heated lime, not mimicked with plaster)
>
> Technical photography (the Zone System, and so forth)
>
> Original lost-wax bronze pouring (Renaissance and Baroque methods, not what's now called "classical investment")
>
> Older tapestry methods.

It is rightly said that there is no good reason to try to return to previous centuries' styles. But that does not mean that older *methods* might not be of interest. Most items on this list take time, and they involve tedious and repetitive mechanical actions. The methods that are taught these days tend to produce faster results and have less complicated techniques. These days artists are impatient, and they won't normally put up with the time-consuming layers of Renaissance painting or the demanding rules of Baroque academic drawing Even so, the demanding techniques that contributed to the forgetting of the older methods might also be a reason to become interested in them again: tedium, discipline, and repetition can even be attractive in their own right.[39] I know several artists who make wood engravings, and their results are bent in curious ways by the unusual demands of their medium. I haven't met any artists who make steel engravings, but I'd like to.

The older oil painting methods are like extinct birds; there is no way to bring them back. But there is no reason why "endangered" media can't be revived. It's just that they aren't usually taught, so they count as things that cannot be learned in studio art classes. With the giddy growth in new media, it might seem that the items on my list are obscure or trivial. On the contrary: they were the central techniques of centuries of art production. In that respect, it's *contemporary* practice that's impoverished, not older practice.

2. Art that takes time. Another kind of art that cannot be easily made in modern art schools is whatever takes more than a few months to complete. It took Seurat two years to paint the *Grande Jatte*, which was not an unusual amount of time for a major painting in Renaissance and academic practice. Imagine, though, what would have happened to Seurat if he had been in a contemporary studio critique. (Here I'm imagining Seurat talking to his painting teacher.)

—Well, Georges, I see that you're still working on the same piece we saw last semester.
—Yes.
—It looks about the same.
—Well, I changed some figures a little, and I'm working on the color balance according to my theory of—
—Yes, well, whatever theories you use are up to you. Whatever makes the art work. But I don't see anything else.
—I finished my last oil sketch last year.
—I think we need to see much more. More drawings, more "oil

sketches," maybe even a sculpture. Let yourself go. Experiment. Try
quick studies, draw from the model. Your figures look frozen.
— I'm interested in that kind of static look.
— Well, I like the awkward quality, but you're bogged down. You've
been looking at <u>the same painting</u> for over a year!
— Yes.

If Seurat were a contemporary student, his painting might be admired for its strangeness, but it is difficult to imagine him getting good critiques for two consecutive years of work on a single canvas: after all, two years is the entirety of an average M.F.A. program. Studio art instruction just isn't geared for long-term projects.

3. **Work in a single style.** Another kind of art that *seems* to take time is work that is in a single style or format. Students who do only small watercolors, or only sculptures that use a single shape, will be critiqued for lack of variety. Here is an excerpt from a critique in which the student had been doing monochrome figure studies. Someone asked why she hadn't used color:

— I just feel I have enough to worry about without thinking of that.
— But if you throw away color, then . . . you know, some of these
things that people are saying—they might be worth trying. They
might work when you don't expect it.
— These arms look like tubes. And it's because light and dark don't
make it for that surface. You need to experiment. Embrace a little
more. Maybe the work will be out of control, but you might find
something.
— Yes, take it to the next step. Destroy it and you may learn something.

It is not easy to develop works in a single style in an art school, because instructors will advocate variety over unity. Sometimes teachers say they want to see different kinds of works just because it is an easy thing to say, and other times they feel confined and uncomfortable when they look at too much of a single thing. But why shouldn't art be limited? And what, I wonder, is wrong with feeling uncomfortable?

4. **Works in too many styles.** Art schools and art departments try to help students develop a "style" (or "voice" or "manner" or "set of concerns"). That seems natural enough, but it also puts constraints on what can be done. Many artists that we call "great" did not have distinctive styles until they were well past the age when most students get their de-

grees. Rembrandt was still struggling with basic matters of technique. Titian was a virtuoso, but his later styles had not begun to appear. Other arts have similar examples. Robert Frost's first book of poetry appeared when he was thirty-nine, and Wallace Stevens's when he was forty-three. Could anything useful have been said to them when they were eighteen or twenty? In premodern China, the idea of developing a style of one's own was scarcely promulgated at all, and some of the greatest Chinese painters spent their entire lives emulating one predecessor or another.

In part the difficulty that teachers have with students who have many styles is that it seems they can't be taught. If a student is approaching the M.F.A. and is still showing abstract work alongside realist pieces, or doing aluminum sculpture along with prints and holograms, it begins to look as if they haven't learned how to choose. And that is because teachers naturally look for what is called in poetry a "voice": a single identifiable set of concerns or styles, a character or a manner. The ideal student is in between a monomaniac who keeps to one style (as in paragraph 3, above) and a schizophrenic who can't decide on a personality. A student's work has to be fairly coherent—otherwise it won't seem right.

5. **Styles that require naïveté.** Art that is anarchic and nihilistic, as dada was, does not *need* to be done in a school; but if it is, there is no particular harm. Even violent, scatological, and sexual performance art has its place in art departments—after all, it is descended from dada.

But some art is threatened and even destroyed by studio classrooms. A prime example is German expressionism and the various expressionisms that have developed from it. Around 1909, Ernst Ludwig Kirchner and the movement Die Brücke achieved an angry, crude, sometimes ugly way of making pictures. But it was a delicately balanced achievement, and it depended on *not* thinking about some questions that art students everywhere learn to think about. Kirchner, Erich Heckel, and Karl Schmitt-Rottluff did not study perspective, academic composition, the construction of fictive space, academic color, the history of styles, the rules of portraiture and narrative painting, the current methods of printmaking, or the whole repertoire of realism. That *lack* of interest was essential for their expressionist style. After World War I, Kirchner continued painting, but he also turned to an increasingly sober and even scholarly research, looking carefully at various historical styles and at what Picasso was doing. His later works, though they are sometimes admired—historians do not like to say he went downhill—are distinctly softer, and some look like decorative pastiches of Picasso's styles.

Daniel Clowes, "It could only happen in art school." From Eightball 7 (1991). © 1991 Fantagraphics Books, Inc. Used with permission.

The old cliché, "My five-year-old son could do that!" is widely discussed in academia. Ever since skill began to recede as the primary criterion of a work's value, it has been less clear how art should be judged. The very possibility of saying "My five-year-old son could do that!" is sometimes understood as the indispensable condition of interesting abstract painting, which needs to be open to the most radical critique in order to function as interesting painting. On the other side of the equation, art criticism has adapted itself to all sorts of situations and has found criteria of excellence where none had existed. In the introduction to this book I mentioned a critique about the quality of embarrassment. This one—which is entirely legitimate—is about frustration.

German expressionism, and some other kinds of expressionism, depend on not thinking about the kinds of things that are routinely taught in studio classes. I do not mean that expressionism can't be done in schools and universities. It doesn't really matter if you *know* about art history, printmaking, chiaroscuro, and the rest—it's that sooner or later you begin to *care* about those things, and expressionism depends on not caring. (From a teacher's point of view, it's hard to imagine how to teach such a style to artists except by putting them under hypnosis and asking them to forget everything they know.) So there are some styles that don't work well in schools, and others that are effectively ruined by them. Teachers can often recognize when studio instruction is not doing a student much good, but not many teachers will counsel students to change classes in order to preserve what's good about their art. By the nature of things, as long as the student stays, she'll be learning more—and that may not be the right thing for someone who cares about expressionism. Years ago, when I was teaching the art history survey, I used to tell the neo-expressionist students to drop out of school. I think I'd still say that if I were teaching the survey today: it's the only honest thing to do.

6. **Art that needs extensive contact with non-art information.** I have suggested that there is a parallel to be drawn between medieval artists shut up in their workshops and contemporary studio artists secluded in their art schools. Both groups miss out on a large part of the intellectual concerns of their time. College students who major in art get a taste of many other subjects, but art school students get very little besides art. In 1986, a commission calculated that Berkeley's 8,100 courses would take 1,000 years to complete, and large university libraries typically have on the order of 10,000,000 books and subscriptions to 40,000 periodicals.[40] It's not that art students need that much information, but the common topics of college-educated thinking are available to them only in drastically simplified forms.

Some art depends on long-term involvement with subjects that are not taught at most art schools. The art that is produced at art schools draws mostly on other art, on issues within the art world, on current politics and social issues, and on personal experience. Art that uses mathematics (for example, the art of Dorothea Rockburne and Sol LeWitt, who have used number theory in their work) and art that involves difficult texts (Joseph Kosuth's, for example) require outside study. Likewise, students who want to make art about history may need more than the single survey of world history—a course that might not even be offered at an art

school. If a student becomes deeply interested in some artist from the past, then it may be a good idea to have access to a high level of art history instruction. For each of these concerns the solution is independent study or courses at neighboring colleges. The same applies, to a lesser degree, for art majors in colleges. I wasn't an art major in my undergraduate college, not because I didn't paint and draw, but because there were too many other things to study.

7. **Art that comes from years of mechanical preparation.** I distinguish this issue from the first ("Art that demands traditional techniques"), because some traditional techniques can be learned quite rapidly. Other techniques are not amenable to art instruction because they are endeavors that take a large portion of a lifetime to master. The practices of the Baroque academies resulted in a kind of art that cannot be made without a number of years of what we would now call drudgery, practicing hatching and other manual skills. There are specialized schools and ateliers that carry on those traditions, but for the most part students are not interested in the kind of skill that seems irrelevant and would eat up all their time in school.

It could be said that subjects like lithography or oil painting take a lifetime to learn, but in such cases there is no fixed course of study that takes more than one year. Instead students learn by a gradual, unplanned accumulation of experience. Persian miniature painting and Eastern icons are other examples of techniques that require a number of years to master. In each case, one year is enough to get a fair degree of competence, but it really takes more. Whenever more than two or three years are required just to learn the fundamentals, the art cannot flourish in contemporary art departments. There is time in a four-year college or art school to take a number of courses on one subject, but those courses seldom build directly on one another the way they did in the Baroque academy. Techniques that require *systematic* progressive guidance are missing from contemporary art curricula.

8. **Whatever is classified as "industrial art" is not taught.** William Morris's shop offered apprenticeship in a variety of household crafts. Today it's possible to learn about a wide variety of materials, but art instruction seldom includes the methods of commercial production. Students can easily learn how to make silver earrings, but they can't make silver candelabras or pewter lamps. Art instructors seldom teach porcelain, crystal, or commercial furniture design. Sometimes that's a matter

of taste (porcelains aren't popular in the art world), and other times it's a question of technology and knowledge. I don't know any art departments that train their students in plastics, in new kinds of glass, or in stamped, rolled, and pulled metals. Such materials comprise the world around us: cars, boats, furnishings, and appliances. Perhaps art students wouldn't want to make toasters, but it's hard to know unless there are classes in making toasters. Vast realms of material technology are not taught because they are associated with commercial or industrial purposes. Few schools follow the model of the Bauhaus and arrange for industrial apprenticeships. The result is that when students want to make metal lamps or refrigerators, they make strange imitations out of substitute materials—lamps out of papier-maché, refrigerators out of junk-yard parts. Even kinetic sculpture, neon, and electronics classes take their materials from outside the studio—no art students I know could manufacture a printed circuit, a battery, or an electric switch. And of course holography, video, film, photography, and computer graphics rely heavily on material technologies beyond the reach of art schools.

Since the Industrial Revolution it has been common to use things whose origin and workings we cannot explain. What I mean here is not that artists should also study engineering, but that it is strange that so few art students are given access to the universe of manufactured materials. Lovely things like iridescent mylar and acrylic medium do make their way into art schools, but for the most part artists' constructions are limited to wood, sheet metals, papier-maché, and ceramics: simple things that were promoted by the arts and crafts movement rather than the sophisticated materials that actually form the substance of our lives.

Unusual materials can be hard to use because they remind viewers of science fiction, or of high-tech business. Clay, wood, and basic metals have the advantage of being more neutral, so they can "disappear" into the work and serve a variety of expressive purposes. Media such as holography are still plagued with sci-fi associations—it's hard to look at a hologram without thinking of the technology. But it's impossible to know in advance what material might make a good artwork. Why not try making something using tinted boron glass or liquid crystal paint? Why not learn how to make a foam mattress or a mousepad?

9. Art that isn't serious. The twentieth century was an unusually humorous century in art history, and it produced a great deal of satirical, ironic, and light-hearted art. Even so, virtually every student and teacher still believes that art is a serious endeavor. Art students are routinely

asked whether they "really care" about their work, whether they feel "obsessed" by their inventions or "compelled" to explore them. Artists still lard interviews with the admonition that if a person can do anything *except* paint (or sculpt or film or turn or cast or carve or weld) then they may not be a true artist. Educators and commencement speakers talk about the artist's "calling," the conviction that something inside has to be expressed, the idea that artists are not so by choice, but by inner necessity. Journalists and parents speak of a "gift," a "talent," or a "potential." Students still hear the catch phrases: Do you have "real" enthusiasm? Are you "dedicated" to something "really important"? Is this a "deep" exploration? Do you feel "passionately" about it? Does it speak to you "on some very important level"? Do you feel that you are being "drawn toward" it?

All of this comes from an originating nexus of ideas that we have inherited from the Greeks and from the Renaissance, and it includes the idea of the artist as genius, melancholic, and sociopath. Postmodern artists have been criticizing those ideas since the 1960s, but it's clear they still have a grip on us because we can hardly imagine art without seriousness.

Why can't an artist paint without involvement? Why not work absentmindedly? Why isn't it possible to conceive of a Sunday painter who is also worthy of being placed with the masters? Why not paint with rock music blaring (Andy Warhol did, and reported that it helped him not to think)? Why not let motifs come and go, without trying to "explore" them (Duchamp did)? Why don't faculty members admonish their students to think of art as a pastime or a hobby? Questions like these sound odd because we still feel that art is at bottom a serious thing to do. When we say that an artwork "contains humor," we betray the assumption that "art" is something serious—serious enough to safely "contain" humor.

The supposed seriousness of art has a widespread effect on teaching. It guides students, often without their being aware of it, toward projects that require a certain seriousness and dedication. Lighthearted, careless work is hard to make in a school environment without seeming superficial, annoying, or flippant. A student who makes a joke out of art is likely to seem irresponsible, as if she refuses to recognize art's underlying seriousness. But if you don't try too hard you might make work that is interesting precisely because you refuse to be "committed" or "obsessed" with what you do. If it's true that students sometimes try a little to hard *not* to care, it's also the case that students are prone to being deadly earnest. Both routes are uninteresting. Too much drive and engagement narrows the possibilities of art just as much as an excess of insouciance.

Unfortunately studio art instruction nearly always privileges and rewards the deadly serious students over all the others.

It wouldn't be hard to add to this list of things that aren't taught in art classes. My purpose is just to show that contemporary art instruction isn't at all universal or free. Art instruction at the beginning of the twenty-first century pretends to be entirely unbiased and open-minded, but it has its own purposes and dogmas. It isn't easy to say what they are—but they're pervasive. It may be, though I do not know any historical evidence to support it, that students in the seventeenth century academies felt just as free as we do. Looking back at them, we see an astonishingly narrow practice. Perhaps future generations will think the same of us.

THE PROBLEM OF DECORATION

Three kinds of people worry about decoration. Abstract painters have an abiding fear—a gnawing anxiety—that what they make might be "wallpaper" or "mere decoration." This is also a concern for students of interior design, fashion, visual design, visual communication, and typography and layout. For them "decoration" is a bad word, a sign of the lower status of what they do. These days few people in the arts would want to say that making a chair is less *important* than making a painting. But furniture designers know everyone believes it anyway. A third group that is anxious about decoration is made up of administrators, teachers, and people in charge of planning art course. They worry because they do not want their departments or schools to become divided between "design" people and "arts" people. Any number of art schools are effectively split in half between fine artists and "applied" or "decorative" artists, and even within a single department—like visual communications or fashion design—some students might be out to make Art, while others might be more interested in making money.

The determination to make money isn't the only thing that separates design students from fine art students. To some degree the two groups draw on different ideas of history. Painters will talk about Kiefer, Pollock, or Bosch. Design students mention Nagel, Chanel, and Lacroix. That means painters can find out a tremendous amount from art history classes, but design students need special courses and readings to learn about design history. From an art history teacher's point of view, a large part of the problem is that it is harder to talk about designed objects than about famous artworks. It is fairly easy to lecture on a sculpture or a painting,

but more difficult to fill an entire hour with discussions of a chair or rug. (Normally chairs and rugs are studied in quick succession, with a few comments about each. The material and knowledge to go into greater depth are not easily available.) In studios, design students need different kinds of criticism. They do not, in general, expect detailed critiques of meaning or symbolism, but they do require teachers who can speak about "look," style, and marketing problems. There is also a philosophic divide among design students. Much of design philosophy is told as a story about capitalism and class conflicts. There is another kind of design philosophy, less often encountered, that is closer to the philosophy of fine art. It is seldom brought to bear on the making of objects because it is abstruse and abstract (I am thinking of Heidegger's meditations on the object, and Merleau-Ponty's phenomenology). Hence the philosophy of design is also divided between teachers who talk about things like bourgeois taste and those who focus on abstract questions like the nature of objects and things.

I've listed four areas in which design students can differ from fine art students: the value accorded to making money, the kind of history that seems relevant, the kind of studio instruction that seems appropriate, and the kind of philosophy that best explains the practice. They all boil down to one central problem, which has been with us since the early Renaissance: the notion that the crafts are not as important as the arts. Other words can be used instead of "important," and the choice is crucial: in the Renaissance, the choice would have been "noble." Or one might say "interesting" instead, or "intellectual," or "versatile." Each word sounds a little wrong, and there is no satisfactory choice. Our indecision about crafts, decoration, and design suggests that it's a deep-seated inequality, built into Western culture: we just *feel* it is true that chairs have a different value from paintings.

Oddly enough, the differences between a chair and a painting can seem to vanish when it comes to studio instruction. Some artists, critics, and instructors assert that there is no real difference between art and design, or between fine art and decorative art. In large art schools students mix and match chairs and paintings (it was done, literally, by Robert Rauschenberg, Lucas Samaras, David Salle, and others from the 1960s onward). The mixtures are a heritage of pop art, but I do not think it is convincing to conclude that the difference between fine art and decoration has vanished. People who advocate that the difference has vanished tend to give one of two reasons.

First, they point to the influence of non-Western cultures that do not

distinguish between fine and applied art, or even between art and other made objects. They stress the popularity of non-Western objects in twentieth-century culture, the contemporary state of world art, the increasing importance of mass media, and the traditional dependence of modernism on non-Western art. All that is true: in the twentieth century, art and non-art, Western practices and non-Western practices, were blended as never before. But does that mean that the differences have been erased?

People who want to erase the difference between high art and decoration also say that since the advent of postmodern—say, in the mid-1960s—art and scholarship have been out to deny hierarchies of all sorts. In postmodernism (so it's said) there is no meaningful difference between high art and low art. Postmodern critics replace rigid hierarchies with lists, and central things with objects from the margins of culture, and pure things with hybrids.[41] It wouldn't be postmodern, so the critics imply, to go on insisting that decorative art is "lower" than "high" art.

Yet for all the seductiveness of the idea that high and low have merged, there is little evidence that artists have stopped caring about the avant-garde, or given up trying to avoid bourgeois taste. Modern and postmodern artists have traditionally *taken* from low art and put bourgeois objects to avant-garde use.[42] (Jeff Koons, for example, got some notoriety for recycling bourgeois porcelain figures as high art; in the same fashion Max Ernst had recycled popular magazine illustrations as high art collages.) But that's different from believing that decoration and fine art have the same value. There were moments in modernism when decoration was a positive value, connoting an honest attitude toward beauty. A decorative work was one that spoke openly about its meanings and the people who had made it. Unfortunately there were also moments in modernism when decoration was the worst thing that could happen to art: it was the end of art, its perdition, its descent into the abyss of vulgarity and bourgeois bad taste.[43]

I suspect the claim that high art has merged with low art is frequently a kind of wishful thinking: if only they *had* merged, we wouldn't need to keep worrying about history, about value, and about the challenge of trying to make truly powerful avant-garde art.

It is notoriously difficult to construct a theory of all artifacts that does justice to fine art and also to decoration and design. E. H. Gombrich tried to write a history of decoration under the title *The Sense of Order;* he produced a massive meditation on the psychological impulse to create design, which has the odd effect of making fine art look like the product

of some *other* deep instinct.[44] Another scholar divided all manmade things, which he called "material culture," into five groups:[45]

1. Art (paintings, drawings, prints, sculpture, photography)
2. Diversions (books, toys, games, meals, theatrical performances)
3. Adornment (jewelry, clothing, hairstyles, cosmetics, tattooing . . .)
4. Modifications of the landscape (architecture, town planning, agriculture, mining)
5. Applied arts (furniture, furnishings, receptacles)
6. Devices (machines, vehicles, scientific instruments, musical instruments, implements)

This is an ultimate generalization of the systems of the fine arts that I was considering earlier. This scholar's list is a little awkward, since it puts objects whose expressive power is irrelevant (such as mines) in with those whose expressive power is primary (such as gardens). Does it make sense to try to force all human artifacts into this kind of democracy? Are all artifacts created equal? Such attempts indicate the lengths to which one has to go to avoid privileging the fine arts over decorative arts. (I might add this list is not entirely successful: "Art" is still first.)

Other people have argued that design is apprehended "not with our minds" but "empathetically" or nonverbally, whereas fine art has nameable meanings.[46] Design and decoration would work in an "intuitive," "sensual," "uncognized" way: fine art means, decorative art emotes. But can that distinction be defended? Surely many things that seem "merely decorative" are symbolic, and—as Gombrich says—there is no firm "distinction between designs and signs."[47]

So far, no theories have managed to encompass decorative and fine-art objects under one rubric, in one classroom or one book of art history. One way to begin is to invest decorative art with as much verbal significance as possible—to talk as long as possible about the chair—and another way is to emphasize the nonverbal meaning of fine art—to bring out the subtle, emotive properties of the painting instead of its history and symbolism. And above all, it helps to remain aware of the problem, so the old differences don't creep in again where they aren't needed.

WHAT IS GOING ON WITH LIVE MODELS?

Here's a question: Which institutions involve people with clothes on, looking at naked people? I can only think of three: hospitals, the pornography industry, and art schools.

It is a simple, inescapable fact that looking at a live model is a charged

experience. No matter how used to it you get—and studio instructors can persuade themselves, over the course of years, that models really are nothing but interesting furniture—it still possesses sexual and social overtones. The model is "objectified," used as an example (as in medical school or hospital rounds—and we might also think of prisoner-of-war camps), and his or her personality is erased or drastically simplified (as in mass-media pornography). The condescension, emotional distancing, and "master-slave" relation are similar in all three institutions.[48]

Now I do not think it makes sense to avoid life classes; live models have been an integral part of art instruction since the fifteenth century. The problem is not the custom itself—surely people do many other things that are worse—but the fact is that teachers do not acknowledge the overtones. It has been said that the human figure should be drawn because it is the most perfect object, and if a Renaissance or Baroque student knew the body they could claim to know everything essential about visual art, from figure painting to the principles of industrial design.[49] Though people are no longer quite so dogmatic on the point, it is widely held that the human form is a privileged object, something fundamental for drawing in general.

Once I saw a life-drawing class in which a black man and a white woman were posed on a bed. Certainly there's nothing wrong with that, but the instructor was behaving as if it were a random configuration— as if he might just as well have put a pear next to an apple. No one mentioned the fact that this particular "configuration" was sexually and racially loaded. Instead the students were critiqued for their use of form and color. A Freudian might have something to say about that class. Yet it's generally true—art instructors treat models as if they were nothing more than objects that are difficult to draw. Surely, though, if the only point of such classes were to train students to draw difficult objects, life-drawing teachers would choose things like toasters or spoons instead— they're just as hard to draw.

Artists are interested in the body for many reasons. Paintings of the body are inevitably about love, sexuality, and relationships, and paintings taken from live models or from nude photographs are *inherently* voyeuristic and objectifying, no matter what genders are involved. These days, sexual and social issues are addressed only when the photographic source material is pornographic (a common enough occurrence in art schools), but they are present as well in ordinary life-drawing sessions even when they are not openly addressed. Sometimes models and students do become sexually aroused (if you're around life-drawing classes long

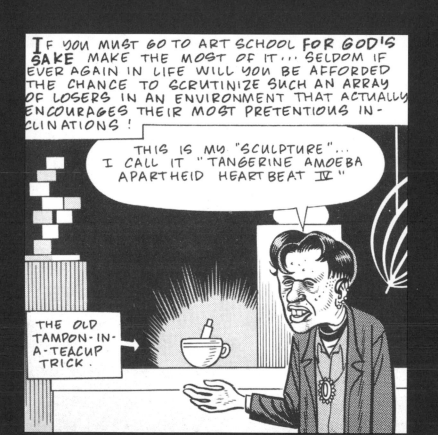

enough, you'll see this), and that possibility is only the most obvious sign of the unacknowledged sexual content in day-to-day life drawing.

The historical response to this issue has been to draw a distinction between the "naked," which is said to involve sexuality, and the "nude," which is said to pertain to the world of art.[50] But is there such a thing as a "nude" that does not involve sexual response? Even if you've never been aroused or even titillated by a life-drawing class, the emotions of the situation end up in the work. There is an elaborate process of *not seeing* the gender or the sexuality, of *not thinking* about the problems of objectification, voyeurism, pornography, academic art, the tradition of the sexless nude, and the social repression that's involved. When you're in a life-drawing class you are meant to avoid thinking about those problems and concentrate on "formal issues." But can you just turn off all those naturally human responses? I don't think so: inevitably, life-class drawings are infused with submerged feelings about sexuality, voyeurism, embarrassment, power relations, and so on.

My point here is that it is dishonest and a little silly to look at a naked person for three hours and talk only about lines and planes. If your drawings are interesting at all it's because you have controlled the sexual and political issues in a complicated but not entirely successful way. The emotions are in the pictures, and they should be critiqued. Here's an example of the kind of conversation that never takes place:

> — Hmm. That's a nice drawing. I see that you've given particular attention to the penis, but you haven't drawn in the eyes.
> — Well, he was looking at me a lot, and I don't like that. So I was trying to get the body right instead.
> — In the drawing, that makes it look like you were very interested in the model's sexuality. Your figure is a little depersonalized, he looks like a sex object.
> — Well, there was something about the pose—
> — The pose is kind of unlikely, like those Playgirl poses. Guys don't sit around naked with their legs spread apart.
> — So you think I should put in the eyes?
> — In a way, I guess I'd say the drawing looks like it's struggling with itself. One part of it says: This is a good drawing. Another part says: this is a sexual object, a fantasy.
> — Is that bad?
> — I just mean that it makes the drawing interesting. It could be that if you put in the eyes, or if you erased part of the penis, then your drawing could be less interesting. It would have less tension.

— Actually, the penis is kind of irrelevant, I mean I think I can draw it okay, it's not a problem.

— Yes, you have the light and shade ... but sometimes when you look at something very closely, it means that you're not looking at something else. And here, I think you are looking very intently at one thing, maybe in order to avoid looking at something else.

— His eyes.

— Yes, there he is, looking at us.

S o far, everything that I have said has to do with specific problems—with the history of art instruction and the issues students and teachers tend to discuss. I have tried to set out the different sides of each problem, even though my own position has usually been pessimistic or skeptical.

In the first chapter, I mentioned the intellectual isolation of medieval workshops, the artificial quantitative rigidity of Baroque academies, and the unreasoned way that the Bauhaus claimed to be giving more fundamental, universal instruction. The second chapter was pessimistic about many aspects of contemporary art schools: I suggested that academicism is still with us, that most art is mediocre and therefore not well served by the habit of teaching masters and masterpieces, and that our hope of expressing our society might be ill-founded. Rhetorically speaking, my strategy has been to set out issues as clearly as possible, and then see how well they stand up to criticism. In most cases I've been tending toward the conclusion that what we do does not make sense.

Theories - - - - - 3

So I think this may be a good place to address the central problem, the one around which these smaller problems circle: Is it irrational to say that art can be taught? And if we think so, how do we describe what we're doing? I'm going to argue two points. First, we do not know how we teach art, and so we cannot claim to teach it or to know what teaching it might be like. This may sound odd—I'll be defending and explaining it later in the chapter—but it's my experience that studio instruction teachers and students often accept some informal version of it. The teacher's lack of control becomes a cliché, and the idea that there is no method for teaching art becomes a truism. Instead studio departments advertise their ability to teach technical preparation, critical standards, models of knowledge offered by other disciplines, operative principles, irreducible elements of perception and visual experience, the ability to manipulate formal language, or the history of questions and responses developed in the medium over time. Art departments are said to offer a "supportive critical atmosphere," "dialogue," "access to large public collections" and to the art world, and the "commitment" and "passion" of their faculty.[1] (That's from an art department flier, addressed to prospective students.)

These are all sensible things, and many of them are possible. Later in this chapter I will try to divide the different claims into more clearly articulated categories, but for the moment I just want to list them to suggest how much art departments teach that is not directly art. The problem—and this will be my second claim—is that teachers continue to behave as if they were doing something more than providing "atmosphere," "dialogue," or "passion." Art schools would be very different places if teachers and students did not continue to hold onto the idea that there is such a thing as teaching art, even when they don't believe in it securely or analyze it directly. That puts art departments and art schools in a self-contradictory position. It may seem normal, but it is pervasive, and I think it has an inimical effect on the coherence of art instruction.

WHAT IS TEACHING?

Before I can ask whether art can be taught, I need a working definition of teaching. (I don't think we need an equivalent definition of art, since "art" is whatever we end up talking about in art school. Its definition is fluid, and it changes along with our interests.)[2] Though I think teaching can be many things, I also think there is an indispensable component to anything that could be called teaching, and that is intentionality. The teacher must *mean* to impart something at a certain moment, and must *intend* it for a certain audience. It doesn't matter whether the teacher is right or wrong, well informed or misguided about what she may intend: what matters is that she intends to teach and does not teach by mistake, or randomly.

An example of intentional teaching is when an instructor tells a student to look at a certain artist. "Your work is similar to Ryder's," the instructor might say, meaning the comment to apply to that student at that moment. It would not be teaching in this sense if the same instructor happened to mention Ryder in the course of a long conversation about other subjects. Even if the result was the same (say, the student went and looked up Ryder), in the first example the teacher meant the student to benefit and in the second the teacher would have been surprised that the student picked up on that one part of the conversation.

Why insist on the single criterion of intentionality when there is so much else to teaching? Because no matter what else teaching is, it is not a comprehensible activity unless the teacher sets out to teach. Any number of things can go wrong, and I think most of the time whatever the teacher thinks is a good idea probably isn't. A teacher's opinion might be entirely wrong, or irrelevant, or misguided, and as we will see, there is no easy

way to tell. There is also the problem of intentionality itself, because as psychoanalysis has taught us, the teacher who thinks she intends to mention Ryder because his works are dark and mysterious might really be mentioning him because he is associated with snakes, or storms, or Wagner, or with something that happened in the teacher's past. But all of that is permissible provided the teacher intends to teach. To put it more accurately, I might say that teaching requires the fiction of intentionality: the teacher has to work with the fiction that she knows what she intends, that she can say what she intends, and that she knows what she means by what she intends. Since Freud and Wittgenstein, those things aren't so simple—but the simpler way of putting it can stand for the deeper difficulties. Teaching isn't teaching unless the teacher *intends* to teach at any particular moment.

It may seem that this definition of teaching is too narrow, since it excludes a great deal of what happens in art schools and in teaching generally. Very often, for example, a successful teacher is one who has enthusiasm and inventiveness, no matter how much she claims to understand about what she is doing. Especially in the visual arts, it seems appropriate to teach without words. We sometimes say that art teaching is not amenable to rational analysis since it is fundamentally a matter of inspiration. Some teachers can produce astonishing, creative monologues, spiced with all kinds of odd insights, and students can pick and choose what they like as if they were looking through a treasure chest. But to see why I would not consider that to be teaching, imagine what would happen if a physics teacher were to do the same thing. Say, for example, that a university physics professor likes to give lectures by improvising a kind of stream-of-consciousness monologue, moving freely among loosely associated topics, mixing material from freshman and graduate-level courses, adding personal reminiscences, fables, mottoes, digressions, repetitions, and poetic appreciations. Then a first-year physics student would need to listen very carefully; she would understand a few equations, but some would be over her head, others would be irrelevant, and a few would be too simple. She would probably misinterpret some equations, thinking that she could understand them. The poems and fables would be hard to integrate with the stricter mathematics. Such a professor would take limited responsibility for trying to understand what the student might need. Instead she would simply be emptying the contents of her conscious mind, like pouring water out of a bucket.

I think that basic physics could not be learned that way, though it is possible that graduate- and professional-level instruction might benefit

from inspired monologues. There have been well-known lecturers in various fields who worked that way and managed to inspire generations of students. (In the humanities, the preeminent example is the psychoanalyst Jacques Lacan.) Enthusiasm, inspiration, and motivation are infectious, and it may also be true that they can only be taught by example: an enthusiastic teacher may be necessary to instill enthusiasm in a student. But subjects other than enthusiasm, inspiration, and motivation generally require focused accounts that are tailored to the audience. I don't think that the hypothetical physics student could learn physics from such a professor unless she already knew a great deal—in which case she would be more like a teacher than a student.

It follows that little teaching takes place in most large classrooms. Some large lectures can be excellent places to learn, because the majority of the audience is looking to learn the same material, and the teacher is tailoring the lectures to the class's common interest. But in art instruction it is not at all clear that any given roomful of people will need the same kind of information. In a large art lecture course, such as the standard freshman art history survey, the idea is sometimes to show the students as many images as possible in order to give them a general grounding and at least a passing familiarity with the range of societies that have made art. If an instructor shows ten thousand slides in the course of a year (which is not an impossible number), a given student might find five or ten of them to be of lasting interest. Of those, perhaps two will turn out to be central images for the student's work. Those numbers are generous on both ends: most teachers show more like six thousand slides in a yearlong survey, and most students I've talked to say that one or two slides proved to be of importance to their work. This is not a reason to cancel the standard survey (there are other problems with the survey that are not related to this), but it does mean that the survey is not taught, except in a very loose sense of "teaching."

There is also a broader reason why I concentrate on the rational side of things when so much else happens in teaching. Even aside from the question of the abstract nature of teaching, my analyses in this book are attempts to find the rational content of subjects that are not usually analyzed. At the beginning of the previous chapter, I noted that our sense of what we do as teachers or as students is dependent on not pushing rational analysis too far. (Our informal ways of talking, I wrote, are ways of *not* coming to terms with a number of fundamental difficulties.) When rational analysis is pressed too far the result can seem a little outlandish or misguided. The benefit of exaggerating the rational component in art

instruction is that it helps highlight the way we're used to talking by contrasting it with a more purely rational position. My insistence on the intentional quality of teaching is an example of that strategy: trying to understand what happens in studio art classes by focusing on the only part of it that can be analyzed. Enthusiasm, commitment, passion, dedication, responsiveness, and sympathy are also parts of teaching (when I am teaching I can feel my own enthusiasm at work, pushing my rationality to one side), and in my experience the best teachers have them— but I think it is essential to bear in mind that if we are going to make sense of what happens in the studio it is necessary to look hard at the few moments that are susceptible to analysis. No matter how small a role intentionality plays in teaching, it is the only part we can hope to understand. It is necessary to say that teaching is intentional: otherwise we relinquish any control or understanding over what we do.

This definition of teaching also applies to learning. From the student's point of view, learning can be as mysterious as teaching, and the moments when learning happens best are moments of high energy, unusual awareness, or good concentration, rather than some formula that can be repeated on demand. Learning can be like absorption or osmosis. Who knows what makes a student receptive? Some students (and this is something teachers know better than students) can be entirely unreceptive, blocked off so strongly from new ideas that they are not even aware that they are resisting. Unreceptive students are just as mysterious as receptive students. Again I would insist on the importance of intentionality. Unless a student believes that she can learn intentionally—that she can learn when she wants to—then it doesn't make sense to say that art can be learned. Intentionality is an essential part of teaching and of learning.

CAN ART BE TAUGHT?

There have long been doubts about whether art can be taught. They go back at least to Plato's concept of inspiration, *mania*, and Aristotle's concepts of genius and poetic rapture (the *ecstaticos*).[3] If art is made with the help of *mania*, then certainly ordinary teaching can have little effect— and if it is inspired teaching, then it isn't teaching in the sense I mean it here, but something more like infection. I may give someone the flu, but I am hardly ever sure when or how I did it. Teaching *mania* by being ecstatic and inspirational is like being infected and spreading disease: you can't really control it. Plato and Aristotle are everyone's historical heritage, to the extent that virtually all art instruction in the world today is influenced by Western norms, and I think most people would be happy

to say that art depends somehow on *mania* and therefore can't be taught. Yet historically, the voices of doubt have been overwhelmed by the institutions that claim to teach art.

After Plato and Aristotle, there have been two main times and places where people claimed inspiration is central and so art cannot be taught. The first was the Romantic art schools, and the second the Bauhaus. (I mentioned both in chapter I.) The Romantics thought that each artist is an individual, so no kind of group instruction could ever succeed in teaching art. The Bauhaus was founded on the idea that craft is fundamental, and that art instruction should be consecrated to teaching whatever is susceptible to basic rules and procedures. As the historian Carl Goldstein says, "proclamations regularly issued from the Bauhaus to the effect that art cannot be taught."[4] Neither the Bauhaus nor the Romantic reason for saying art cannot be taught is quite the reason I am claiming it here, but all such claims, including mine, descend ultimately from Plato's and Aristotle's notions of artistic inspiration.

Some contemporary art instructors freely admit that art cannot be taught, and admitting it put them in a fundamental logical bind: they say art cannot be taught, and yet they go on teaching students who believe they are learning art. I think most teachers would say that they don't claim to teach art directly; but on an institutional level, the schools and departments where they work continue to act as if art teaching might be taking place. The two positions—for and against the possibility of teaching art—are incompatible. Studio classes could be advertised as places where students learn techniques, or the vagaries of the art world, and that would be consistent with the ordinary teacher's claim not to know how to teach art directly. Somewhere along the chain of command and publicity, from the ordinary studio art instructor up to the chairman, the dean, the public-relations department, and the trustees, the day-to-day skepticism about teaching art gets lost, and institutions typically end up making claims that their instructors really do teach art.

It seems to me that this indecision or unclarity or disinterest in exactly what we do is not at all a bad position to be in. There is no need to teach without self-contradiction, or without letting students in on our indecision or incoherence. The fact that it is so hard to know what it might mean to teach art tends to keep teachers going: it spurs them to teach in many different ways. In that sense, teaching physics or television repair is much less engrossing, because there is no need to continually question the enterprise itself. So in that sense there is nothing wrong with our inability to say exactly what we're doing. But it is also important not to

forget that it *is*, after all, a logical contradiction, and that art instructors work right at the center of the contradiction.

The contradiction is complicated, but I would like to tease it apart a little by sketching some specific answers to the question of whether or not art can be taught. As in chapter 2, the purpose is to illuminate the kinds of contradictions that students and teachers tolerate—or that they need—in order to go on doing what they do. Perhaps you can find your own position somewhere in this list.

1. **Art can be taught, but nobody knows quite how.** A typical piece of evidence here is the track record of art schools—the fact that famous artists have graduated from them. School catalogs typically list their graduates who went on to become famous. Instructors praise the work of famous students as if they helped guide them to their success. Still, there is very little evidence that art schools have control over the production of really interesting art. It may be nothing more than chance. If an art school is around long enough, there are likely to be famous people who studied there. Sooner or later, a student will find an instructor, or a curriculum, or an environment that is just right, and that might then propel them to do work many people find interesting. But do teachers have the slightest control over this interaction, or the vaguest idea of how it works? How do we know that the art school was anything more than a neutral backdrop, a place that didn't *stop* the artist from developing? How do we know that another environment—say, a steel factory—might not have been better? The problem with this first theory is that it isn't a theory. It proposes a correlation without proving a cause-and-effect relation. In that respect, it is like the many studies linking cancer to various foods: there might be a correlation between drinking coffee and getting cancer, but that does not prove there is a causal link.

2. **Art can be taught, but it seems as if it can't be since so few students become outstanding artists.** I haven't encountered this view very often, and I think it might be an older view. It is consonant with what the Bauhaus claimed—that real art is rare, even though it can happen in a school environment. The difficulty with this view is that those few "outstanding" artists could well have been "outstanding" before they got to school, so the art instructors did not make them that way. If teachers could create artists, then they would, and it would not be so rare to witness art being taught. This view is close to another view that is much more common:

3. **Art cannot be taught, but it can be fostered or helped along.**
In this way of looking at things, art teachers do not teach art directly, but they nourish it and provoke it. In my experience most people hold some version of this theory. There are various ways of putting it. Perhaps teaching is like dreaming, where you don't really know what you're doing, or perhaps teaching is like gestation.[5] The school nourishes the student and helps her grow, sheltering her from the outside world like a fetus in the womb. Few people would argue that students need a special atmosphere in which to grow, and the womb is the most special of all protected places. I think this is perfectly reasonable, and it applies to many other disciplines beside art. But it is not teaching in any comprehensible sense. A pregnant woman has very little control over the health or looks of her child. She can stop smoking and eat well, but that just ups the chances of a healthy baby, it doesn't control the outcome. The art teacher cares about the idea of nurturing, but she can't make a baby (that is, an artist) by thinking about it—indeed, thinking doesn't help. A real mother has no theories about how to form her baby's hands or head, and without the help of a doctor, she has no idea if the head is even being formed correctly. In similar fashion an art teacher can hope that she is providing the right atmosphere, but she can't control what happens in the atmosphere she's created.

I don't want to call this the "pregnancy theory" of art instruction, because the student is neither entirely passive nor entirely unaware of the outside world. A better name might be the "catalyst theory" of art instruction, since it is also said that teachers can speed up the natural course of a student's development. The art classroom is a nurturing environment, a place where all kinds of friendships and opportunities exist that might never develop in the outside world. My favorite simile is that the art school is like agar-agar, and the students are like bacteria or fungi. They grow better on the controlled medium than they would in the real world. They are healthier, less at risk from disease, and they grow faster than they would with a less nutritious substrate. Artists' "colonies" (like bacteria "colonies") can spring up rapidly, and the "culture" of the art world can be fairly dense. Like the pregnancy image, this has a great deal of truth and good sense to it, but it is open to the same kind of objection that the teacher doesn't control the growth itself.

If teachers and the studio department in general are like agar-agar, then there is no teaching in the sense that I have proposed. The agar-agar does not know that it is nurturing the bacteria: it simply exists, and the bacteria feed off it without its doing anything. If we want to say that art

instruction works that way, then we have to say not only that art isn't being taught, but that when teachers help students along—or nourish them, or catalyze their work—they do not know what they are doing or how they are doing it.

Ultimately, the best image for this theory is infection, since it stems from Plato's original definition of *mania*. Inspiration is infectious. If you are around someone who is enthusiastic, you are at high risk: you may catch the passions that animate that person, even if they may not be good for you. Teachers who have infectious enthusiasm are also teachers who are not in control of *when* they are teaching. They know *what* they are saying, but they don't know *when* it will connect, or whether it will do any good for the student. To some people, this is not a bad way to work, given that art is such a personal and intuitive thing. But it still means that art is not taught—teachers nourish their students like embryos, or feed them like bacteria, or infect them like Typhoid Mary. Sometimes the students turn out well: they are "born" into the world, or form "colonies," or—in the infection metaphor—develop resistance to dangers, or go on to infect other people. But it is essential to bear in mind that in order *not* to see this as a problem, teachers and students have to be content to teach and learn without knowing what is happening to them.

4. **Art cannot be taught or even nourished, but it is possible to teach right up to the beginnings of art, so that students are ready to make art the moment they graduate.** Howard Conant, an educator who wrote widely about art education, says flatly: "Art cannot, of course, be 'taught,' nor can artists be 'educated.'"[6] Conant does not account for what happens in art schools—he does not have a theory of the exact content of studio instruction—but he says good teachers can bring students to the "threshold" from which they can "leap" or "journey" into art itself. Conant's position is a common one, and it has been put in many ways. It is also said that art itself is ineffable, and people teach "around" it or "up to" it. Oscar Wilde says the same thing, a bit less ponderously: "Education is an admirable thing, but it is well to remember from time to time that nothing that is worth knowing can be taught."[7] The difficulty with this theory is knowing what it is that *does* get taught, if it is everything right up to art. Before I try to answer that, I want to round out the list of theories by adding two more that beg the same question.

5. **Great art cannot be taught, but more run-of-the-mill art can be.** This theory divides art into two classes: something "great" that's

worth buying and selling and studying, and something not-so-great that is only worth paying tuition for. If you look at the statistics and compare the number of art students to the number of "great artists" who came out of academies and art schools, it is clear that most art instruction does not produce "great art," not to mention interesting or successful art. In this theory, art classes produce a special kind of low-grade art. It seems reasonable and sober minded to say as much: as I argued in chapter 2, most art students are necessarily mediocre. But then it is not clear why students enroll in art classes: what is this run-of-the-mill art that is still worth the price of tuition? Can it be transformed into "great art," or is it a different species, more primitive and less interesting?

6. **Art cannot be taught, but neither can anything else.** Conant also says this: "Like art, literature cannot be 'taught,' nor can history, philosophy, or science."[8] (I wonder about Conant's quotation marks. Without them his sentence would be harsher, but perhaps more honest.) According to this theory, teaching is impossible, and art is basically not different from science or any other subject. Luckily the claim is easy to argue against: if art is not different from science, it would be hard to explain why four-year undergraduate curricula in physics do not have group critiques instead of standard exams. Why do physicists measure accomplishment by giving tests? Certainly scientists work on an individual level in laboratories, and doing science is more complicated than simply applying information. But if there is no important difference between an art degree and a science degree, why don't science teachers abandon tests (which are such a bother to write and grade) and settle for critiques? And why aren't art instructors content to stop staging critiques, and just give their students multiple-choice tests?

I think that people who espouse this sixth theory do not usually mean that science is the same as art, or that *all* teaching is impossible, but that what is important or essential about any subject cannot be taught. You can learn the fundamentals of your discipline from many people, but no one can show you how to become first rate at anything. There is a strong and a weak way of looking at this. In the weak view, the only reason the highest accomplishments can't be taught is that there is no one higher to teach them. People who have high IQ's are tested for admission to various societies, and the people who make the tests have to be at least as smart as those they mean to judge. Mensa is the largest high-IQ society. Above Mensa is Intertel, and above that Triple Nine, and then Prometheus, and then Mega, and at the top is Savant, named after the one person who has

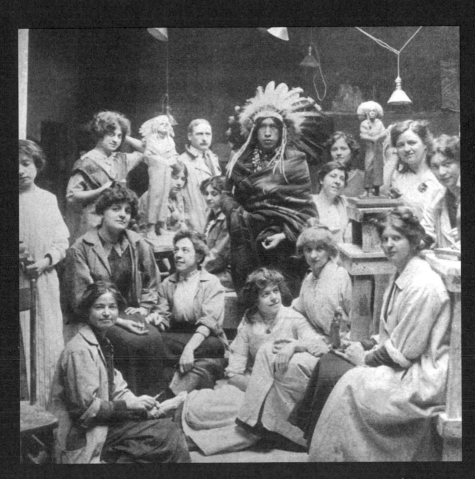

Women's sculpture class. 1918. Chicago, School of the Art Institute. Photo: author.

Art classes aren't particularly good places to learn about race, ethnicity, and gender. The practice of posing models in ethnic costumes probably became common in the mid-nineteenth century when academic painters were drawn to exotic and oriental subjects. In many parts of the world, where old-fashioned academy instruction is still in force, life classes continue to make use of colorful "ethnic" models. In China in 1998, I visited a painting class not unlike this sculpture class—except the model was dressed as a Chinese "ethnic" from Tibet. After the 1960s in the United States, the kind of instruction shown in this photo became more problematic, but now the pendulum has swung the other way: art schools pose all kinds of people as if they were all indistinguishable. It still isn't possible to learn about race, ethnicity, or gender. (Notice the very white male instructor, staring severely at the Indian chief.)

qualified. With some overlaps, each society prepares tests for those below it. By the same analogy, people at the top of their professions tend to lack constructive criticism, and the fact that they can no longer be taught may be simply a matter of the absence of people to teach them. This is the weak view of the claim that no teaching can impart anything but rudimentary or lower-level information. In the strong view, nothing important can be taught, regardless of who is doing the teaching. Both the strong and the weak view may be involved when someone claims that "ultimately," no subject can be taught. My own stance is that there is a great deal of truth to the weak view, and that education sometimes stops too soon, and sets people free to meditate on their own when they would still benefit from straightforward instruction. This is certainly true in academia, and I assume it is in public life as well. It may be connected to the same Romantic idea of the importance of the individual that influenced the history of art schools. But that is not my subject here: instead I am interested in the strong view (that nothing important can ever be taught), because it is typical of what people mean when they are talking about art instruction.

IF ART CANNOT BE TAUGHT, WHAT CAN BE TAUGHT?

In relation to the last three proposals—numbers 4, 5, and 6—the question still remains: what things *can* be taught? Since many people believe in some version of these last three theories, it becomes particularly important to say what it is that we actually hope to teach, or learn, in studio classes. In a rough count there are at least these four things that people claim to know how to teach, even though they may not claim to be teaching art itself:

1. Perhaps studio instructors teach knowledge of contemporary criticism and art theory. Students who intend to be a part of the art world need to understand theoretical writing, and often they want to make full use of the ideas of postmodernism, postcolonial theory, and related cultural critiques. According to this view, students would go to studio classes in part to learn critical terms (the gaze, the simulacrum, the native informant, the *objet petit a*, the rhizome, the punctum, *différance*, and so on ad infinitum), together with relevant philosophies of art and vision, and theories such as psychoanalysis, multicultural theory, and gender critiques.

2. It is also said that studio teachers show students how to get along in the contemporary art world: how to talk like critics, how to successfully enter a juried competition, and how to present their works to galleries. In

the words I quoted at the beginning of the chapter, this would involve "dialogue" about the art scene and "access to large public collections." There is a crass side to this, and some art departments try to keep away from giving too much commercial advice. The majority of art departments I have visited take a moderate view, giving students the opportunity to make connections with gallery owners and critics, and introducing them to their local art community so they can work within it to get where they want to be.

3. Perhaps what is taught is visual acuity, as in the Bauhaus. In the beginning of the chapter, when I was listing things art departments advertise, I also mentioned "operative principles," "irreducible elements of perception and visual experience," and the "ability to manipulate formal language." Those are Bauhaus concerns. Art students sometimes speak of learning how to see, and I would describe part of my M.F.A. experience that way. I became more sensitive, more alert to visual cues and subtle phenomena.

4. But certainly the most widely voiced answer to the question, What can be taught? is that studio classes teach technique. Here again I agree: the majority of art classes I have experienced teach techniques alongside theory, commerce, and visual acuity.

Each of these four answers to the question of what art classes teach is partly right, but none is a good definition of what happens in college-level art instruction. Teachers don't usually sit down and tell students about art criticism or theory (there are often specialized courses for those subjects), and most of teachers would not be happy to be told that the central function of an art department is to teach students how to become commercial successes. The problem with saying that art classes instill visual acuity or technique is that teachers and students do not behave as if those were their principal goals. If someone took a survey of a typical upper-level or graduate art class, it would show that technique is hardly a central concern, and visual acuity is virtually unmentioned. Teaching at the graduate level is directed toward complicated questions of expression, control, self-knowledge, and meaning—subjects that have little to do with technique or sensitivity or even visual theory, and everything to do with the reasons we value art.

I am not denying that art classes can teach these four things, nor am I saying that they aren't reasonable goals. But their marginal positions reveal how deeply we must believe that we are doing *something else*, whether or not we can say what it is. That other goal is nebulous, and it has to

remain that way: otherwise teachers and students would be impelled to think about the contradiction between their claim that we can't teach art, and the reality that we behave as if we might be trying to do just that.

The art department flier I quoted at the beginning of the chapter also mentions a few things that are not among the four subjects I have just surveyed: it also promises the "support," "commitment" and "passion" of the faculty. These are things that every faculty would like to provide, regardless of what they teach, so they are not specific to the question of teaching art. But it matters that they're vague, because it is a sign that the *real* interest of the department—teaching actual fine art—cannot be mentioned.

As the historian Paul Kristeller said, art teachers are "involved in the curious endeavor to teach the unteachable."[9] Art department fliers like the one I quoted also usually list the famous artists who studied in their department or school. (Where I teach, we list Georgia O'Keeffe, Thomas Hart Benton, Claes Oldenburg, Richard Estes, and Joan Mitchell, though most of them dropped out.) It might be more honest and thought-provoking to go ahead and list famous graduates in the college brochure, but to preface the list with a disclaimer—something like this:

> Although these artists did study at our school, we deny any responsibility for their success. We have no idea what they learned while they were here, what they thought was important and what wasn't, or whether they would have been better off in jail. We consider it luck that these artists were at our school.
>
> In general we disclaim the ability to teach art at this level. We offer knowledge of the art community, the facilities to teach a variety of techniques, and faculty who can teach many ways of talking about art. But any relation between what we teach and truly interesting art is purely coincidental.

And such a flier might add, in the interests of full disclosure:

> We will not discuss this disclaimer on school time, because our courses are set up on the assumption that it is false.

AN EXCURSUS ON FINE ART AND MERE TECHNIQUE

Art teachers and students are in a bind. They do not teach or learn art, but they also cannot talk too much about the fact that they do not teach or learn art. The conundrum comes in large measure from the historical

development of the modern concept of art. In Greek philosophy there was a distinction between subjects that could be taught and subjects that could not. Whatever could be taught had a theory, or a body of information, a set of methods, or something that could be written down and handed on to students. Such subjects were called *techne*, and for the Greeks they included arts, crafts, and sciences. Other subjects could not be taught. Instead they had to be absorbed, or learned by example. Aristotle called them *empeiria*.[10]

What we think of as art is more like *empeiria:* it does not depend on rules so much as on nonverbal learning, things that can't be put into words. To Aristotle art was *techne*, essentially a matter of rules.[11] Since the Renaissance the concept of *techne* has shrunk so that it means basically "technique," and we have demoted "technique" to a level below fine art. One way to address the problem of teaching art, therefore, is to rethink the role of *techne*, technique, in studio art.

When people say that technique can be taught, but art cannot, they are assuming that technique is separate from art. This is one of those wonderful ideas that is so simple it almost seems transparent—as if we could change what we assume just by thinking about it. But the fact is that modernism—really, art since the Renaissance—is predicated on the idea that technique is ultimately separate from art. Contemporary initiatives that privilege design or multimedia are steps in the other direction—they imply that technique is woven into artmaking, and that there is no distinction between *techne* and *empeiria*—but so far those are just experiments. Verbal instruction still seems menial, and nonverbal instruction both valuable and impossible.

ANOTHER EXCURSUS, ON ART EDUCATION

I want to pause over another related issue: teaching people to appreciate art, as opposed to teaching people to make art. Technically, this is "aesthetic education."[12] Art appreciation sounds elementary, and it tends to be thought of as an introductory or remedial subject—but it is universal in liberal arts colleges and research universities, and it suffuses even the most advanced teaching and criticism. Not many art schools or large university art departments offer the kind of art appreciation courses that are common in small liberal arts colleges, but they do carry on aesthetic education in other ways. Whenever a studio instructor gives advice, whenever an art historian shows a slide, they are trying to get students to appreciate something they think is worthwhile. The simple act of showing a slide is riddled with problems. How does the teacher recognize good art?

How does she know it's good for the students she is addressing? How does she know it's better for them than, say, playing chess (as Duchamp did)? One aesthetician who has wondered about these ideas asks why there is driver education but no driver appreciation. (He thinks there is a parallel to policemen waiting in speed traps, "appreciating" drivers. Perhaps art appreciation has something in common with surveillance.)[13] Art appreciation is a problem that belongs in this book, because teaching people how to make art inevitably involves teaching them to appreciate art.

There is a surprising amount of literature on the subject of teaching art appreciation. Most of it is put out by educational theorists under the auspices of large corporations and trusts, and it is virtually unread outside the circles of professional educators. The Getty Foundation's program called Discipline-Based Arts Education (DBAE) emphasizes four disciplines that are thought to be elemental: art production, art history, art criticism, and aesthetics.[14] Much of the literature is encumbered by theories of learning that do not correspond to the disciplines that they borrow from; a typical DBAE account of art criticism has little to do with the way actual writing is done.[15] This observation is not an a priori objection to the conceptual schemata of art education: but it points to a serious difficulty that needs to be considered in any larger account of the ways that institutionally supported theories like the Getty's interact with practice. The DBAE is a philosophy of art education with its own history that runs parallel to the history of art academies I explored in the opening chapter.[16] It can be applied to college-level courses, though most research has been on elementary and high school education.[17]

Aesthetic education has always had its albatrosses. Its history is connected with dubious social and political values, including Germanic notions of *Kultur* and *Bildung* (formative education, enculturation), so it is not certain whether the systematic inculcation of art is desirable at all. Do you really want your children (or your students) to appreciate the same people you appreciate?[18] Is there really a connection between mastering a certain knowledge of fine art and being a good citizen or a good person? And which art is to be appreciated? How is an art-education specialist guided when she chooses pieces of aesthetics, art history, art practice, and art criticism?[19]

From my point of view aesthetic education is no more or less problematic than the other questions I have been considering. Studio art teachers routinely send their students to look at various artworks. There is no essential difference between that and art educators telling high school students what is so wonderful about Monet, or parents buying their chil-

dren books like H. W. Janson's *History of Art for Young People.* In both cases the teachers are trying to instill a sense of value and to promote the artists they find most important. Even at the highest levels, studio art instruction *is* art education. Studio instructors want to help their students make art, and high school teachers (or parents) only want to help their students (or children) to appreciate the same kinds of art they appreciate. But there is only a fine line between them. Maybe the most responsible studio art teacher will mention only artists she *dislikes,* in order to avoid making art a matter of aesthetic education.

BACK TO THE SUBJECT: THIS BOOK'S FIRST THREE CLAIMS

In books of analytic philosophy, individual claims are sometimes numbered and set apart from the text like mathematical formulas, so the reader can refer to them more easily as the argument proceeds. I am going to follow that tradition here, in order to make it clear where I stand on the question of teaching art. The first claim I made in this chapter could be put this way:

1. The idea of teaching art is irreparably irrational. We do not teach because we do not know when or how we teach.

Even if teaching art is an incoherent enterprise, the *idea* of teaching art remains vitally important to the existence of art classes. At the same time that instructors teach technique, critical thinking, the values of the art world, and other subjects, they continue to think of our activity as something that is greater than the sum of those parts. A second claim follows from this:

2. The project of teaching art is confused because we behave as if we were doing something more than teaching technique.

This is using the word "technique" to encompass all the things that art schools impart aside from the possibility that they may also teach art itself. It would be more honest to give art schools names like the Technical Art Institute, the Department of Supportive Critical Atmosphere, or The Center for Artworld Networking, but to do so would be to change art instruction at the deepest level. Teachers and students need to sense the presence of art, even if few people would be so brash as to claim that they actually understand or teach art itself. Without the sense that art is hovering somewhere around the classroom, I think everything that hap-

pens in art teaching, even the driest technical workshops, would look entirely different.

These two claims, together with the doubts and reservations I have had about other subjects, might imply that I intend to propose some new configuration for teaching art. I have made a few suggestions already—I think it might be interesting to address mediocre art directly, to talk about the sexual meaning of live models, or to experiment in historical ways of teaching art. There are more proposals in the second half of this book. But in a wider sense, I am not advocating any changes in the ways art is taught. Because I teach in an art school, I am constantly involved in discussions about how to change the curriculum. But in the end I am not really interested in tinkering with classes and departments. What art schools and art departments really need, I think, is to understand what they are already doing. There are several reasons why I am skeptical of trying to change the *way* art is taught.

First, we know very little about what we do. Most of what happens in the studio is entirely unknown to us: it is uncognized, unanalyzed, unthought. Mediocre art is a typical example: even though I can raise it as a subject of discussion, it remains almost entirely beyond our understanding. What is the psychology of timidity? What artistic choices are related to timidity? How do people respond to artworks that are not engrossing? How does a teacher know when to encourage a mediocre student to follow great models? There are so many questions that I would say the topic is still barely visible, like the proverbial iceberg that is nine-tenths submerged. And if teaching art is something we know virtually nothing about, then it does not make sense to jump in and change it.

There is another reason why I will not be advocating any new program in this book, and that is that any fundamental change in teaching habits will also change our concept of art. Teaching, learning, and making are indissoluble. An easy way to see this is to imagine an extreme case, in which art critiques are replaced by rational analyses, in the manner of French Baroque practice. Instead of getting together and talking about a student's work, say the instructors were to grade the work according to *préceptes positifs*, the way Roger de Piles did (see chapter 1). A sculpture would get 10 points for invention, 8 for form, 2 for political value, and so forth. That kind of teaching would eventually produce an entirely different kind of art. The altered teaching would produce altered goals and ideals, a new critical language, and a different mind-set. In many less obvious ways, changes in teaching involve changes in the concept of art.

Sometimes it is important to try to change the idea of art, and major

curricular changes, from the Renaissance academies through the Bauhaus, incited and reflected changes in art. But that goal would not make sense for a book like this one. I have no way to connect the concerns I have about some contemporary art with the problems I see in the ways art is taught. Say, for example, I were a conservative Republican, lamenting the absence of truly moral art. I still could not say that ethical instruction in the studio would promote ethical works. It might do the opposite—it might provoke immoral art—or it might have some other, unpredictable effect.

These considerations prompt my third claim:

3. It does not make sense to propose fundamental curricular changes in the ways art is taught.

I say "fundamental curricular changes" to distinguish them from the kinds of experiments that I have in mind in this text. My suggestions— about mediocre art and so forth—are designed to describe what we are already doing. Fundamental curricular changes are designed to *replace* current practices. Art teaching is irrational, and attempts to reform it are therefore also attempts to stop teaching art as it is currently understood and begin doing something else. To hope for an improved kind of art teaching is also to hope for an impoverished art, one that depends more on rational, speculative, and philosophic discourse and less on imagination, intuition, and all manner of uncognized and inadvertent discoveries. It is always possible that fundamental changes in art teaching might produce a more interesting (and equally irrational) art practice: but curricular decisions are always made on rational bases, and our ideas about art aren't rational. It's the certainty of the value of rational criticism that I doubt. You can't fix something irrational by trying to rationalize it.

SKEPTICISM AND PESSIMISM

My position here is close to the classical kind of skepticism known as Pyrrhonism.[20] Greek skeptics believed that we can know very little about the world, and that we should therefore make no judgments on one side or the other of any issue. They had various catch phrases for that idea: *isostheneia* is the balance of arguments on both sides of an issue, and *aphasia* is the refusal to make judgments.[21] Both of these ideas are at work in this book. *Isostheneia* and *aphasia* lead to a state of inaction: they make the skeptic unable to prescribe any course of action, because any act is the result of a decision, and any decision is the result of a judgment on

one side or the other of an issue. Hence when I say that art teaching is irrational and largely unknown, and I conclude that there is no clear course of action, I am exemplifying the Pyrrhonist *aphasia.*

I mention Pyrrhonism because the Greeks also knew how to argue against it. In this case the argument would have gone something like this: everyone makes uninformed judgments, and in many spheres of human activity the only kind of judgments are uninformed, and the only available kinds of actions are ill-based. The natural human way of getting along in the world is to act on things according to the way you happen to understand them at the moment.[22] By that argument, what I should be doing is prescribing new ways to teach art based on whatever I can find out about what we already do. Even though we don't understand art teaching, we know what it *seems* to be, and we can adjust our practice based on that. My answer to that, and my defense of Pyrrhonist inaction, is that we should not have confidence even in the little we know about art teaching. What we can discern about the way art is taught is unpersuasive, self-contradictory, and limited, and therefore not a good basis for action of any sort, even the conventional, ill-informed kind.[23]

At the risk of making this too academic, I would add that I'm also pessimistic about the outcome of any "fundamental curricular change." Pessimism, unlike skepticism, is a modern doctrine, and it essentially has two meanings: in everyday use, it denotes a belief that most things will come out badly, and in philosophy, it signifies the conviction that the world is essentially evil.[24] As I see it, art teaching is already a mess, and any attempt to change it is very likely to change it for the worse. I'm fond of pessimism, but there are also some grounds for optimism here because there is always the challenge of finding out more, and the possibility that the parts of art teaching that *can* be understood will be of some use. But that's not much in the way of optimism, and in the final chapter I will have an even more pessimistic answer to those few optimistic ideas.

I turn next to the central theme of this book, art critiques. I have given them a separate chapter since they are the most complicated aspect of art instruction. Critiques epitomize the problems of teaching art, and they condense the issues I have been exploring into an agglomeration of nearly intractable difficulty.

I n some early Renaissance architectural competitions the models were shown to the public, and there is evidence that the public became involved in discussing who should win. The inception of art criticism was an indispensable component of the rise of the Renaissance, because it encouraged people to find words to describe and judge what they were seeing.[1] Today some publicly funded architectural competitions are still done this way, and in some cases the rejected designs are kept for future generations to see.[2] For the most part, however, art is judged in private by people who have themselves learned to judge it by being trained in art classes.

Competitions in the Carracci Academy were judged in private, and the works were inscribed "1º," "2º," and so forth. They were then passed out to the students without comment. The object, according to Ludovico Carracci, was in part to soften "the bitterness of being criticized."[3] Some Renaissance drawings survive with these markings, and it was probably a common practice. As late as the early twentieth century, art students'

Critiques ----- 4

works were ranked in numerical order and put up on the studio walls. Winners, according to the French custom, were allowed to place their easels in the best spots for the next month's drawing sessions.

The apparent unfairness of this process, in which decisions are handed down without explanation or hope of appeal, was instrumental in provoking the modern system of critiques. Art critiques are descended from the Romantic master classes I mentioned in the first chapter, whose purpose was to avoid the unexplained rankings that were the norm throughout the Baroque. To Romantics and post-Romantics, mute rankings and anonymous boards of judges seemed authoritarian. It also did not seem right, from a Romantic point of view, that individual students should be compared with one another and ranked as if they were all trying to do exactly the same thing. That would make art school critiques too much like technical-school exams.

Today the Romantic revolution is still in force, and critiques take the place of final exams in art classes. Although there have been some attempts to test artists the same way other disciplines are tested, they usually do not work. There is a High School Advanced Placement Exami-

nation in studio art, just as there is for physics, American history, mathematics, foreign languages, and art history. The art history test is very much like the other Advanced Placement examinations.[4] But the art test is different. Students spend a year putting together a portfolio, which is judged over a six-day period according to criteria of "overall quality," "breadth," and "the student's thematic area of concentration."[5] Clearly, studio arts cannot be judged in quite the same way as other disciplines.

Like tests, critiques can be less than fun for both students and teachers. But if you get something wrong on a test, you can find out what you did—that is, it is always possible to learn from your mistakes. Critiques are not like that, and when something goes wrong it is not always easy to know what it is. The same can be said for successful critiques: when everything goes well, it is sometimes hard to tell why.

Critiques are different enough from one another so that it is not possible to sort out all the things that can happen.[6] I've arranged the chapter as a list of eleven reasons why critiques are hard to understand. I want to help make as much sense of critiques as I can, but I am also interested in demonstrating that critiques really can never make sense. (All eleven suggestions fail in the end.) To me the irrationality of critiques epitomizes the irrationality of art teaching. In effect, they are simply too complicated to understand. Unlike tests, critiques leave no written records to guide the next generation of teachers; partly as a result of that, there is no good way to judge when a critique is a success. All that supports my pessimism, which I take up again in the final chapter.

1. NO ONE KNOWS WHAT AN ART CRITIQUE IS

First it's important to acknowledge that there is no good definition of "art critique"—no model, no history, no guide. An art critique is very different from a philosophic critique, which is—put succinctly—an analytic inquiry that attempts to find the rational conditions under which something might be known. Kant's critiques were meant to discover the "categories of thought," the ways that we can perceive the world.[7] Certainly art teachers don't mean anything that specific or philosophical when they use the word "critique." What they mean is something more like *criticism*—a general activity that embraces analyzing, inquiring, debating, finding fault, and giving praise.

If art critiques are really just criticism, it is natural to wonder if they have an overarching purpose, a goal or a tendency to which they all incline. A comparison with criticism in other fields seems to suggest that we might have such a goal in mind. It is possible to think of critiques

Are critiques irrational?

according to their ultimate principles—what one author calls their "meta-normative" goals.[8] In that way of looking at things, some critiques are ethical, theological, and metaphysical, and others are scientific or teleological.

Teachers in the military, law, and political science sometimes organize their material along ethical lines. Their purpose is to teach responsible social action, and when they critique someone's performance, they are thinking of that individual in relation to their squadron, their unit, their social stratum, or their society as a whole. Teachers in divinity schools teach with a theological purpose in mind. Ideas are judged according to their relation to the possibilities of pastoral care or personal belief, rather than simply their logical sturdiness or their historical origins. Overtly metaphysical principles guide some philosophic and literary-critical studies. A philosophic critique, like Kant's, may present itself as something led by "the laws of reason," or the modes of being—that is, metaphysical criteria. By "scientific criteria" I mean experiment, hypothesis, and falsification. When teachers develop courses aimed at imparting experience, skills, or information, they are thinking first and foremost of teleological criteria: that is, they are asking how to put the material to use, whether it is important that it be useful.[9] So there are at least these six fundamental principles for arranging course material: professional, ethical, theological, metaphysical, scientific, and teleological. They aren't entirely separate, and there might be many more.

Where do art critiques fit in? Teaching principles are especially heterogeneous when it comes to art. Some instructors think primarily of their students' professional goals, and others concentrate on technique. Ethical criteria surface occasionally, when curricula are set up in order to demonstrate the postmodern idea that the history of art is discontinuous, or subject to "an on-going process of reinterpretation."[10] Some educators argue that teachers are "ethically and morally obliged" to give students an "adequate general education."[11] But by and large, if they were asked to name the underlying principles of their instruction—what they aim at when they teach—most art teachers would cite concepts like interest, power, or strength. Words like those are the *ultimate terms* of art critiques: they are the final goals, the ideals, the ultimate terms of praise.

See next p.

There are a number of such words:

Interesting	Powerful	Strong
Moving	Authentic	Original
Inventive	Compelling	Difficult

Gorgeous Stimulating Beautiful

Innovative Wonderful Excellent

ULTIMATE TERMS IN ART CRITICISM

I will have another look at these words in the final chapter. Note that they are neither professional, ethical, theological, metaphysical, scientific, nor teleological: they do not fit any of the kinds of critiques I have just named. They are *rhetorical* criteria, strategies to help students get noticed. A student whose work has some of these criteria is likely to get a show, or get a good review, or sell her work. Rhetorical criteria do not say anything about what the work looks like, or how true it is. They are practical ideas, and they may crop up in professional, ethical, theological, metaphysical, scientific, or teleological critiques.

Rhetoric is a miscellaneous category, the "category" of whatever works best. Rhetoric is the study of multivoiced argument: a teacher of classical rhetoric finds advantages wherever possible, and she may shift her strategies and even her beliefs in order to persuade her audience.[12] (Think of lawyers; in ancient Rome, lawyers were trained in rhetoric.) Ultimately, rhetoric in this sense becomes sophistry, the art of persuading an audience regardless of whether or not the argument is true or false, good or evil. I would almost call art teaching sophistic, except that I do not want to imply that art instruction is overly clever, devious, or dishonest. But it is rhetorical since it is not concerned with consistency or even content as much as it is the art of persuasion. Art critiques are less dependent than other kinds of criticism on guiding principles.

I'd like to take this analysis a little further and look at several historically prominent forms of criticism that have been applied to literature and the arts. If we narrow the scope of the inquiry, excluding science, theology, and other outlying fields, it becomes apparent that Western criticism has taken a fairly small number of forms. I will call them "critical orientations," following an account by M. H. Abrams.[13]

four

1. The first orientation is *mimetic*, meaning that the artist's work is judged according to how well it matches nature. At first you might think that this is the same as the old criterion of skill: a mimetic critic would praise an artist by saying, "Those grapes make me want to eat them." These days mimetic criticism seems too narrow because it sounds like the kind of instruction that nineteenth-century academics gave to their painting students. That kind of narrow mimetic criticism is still fairly common in undergraduate drawing and painting classes, where you might

hear comments such as, "The hand bothers me. I think you should spend some time looking at hands." But imitation is a wider category than that. It has been said to be the sole principle for all of criticism,[14] and it can be applied to any case where art recreates something in the world—whether it's a hand, a grape, a word, gesture, or a mood.[15] To Aristotle, Socrates, and Plato, all arts were imitations, even flute playing, poetry, and dancing.[16] (*Mimesis* seems to have been originally connected to dancing, before it became a general critical term.)[17] As Abrams says, imitation is a relational term—it stands for two items and some correspondence between them.

So in its general sense, mimetic criticism is not entirely irrelevant to contemporary art critiques where sheer skill is not usually the issue. Teachers still speak about the artist's ability to imitate something. It is also a mimetic criticism to say to a performance artist, "That gesture doesn't look like something I would do if I were *really* exhausted," or to say to an abstract painter, "This really has the quality of evening light in Atlanta."

2. Abrams calls the second orientation *pragmatic*, meaning that is intended to help the student please, delight, move, or instruct. Horace's *Art of Criticism*, the key classical text for this approach, tells poets how to keep their audience "in their seats until the end, how to induce cheers and applause."[18] Horace says the poet's aim is either to profit or to please, or to blend the delightful and the useful into one. These days I do not think many teachers would agree that pleasing the viewer would always be a good idea, and only a few teachers would say that artists should teach the public. Propaganda is a counterexample, because it tries to sway its audience. Advertising is another counterexample. Advertisers would probably be happy with the pragmatic orientation, since they want to "keep people in their seats" and persuade them to buy. Still, art teachers, propagandists, and advertisers would agree that art should delight or move the viewer, and those are pragmatic criteria.

There is an element of pragmatic criticism in most art instruction, just as there is a bit of mimetic criticism. Contemporary artists usually do not create work tailored to please the government, and they may not even be thinking of pleasing, delighting, or moving people in the local art scene. But every artist works with at least a few potential viewers in mind—even if they are only relatives or close friends. It is hard to make an artwork without introducing some element designed to please some specific viewer. And even those few artists who claim they work only for themselves,

without thinking at all about other people, rely on an inner "viewer" to assess the work and act as a spectator as it is being made. That inner division between the "self" that is making the work, and the "other" that is viewing it, is all that is needed for pragmatic criticism to gain a foothold. If part of us is "standing off to one side," viewing the work we are making, then there is already an audience, and the artist-audience dynamic is already in place. Even the most private art is made according to some criteria of pragmatic criticism.

This scenario raises the interesting question of whether or not an artist can work to *displease* the inner spectator. When artists work to alienate a particular public, often enough they mean to be even more pleasing than they could be by creating something beautiful or pleasureful. Creating unpleasant work is sometimes a strategy for winning more praise. The same holds when there is no one around but the artist: the inner observer might look on, horrified, as the artist creates something ugly, but there might also be secret pleasure in breaking the rules. It seems to me that it is rare to find artists who genuinely don't care about audiences, and it may be impossible to make art that does not in some sense please the inner spectator.

3. With the end of the eighteenth century and the inception of Romanticism came a third orientation, which Abrams calls *expressive*. It shifted attention to the artist, and art was seen as "the overflow, utterance, or projection of the thought and feeling of the poet." A work of art was "essentially the internal made external, resulting from a creative process operating under the impulse of feeling."[19] Here we're closer to home. The audience is no longer as important (as in pragmatic criticism) and neither is the external world (as in mimetic criticism). Spontaneity arises as a new criterion of excellence, since it is important that the artist is communicating inner feelings without the imposition of some conventional rule.[20]

Art instructors don't undertake expressive critiques as consistently as the early Romantic doctrine would require. We don't usually try to interpret an artwork exclusively as the product of the artist's sensibility or psyche. Pragmatic and mimetic concerns usually intrude. But contemporary art is fundamentally late Romantic in this sense: art is understood basically as an expression of something inner.

4. Abrams's last "orientation" is *objective*, meaning that the critic concentrates on the object itself and tries not to mention the external world,

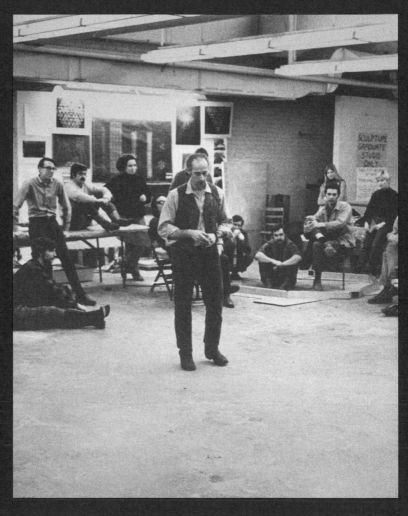

Robert Morris leading a critique. January 1969. Chicago, School of the Art Institute. Archives of the Art Institute of Chicago, folder 7500FF1. Used with permission.

Here is Morris, the perfect minimalist: he has turned his back on the students and their artworks and stares at a patch of concrete floor. Art schools and academies are always just a bit behind the times—even if it's only by a few weeks. Minimalism took a while to catch hold in the School of the Art Institute, and I wonder if Morris didn't find the place a little conservative. The pictures on the wall look like standard-issue Bauhaus exercises: bars of color and textures, crystalline and star-shaped patterns—tentative explorations of composition and space. A student in a situation like this (hearing Morris, not knowing really who he was) would literally not know what she was missing—it would seem to her that she had a good critique, when the instructor was really miles away.

the audience, or the artist's inner world. In late twentieth-century literary theory, printed words were normally called "texts," partly in order to acknowledge the fact that there is no unproblematic way to deduce what the author may have been like.[21] A collection of printed words may seem to imply a certain kind of author (an astute reader might guess Stendhal's clever, roly-poly self behind the pages of *The Red and the Black* or wonder what kind of person could have written *An American Psycho*), but such a deduction is unreliable—it depends entirely on habits of reading and interpretation. A few late twentieth-century critics used the word "text" for visual art like paintings. They meant, in part, that the objects themselves must seem to generate their meanings, and that there is no good sense in trying to understand the artist or the surrounding society *through* the works. The objectivist orientation shows up whenever a teacher tries to talk only about what happens in the work, without mentioning the artist as a person, or the problem of the audience, or the mimetic correspondences with the world. The two most common kinds of objectivist criticism are formal analysis, which restricts itself to colors and shapes, and iconography, which is the study of symbols and signs in artworks.

Logically speaking, objectivist criticism does not exist, because it is impossible to speak about shapes, colors, or symbols without referring to things outside the artwork. Everything that can be said about an artwork is also a statement about the world, the viewer, or the artist. If I say, "That blue is beautiful," I'm evoking the feeling of melancholy (drawing on the Romantic critique of the artist's mind), and the blue of the sky (recalling ancient mimetic critiques), and I am also pronouncing a judgment (introducing pragmatic concerns). What Abrams calls objective criticism can only be a fiction, but that does not mean that it is not important or common. Sometimes it is helpful to listen to a formal analysis as if it were only referring to the artwork, and other times it is best to listen more skeptically, in order to hear how the analysis avoids references to the world, the audience, and the artist.

Formal and iconographic analyses are occasionally strategies to avoid speaking about difficult subjects. If a student looks a little anxious, the teacher critiquing her might prefer to talk about something other than her mental state. Objective criticism can also be a defensive wall against troubling ideas. If the teacher happens to know that the student has been having serious personal or mental problems, she might take refuge in the work rather than risking a difficult conversation. In those cases, formal analysis is a mask—but I think that the other three kinds of criticism can work the same way.

Abrams's four "orientations" of criticism are a nice complement to the six or so "kinds" of criticism I mentioned (professional, ethical, theological, metaphysical, scientific, teleological). It is interesting that both lines of thought have ended with the same conclusion. At first, when I was comparing art criticism to what happens in the army or in divinity school, it seemed that art critiques belong to a miscellaneous category that I called "rhetorical." Art criticism borrows its strategies from various fields, and it can seem as if it does not have a strategy of its own. Then when I surveyed the "orientations" of criticism the same thing happened: art critiques seem to draw on all four of the major historical kinds of criticism—mimetic, pragmatic, expressive, and objective.

I take this as a warning. The fact that there is no good theory about art critiques does not bode well for the possibility of understanding what actually happens in art classes. There is no model, no classical text that might help guide us. That is the first reason why critiques are hard to understand.

2. CRITIQUES ARE TOO SHORT

Another reason critiques can't be easily understood—this list isn't in any particular order—is that the average critique is too short to really get at the work. Consider how the time is usually spent: it takes five or ten minutes just to see the work—to walk around and look at it, to find the right angle, to feel it or hear it. In the first few moments—which I will call the "recognition stage"—a large number of reactions go through the teacher's mind, most of them uncognized or unpondered, and the result is a tentative overall verdict. The first thing a teacher might be aware of thinking, after a minute or so, is "I like it," or "I'm interested," or "I don't quite get it yet."

In the next twenty minutes or so the teacher acclimates herself to the work. Some comments are inevitable, and there are things that always seem to have to get said, and that also takes time. If the works are paintings, it is inevitable that the teacher will mention framing, hanging, lighting, scale, or quantity. If the work is an installation, the teacher has to mention the studio space and how it's inadequate. In the "acclimation stage," teachers tend to review their first reactions. That means the really interesting, difficult questions are only just ready to be asked when a half-hour critique is drawing to a close. In the last fifteen minutes of a forty-five-minute critique there may be time for scattered inquiries to get

[handwritten margin note: What are the stages of a crit?]

[handwritten margin numbers: 1, 2]

119

underway. This third stage I would call the "analysis stage," but typically it's short, since there isn't enough time to go into any particular topic in a leisurely fashion.

In some kinds of critiques, the students begin by making presentations or introductory speeches, and that can severely cut into the time allotted for comments. In architecture critiques, for example, a group might present its work in a sequence of short speeches, comprising a quarter or a half of the entire critique. Because of the nature of architectural projects, there is arguably *more* information to be seen than in some other fields (plans, elevations, sections, models, details, and supporting graphic material all have to be "read"), and as a result a smaller percentage of the material is actually understood than in other kinds of critiques—or to put it another way, the critique takes place at a higher level of generality, with more emphasis on general concepts and less on detailed comprehension.

Time goes by in a critique the way time passes in conversation. Some opportunities for understanding are lost in the silences between statements, some remarks don't go anywhere, some things only repeat others, some comments have to do with work that is not present, or unfinished, or not yet made. Time is spent on simple mistakes of seeing ("Oh, I see what that is now!"). The best critiques are amiable as well as insightful, and that means another five minutes for parenthetical remarks, jokes, and stories meant to ease the tension or to be polite. In a typical critique the acclimation and analysis stages are intermixed, so that people speak at cross-purposes, and that also wastes some time.

So the time can pass altogether too rapidly, and it is rarely sufficient for a serious discussion. If the critique is forty-five minutes long and there are five or six panelists (a standard configuration in graduate critiques), and if no one else speaks and each of the panelists speaks continuously, then each panelist has less than nine minutes. Some critiques are a half hour long and have ten or more people participating, which would give each panelist about three minutes. It takes time to discover a work—sometimes, it takes years—and in those few minutes, between silences, repetitions, mishearings, and mis-seeings, the panelists scarcely have time to adumbrate a considered response.

Critiques are too short in the sense that measured inquiries are not possible. But couldn't it be said that good critiques make a virtue of brevity? Can't a large number of disconnected remarks be more provocative than a sequence of well-analyzed responses? When students say a critique "works," they mean that there were helpful ideas in it, and certainly the more ideas per minute, the more likely it is that one will hit the mark.

My objection to that is that it's true, but if the remarks are *random*, then it is not teaching. If critiques are helpful because of random insights, then the concept of a critique is meaningless: the critique is really only a collection of people in a room speaking without order or coherence. It may very well be that a group of people in a room, speaking on any topic that they fancy, is a good way to teach: it happens in gallery openings and at parties, and in Enlightenment philosophical conversations like Diderot's *Rameau's Nephew.*[22] But surely people who conduct and take part in art critiques intend them to be something other than disordered conversations. We call them *critiques*, distinguishing them from tests, conversations, and parties, and aligning them with the eighteenth-century concept of a critique as an ordered rational inquiry. If we meant only "conversation," we would say so.

There is a limited sense in which a forty-five-minute critique, or even a twenty-minute critique, is too long. People who have experience in art judge very quickly, and most teachers will have a provisional opinion about a work in the first ten seconds. Teachers, jurors, admissions panels, and interviewers can look at slides very quickly, and that is not simply a matter of callous indifference. It corresponds with a truth about visual art, that it can be taken in rapidly. Few people would say that their first opinion would not be open to revision, but first impressions of visual art are probably more important and lasting than first impressions of a person, or the impression given by the opening bars of a composition or the opening lines of a novel. So critiques are too long since it doesn't take forty-five minutes to form a first impression. On the other hand, it may well take *more* than forty-five minutes to change that impression. If a panelist doesn't like the work, it may take quite a while to find a way to say so without being curt. Sometimes it is possible to see that dynamic at work: the first few minutes, the teacher will be deciding how to say what she has already decided about the work; in the next twenty minutes, her opinion will slowly be shifting, and in the last few minutes, she might have time to develop second thoughts. Because there is no way to predict the speed at which a person relearns an art work, or erases and adjusts her first impression, there is not much to be said about how long critiques should be. But here as elsewhere, I am going on the assumption that there is a great deal to say about works, and so a critique that is too short may provide a poorer account than a critique that is too long.

A short critique may be good if you've just started to make art, or if you're a graduate student and you've cynically slapped together your piece just before the critique. Either way it might not pay to hear too

much. A student once told me she resented having to spend an hour talking about another student's work that she knew was put together in less than twenty minutes. I'm not so sure of that—after all, it didn't take Duchamp all day to construct his *Fountain*—but it surely doesn't make sense to overload a beginning student. If you are just starting to think about art, then a long critique may not be appropriate, because it would overwhelm you with critical judgments that might be difficult to use. When the student is not an absolute beginner, I think that the critique should proceed regardless of the amount of effort or intelligence the student put into their work. Every instructor has had the experience of lavishing more creative effort on a critique than the student spent in creating the object. But the thing to do in that case is not to try to match interpretive effort to the effort of creation (that equation doesn't make sense, and the two need not be related), but rather to address the issue directly, in the critique. And so once again I would conclude that most critiques are too long.

As a rule, critiques are too short. It doesn't help that time is often wasted going over topics that the student has already considered. Typically the student and her advisors will have considered a few subjects at some length before the critique, and it is nearly inevitable that teachers seeing the work for the first time will repeat some of those topics. If the student has been thinking hard about them, the panelists' thoughts are likely to be somewhat simple, and the student may want to talk at a higher level. Here, as in many other places in this book, I find a fundamental difference between art instruction and other disciplines. Isn't it reasonable to assume that students can not only *accumulate* knowledge of their work, but *build* knowledge from easier to more difficult or complex problems? Two assumptions in art schools work against this and ensure that every new conversation begins from scratch. First, it is said that the spontaneity of critiques allows for unexpected opinions that the student might not otherwise hear. Though that is certainly true, it is also the case that our thinking is not as inventive as we sometimes take it to be, and that many thoughts repeat other thoughts that have been said before. Often enough a student gets the same kind of critique semester after semester, as the panelists discover and rediscover the same qualities in the work. It can also be said that this kind of repetition is a self-fulfilling prophecy, since the conventions of spontaneous commentary do not promote the kind of teaching in which an advisor sits down with a student to research meanings and build on previous conclusions. In the final chapter I will consider a kind of critique that tries to *build* meaning, but even within ordi-

nary critiques there are various ways around this problem. You might begin your critique by listing some themes you have been considering. Then, if one of the themes appears in the conversation, you can say, "Yes, I have discussed that with my advisor, and it seems to us that your observation leads to the conclusion that . . . ," and then you might add a request: "What *we* were wondering was . . ." Without some sense of building, a critique can easily end up going over old territory. That wouldn't happen in any other discipline. Would a graduate-level physics seminar allow freshmen to participate?

3. CRITIQUES DRIFT FROM TOPIC TO TOPIC

Since there is usually no moderator in a critique, teachers skip unceremoniously from one subject to another and it is not always clear when one is finished and the next is underway. This "drifting" quality pertains not only to the subject of the analyses but to their key words or images and their methodologies (formal analysis, iconology, technical advice, and so forth). Some of the best exchanges drift in this sense, since the participants' thoughts evolve as they speak; and it can also be argued that the best artworks inspire exactly this kind of metamorphic, "nomadic" thinking.[23] Nevertheless there is drifting that is commensurate with rational argument and drifting that is inimical to it. In particular there is a difference, crucial for the clarity of the critique, between a kind of drifting that divides thoughts one from another and reports them in sequence, and a kind of drifting in which the speakers are discovering their thoughts in the course of speaking. In the former, the content and vocabulary might shift rapidly, but—in accord with an ancient ideal of rhetoric—form will be remade to fit content, and sentences will usually be complete. In the latter, half-formed ideas will be couched in sentence fragments, and the conversation will become disjointed. These differences are of course not absolute, but there is a distinction to be made between normal conversation, including gossip and small talk, and the kind of talking that happens in critiques, in which everyone is struggling to say the most interesting or insightful thing they can. In such an environment the contrast between *reporting* thoughts and *discovering* thoughts while speaking becomes unnaturally crisp. The difference is present in these two statements, both from a single critique:

A It seems to me that this is the first one of your pieces that's about incomprehension, or that leads me to incomprehension. There might have been, in some of the prints and earlier works . . . there

might have been pieces on the left and the right that looked a lot like those. But in the middle one, there would have been a "third term" that you're invited to read as music, or a sentence, or as a class in a foreign language that you only understand when the class is over. And everything in between the first time and anything of yours that I've seen seems to say, "You will never understand this." Of course, there's always the possibility here that you might.

B I'm not quite sure what you're doing, how much of it is playful, how much of it has to do with the person. It seems to have all those qualities. I don't know how much you want to pin it down . . . a commentary on a tree, or . . .

Both speakers are groping for insights that they do not quite possess; but the first continues to speak as his thoughts form, and the result is nearly incomprehensible. The second speaker's thoughts are also changing, but each grammatical unit contains and expresses a comprehensible idea, even if it is only a hunch or a declaration of confusion. The result is something that can be immediately understood and built upon by subsequent speakers. It is the former kind of "drifting" that is particularly detrimental to the minute-by-minute sense of the critique.

Like most of the quotations in this chapter, these are transcriptions of actual critiques, and they show how easy it is to fall into incomprehensible habits. I am the speaker in that first passage, and when I saw my words transcribed onto the page, at first I couldn't understand them myself. In a minute I remembered what I had been trying to say, and I could see how I was thinking ahead to something new while I was still talking about a previous thought.

If this were all there is to the problem, it would be enough to counsel that students listen to what panelists and advisors say, in order to see whether their thoughts come out in discrete units or all chained together. But it's more complicated than that, because a speaker who composes his thoughts while he speaks might say something that *sounds like* a complete thought but is really a kind of rough draft for some other thought that is still not quite composed into words.

In the following example a speaker seems to be asking a single question, but as the exchange progresses it appears that she is drifting from one subject to another, working out her thoughts as she goes. The first question seems pretty clear, until it becomes apparent that she didn't really mean it—or rather, she meant something larger, and the first question was just a way of starting out. I have annotated the critique in the right column to show how the topics shift.

A Do you give titles? Individually or as a group?

B No, not yet.

A Will you, though?

B Eventually, probably. Eventually, I mean that's more associative, I'll just sit down with my wife, get a six-pack, and start thinking about it. [. . .]

At first the question seems to be a straightforward request for information.

A I'm curious . . . the reason I ask is, how do you see the attitude of the paintings? There's a sort of temperature, or an attitude to them.

It is like—maybe I'm not making my question clear—I'm speaking of temperament, how do you see the temperament of the paintings?

Now it seems as if the question was loaded, and the panelist is really wondering about something she saw in the paintings. That "something" is not at all clear, it seems, to the panelist herself. Perhaps it is an "attitude" or a "temperament" that might be explained in a title.

B Probably pretty much like myself. Hyperactive. Sort of hyperactive, but analytical in a way, in terms of the—

The artist does not address the panelist's implication that the paintings are double-entendres, that they might not be straightforward and serious. He is just explaining his character.

A —Are they ironic at all? Do you see them as ironic?

The panelist asks again, this time implying more forcibly that the paintings have an "attitude": Do you realize that your paintings are ironic?

B No. I can see where they have elements of that, perhaps. Sort of [. . .] in juxtaposition [. . .], especially the irony of a certain kind of stroke, and then you have this real artificial stroke, like in that one, the sort of candy-cane aspect—

The student has a specific answer for the specific question of irony: to him it means a contrast of "artificial" and natural marks.

A Yes.

B —of the silver [paint]. But I—

A But my question revolves around the use of materials, and attitudes that seem very preconceived, a [will] of the painting, so to speak, as opposed to a painting that wound through the landscape, a sensuous aspect of it. [. . .]

The panelist is not speaking of that kind of contrast. It now seems (if the student had time to think back to the previous comments) as if the words "temperament" and "attitude" were attempts to describe something "preconceived" and rigid in the paintings, which is contrasted against something exploratory and

I'm just asking a question, wondering how you're thinking about your paintings.

B I don't think I feel that ironic about them; I'm not trying to make a statement about the futility of painting or something. That would be—

A I meant more perhaps in a more humorous—

B You mean like Lichtenstein, like the Lichtenstein brushstroke?

A A little bit.

B Humor, I think, is an aspect of it, because I think there are elements of these that are funny.

A Yes.

B Because there's really something—if you think about it—stupid, about making this gestural brushstroke and then this preconceived thing next to it.
But I think those things give each other a kind of vitality that's hard [to top] within the painting; that's really why I was doing things like that, and it's not—

A Is that pretty much a process in your painting, that there will be something more spontaneous, and then a response to it? A more literal response to it?

A Definitely.

"sensuous." Her questions are doing two things at once: seeking to clarify (perhaps to herself) the nature of the "temperament," and asking if it is intentional. This is what is really important. Not precisely what is going on in the paintings but whether the artist is in control of those qualities.

The artist has reinterpreted the word "irony" in light of the panelist's last remark about the "will" of his painting that won't let go in a "sensuous" way. Perhaps he is thinking that she means painting is futile unless it will let go. The panelist redefines her position, and substitutes humor for irony and the other terms.

Though the student agrees . . .

. . . he explains by citing the same example he had used as an example of irony in his painting.

—perhaps this would have continued, "not a matter of 'irony' or 'humor.'" The contrast is reformulated again, this time as "spontaneous" and "literal."

This particular exchange ends far from where it started. These latest terms do not resolve or include the many intermediate concepts.

This dialogue is between one faculty member and the student; the more common, and more confusing, exchanges occur when several panelists are talking in succession, interrupting each other as they discover their own meanings and those of the other panelists. Drifting is inevitable whenever people have not thought out their reactions in advance of the moment they begin a sentence. It can be creative, and also difficult to understand.

4. TEACHERS MAKE THEIR OWN ARTWORKS, DIFFERENT FROM YOURS

Another source of confusion is the one-way nature of the critique. It consists of students and teachers (often called "panelists" when they are doing critiques), both of whom typically make artworks. Of course, only the student's works are on display. The panelists' works are not, and they may be unknown to the student. That means the student doesn't always know where the panelists are "coming from."

From a student's point of view, there are good and bad reasons for wanting to know what kind of work the faculty does. A bad reason is to try to weed out instructors whose work seems less than interesting. (That is a bad reason since the kind of work someone does has no correlation with the relevance of their judgments.) A good reason is to be able to better understand why the panelists say what they say. If a panelist remarks, "Your video looks too soft. It might be better if it was crisper," then "soft" and "crisp" might have a wide range of meanings. It is easier to understand this criticism if it is known that the panelist paints geometric abstractions. At the same time, it is not helpful to use your familiarity with the panelist's work in order to pigeonhole his or her remarks. (From the teacher's point of view, it is sometimes troublesome to have the students know what you do. Students will definitely pigeonhole you, and they may not take what you say seriously.) Explaining the panelist's judgments solely by reference to his work—no matter how well-known it is—can create a false sense of understanding. You might be tempted to think "I can see why he would say *that!*" You may be wrong, but knowing the panelist's work does allow you to understand what is said a little more *specifically*. Hard-edge abstraction evokes a certain sense of "crisp" and "soft," and so you will have a better idea what the panelist has in mind and what to ask next. So there is a highly qualified sense in which knowledge of the panelist's work can be helpful.

This is equally true of panelists who are philosophers, historians, or art critics. As a student, you're well advised to take the time to read

whatever you can of your teachers' writings. Often their publications are available in the department offices or in the library. This is not commonly done, perhaps because students think that the written works of historians or liberal arts teachers are irrelevant or overly difficult. But they are arguably no less relevant than studio instructors' works, because in both cases they are "what the teachers do": both essays and artworks represent the teachers' knowledge and express their interests. It may be that some publications are too difficult, but the same can be said of artworks in unfamiliar styles. Older studio faculty make works that can be more difficult than the most abstruse piece of philosophic art criticism; simply because the works are old, it can be very hard to sympathize with them. The moral is: read and look at everything the faculty does. It probably won't hurt, and it may help.

5. TEACHERS MAKE IDIOSYNCRATIC PRONOUNCEMENTS

All criticism—and some would say, all discourse, including science—depends on "interpretive communities."[24] A group of people who think along the same lines form a "stable interpretive community," meaning they will be likely to agree among themselves. It may seem that the ateliers of the French Academy were such communities, because it appears to us that they agreed on a single kind of art. We might imagine that typical atelier contests would not provoke heated discussion, that people would either agree on what works were best or else disagree in predictable ways. It seems that situation is no longer true today. There are many ways to judge postmodern art, and many different short-lived schools and styles. As a result, we have "evanescent interpretive communities," and no one kind of art is valued for very long.[25] But we need to be careful in assuming that there is more disagreement today than there was in the Baroque, or even that standards of judgment change more rapidly now than in the past. The passage of time collapses nuance, and it is not true that more people in the eighteenth century agreed more of the time, or that standards of taste took longer to change. Then as now, the judgment of artworks depends on a consensus of like-minded people.

In a critique it sometimes happens that all the panelists agree. In that case, the critique panel comprises a stable interpretive community—stable, at least, for the duration of the critique. Standards of taste or quality will remain reasonably constant. When two panelists do not agree, it can mean that they are "representing" two disparate interpretive communities. To take an artificial example: one might like Andrew Wyeth, and another Joseph Beuys. If the panelists are affiliated with two such

What is an interpretive community?

WHY ART CANNOT BE TAUGHT

A critique. Chicago, School of the Art Institute. Archives of the Art Institute of Chicago, folder 7550FF2. Used with permission.

Here some faculty of the School of the Art Institute gather in a graduate studio, in typically cramped surroundings. The School of the Art Institute normally assigns five faculty from different departments to one student. Here the woman at the back left is a fiber artist who works with organic forms; the man standing at the right is a ceramist; and the woman at the center is an art historian—an authority on the early twentieth-century scholar Alois Riegl. The teachers' viewpoints are necessarily quite different. The challenge for the student (seated, at the left) is to understand why the panelists judge as they do— even if he has never met them before. In addition, the panelists might have differences among themselves that the student doesn't even know about. It all adds up to a challenging and very confusing situation. Here the student looks a bit apologetic, and some of the faculty a bit unconvinced.

radically different ideals, then you can expect many of their statements to disagree, and in addition you can expect them to disagree in some predictable ways. In such a case the panelists are like ambassadors for absent interpretive communities.

One difference between the Baroque and contemporary art worlds is that today there are many more points of view. There are more movements, more "isms," in the early twenty-first century than there were in eighteenth-century France. The art world appears to change rapidly and contemporary artists can be pluralistic and work in a variety of media; but as a matter of practice, it is often fairly easy to decide what affiliations a faculty member has.

This idea of categorizing a faculty member according to her stylistic or ideological affiliation may sound coarse. But the concept of interpretive communities, and the idea that a person can "represent" a community, are indispensable to critiques and studio teaching in general. To see why this is so, imagine a version of postmodernism in which there were as many schools as there were artists. Everyone's opinion would be theirs alone, and no one would stand for a community of any size. Each person would have only her own standards to rely on, and she could change them at will, perhaps every day, without anyone being able to follow the changes. In such a world there would be no purpose in art criticism: meaningful criticism demands a set of standards that can be comprehended as instances of standards held by other people. A critic or teacher who is absolutely unique would also be absolutely useless: though a student might want to imitate such a person, it would not be possible since the teacher's judgments would be *incomprehensible.*

In the real world there are sometimes people who approach that condition. In effect, they are evanescent interpretive communities comprised of one person. Here is a speech that is, I think, nearly incomprehensible (this time it's not one of mine):

A They don't look like Baroque paintings. They look like nineteenth-century versions of Baroque paintings. And you believing that you are somehow more connected to that space is where you're meeting your invisible barrier. You're not really connected to that space, you're doing something about that space, and that's why, as you try and move toward that space, you constantly have to repaint the painting, because there is no such space, really. You're trying to paint something very representational, and it's meeting up against the fact that fantasies don't have substance.

It may be that this is hard to understand because it expresses the panelist's personal thoughts about space and history. It may also be that it derives from an idiosyncratic reading of historical texts. Either way, it would take time to untangle the various judgments, and often enough it is not a good idea to take that time in the middle of a critique.

This kind of idiosyncratic commentary can also be a problem for critiques because it is not easy to interpret the *cause* of an idiosyncratic remark. An incomparably odd statement might proceed from at least five causes: (1) When a teacher disagrees with something she herself said a few minutes before, sometimes she is in the process of switching interpretive communities. The result is self-contradictory advice. (2) Judgments can also be self-contradictory because the panelist habitually works in several partly incompatible styles. In that case, "self-contradiction" may not have a negative value: it may be a quality the panelist is praising. (3) It may also be that the panelist is daydreaming or free-associating, and the comments do not owe allegiance to any particular set of values. (4) It also happens that panelists can be ironic, or just perverse, and say the opposite of what they might ordinarily say. Sometimes this is done in order to play devil's advocate, and other times it is destructive in intention. (5) And finally, it is not uncommon that panelists confuse themselves as they try to articulate a difficult idea (*discovering* thoughts rather than *reporting* them, as I said earlier). A comment that seems "strange" may also signify a state of confusion, either conceptual (an error in thinking) or grammatical (an error in speaking).

It is not necessary to play the game of trying to identify each panelist's interpretive community, that is, her allegiances beyond whatever remark she has just made. Truly idiosyncratic commentary is a special problem because it leads to radical interpretive quandaries. Why is the statement self-contradictory? Why does it sound odd? Is the speaker contradicting herself out of perversity, confusion, or absent-mindedness? In philosophic terms, this problem is called the "recovery of intentionality." Ordinarily, we make guesses about a speaker's intention, and those guesses help us construct a version of the speaker in our own mind. If the speaker says enough, we can gather together a concept of her personality and be reasonably sure what she might say to any given kind of art. Contemporary philosophy stresses that it is never possible to figure out a person's intentions from things they say, but the informal guesses we all make help us to continue conversations by providing us with a usable fiction of a speaker's intentions. Idiosyncratic

speakers just make things that much more difficult: their comments are like static in a radio signal.

6. CRITIQUES ARE LIKE SEDUCTIONS, FULL OF EMOTIONAL OUTBURSTS

It is a dogma of art criticism that a critique should not be taken personally. I regard that as an "enabling fiction": a lie that lets us get on with what we want to do. Critiques are supposed to be focused on the work, rather than the artist, and to that end they usually proceed as if the artwork were separable from the student who made it. Poststructural theory lends support, by claiming that artworks are effectively autonomous objects, detached for purposes of interpretation from their makers. I do not need to disagree with the poststructural stance to say that at root any criticism of an artwork is also a criticism of the artist. That is so because the very terms and notions of criticism are themselves rooted in "agency"—in latent connections to the maker. Even when critiques stick to formal analysis, the teachers' judgments are connected to issues such as extroversion and introversion, emotional control, stability, and exhibitionism. It's hard to imagine how a work could be emotionally disconnected from the artist's personality, and typically the connections run deeper than the artist or the panelists know.

Most critiques maintain the strange fiction that the work can be considered entirely apart from the person who made it. There are exceptions: in performance art, for example, the emotional content of the work cannot always be distinguished from the emotional state of the artist, even if the "character" can be distinguished from the actor, and the actor from the student. Perhaps the most extreme exclusion of psychological criticism occurs in architecture critiques, where it is not usual to speak of the student's emotional investment in the work except as a matter of assessing commitment. Since most critiques are somewhere between those two extremes, it is usually possible to proceed as if the critique is not personal, though I would say that it is not a bad idea to keep in mind just how artificial that enabling fiction really is.

When the personal elements rise to the surface, they can become a *dis*abling fiction. For that reason it is good to have a theory about emotion in critiques that become virulent or psychologically destructive. One possible theory, which I have found quite useful, entails reading critiques as enactments or metaphors of seduction.[26] There is much in what artists do that echoes the customs and strategies of seduction, and we should not omit the most obvious signs, when instructors declare "I love that!"

or "That's wonderful!" or "I'm very taken by that!" In addition seduction operates in more general and more intricate ways.

At the very least, an artist wants attention. The panelists and guests of the critique (usually other students) should be engrossed, interested, intrigued, responsive, excited. The work is meant to draw them in, to invite them, to provoke them. Sometimes, to be sure, the artist wants something more like friendship, a lasting and renewable dialogue of equals. But more often, given the briefness of the encounter, and given the difference in rank and age between the teachers and the students, the aim is more immediate and also more intimate than friendship. I want to distinguish this from what happens between teachers and students; what I think is worth modeling is the indirect relation between teachers and artworks, and in that relation the students themselves play variable and sometimes unimportant roles. The artwork "presents itself," or is introduced, and *it*, not the student, is to be the object of the teacher's attention. At it's best, the artwork can incite a range of responses within the compass of a critique: at first, one might be repelled, then attracted; there might be the promise of "depth" or lasting interest; the work may seem "coy" or overly aggressive; it may appear as an "other" or as an acquaintance, as a relative or a stranger.

This way of thinking about critiques permits a closer understanding of some of the sources of strong emotion that sometimes ruin critiques. It is essential to bear in mind that even a successful critique ends in unfaithfulness. Those teachers who are not the student's advisors will leave the work at the end of the session, and most will not return. This is a simple fact, and very important: panelists who are themselves artists know that the artist has been alone with the work for days, perhaps for months, all that time preparing the work to be seen. The classical metaphor for this is childbirth, since the work is like an offspring; but in this context, I would suggest that the solitary time spent creating can also be seen as time spent in front of a mirror, "fixing" or primping an ideal image, and it is that image that is displayed for the panelists. Given the importance of this time spent in preparation—however it is to be imagined—it follows that the brevity of the critique and the inevitable dispersion of the critique panel correspond to rejection. Often enough the teachers will continue to discuss the work, and it will remain in their minds for some time, but eventually will come the moment when each panelist will be unfaithful to the student's work. And this is a principal source of emotional difficulty, both for students and for teachers. To the degree that showing work is like an invitation, there is a potential for hurt. And it is

133

made even more virulent by the fact that everyone involved knows that spurning and unfaithfulness are inevitable consequences of showing work.

I am not suggesting you should imagine each critique as a bedroom scene. Seduction is a model, a way of understanding the curious emotional charge that often accumulates and discharges during critiques. In this sense critiques are veiled psychodramas, and they necessarily involve the entire spectrum of "unnatural" as well as natural responses to seduction, including voyeurism, lechery, perversion, and bad faith. In ordinary critiques the fundamental sequence of display, appreciation, and "unfaithfulness" runs like a familiar story and is not obtrusive. The student and the teachers can learn about the specifics of the work without breaking professional decorum. Typically there is a fair amount of praise in critiques, and if you listen carefully it is apparent that the praise is sometimes inserted into places in the dialogue where it does not logically belong. In such cases its function is to reassure. An incongruous, sudden or irrelevant statement of praise says, in effect, that the seduction is going well, and there is no cause for alarm.

Sometimes it can be useful to actually talk like this, and to say, for example, that a certain work "seduces" or appears "friendly." But it is rarely useful to mention that a student is behaving as if he or she wanted to seduce the panel. Doing that would only impede the real seduction that is going on between the work and the panelists. In an emotional critique, this is exactly what goes wrong: the seduction is not succeeding, and both parties know it. The discomfort and suspicion build on both sides, until they find expression in remarks that are loaded with emotional freight. Ultimately those pretenses are cast aside and people become openly rude, breaking down the dialogue.

The example I have chosen is from the earlier stages in this process, when the critique can still be salvaged. The panelists have just come from a frustrating critique in which they saw work that most of them thought was misguided. They had been unable to persuade the artist to change. That was on their minds when they came into the new studio, and even though that emotional charge had no relation to the work at hand, it carried over—much as a lovers' quarrel will cast a pall on the rest of the day—into the new critique.

S Anytime you're ready, or any-
 time anyone else is ready.

F We just realized how incredibly *By starting out saying how "bad" the*
 bad the light is in this room. *light is, this panelist is also insinuat-*
 Looking at the [previous stu- *ing—but not yet implying—that the*

dent's] paintings in the hallway, they actually looked better than in the studio.

paintings themselves are bad. It is a troublesome opening comment.

Speaking about the quality of light is also insidious, because it obliquely declares that the paintings are invisible. What can be said, after all, when the paintings "themselves" cannot be seen? The student agrees that the paintings cannot be seen, but he suggests that the defect can be compensated for, since it is only a matter of brightness and not something less tangible.

L Yes, ideally I would like to have had them in my studio [at home], because I have the combination of fluorescence and incandescence. You know, these are actually brighter than they look.

F What kind of paint is this?

L Oil; the silver is enamel, oil-based enamel.

S Do you mind that they're going to fall apart?

A deliberately provocative way of putting it. The question implies that the panelist does not care about the paintings, that the seduction may have already failed. The first words, "do you mind," belong in a more courteous sentence, so in this context they are ironic, as if to say, "Can we be friends if we agree that these paintings are not important?" The proffered intimacy of the initial phrase turns into a challenge.

L I don't think they're going to fall apart.

The student does not respond to the ironic politeness of the panelist's challenge.

S I can guarantee you they are.

And so the panelist responds in kind, with unalloyed aggression.

L Ah—

It's a skeptical "ah—" but no argument is offered.

S What are the ingredients?

The question is a declaration that the seduction is still on, since if it had failed entirely, the panelist would have been silent. It is still possible for the student to win her affections.

L It's mostly oil, and there's some enamel. The silver is enamel.

R The silver is the only enamel?

L Yes. I think what's going to happen is that at some point the

A moment ago, the student didn't think the paintings were going to deteriorate.

silver is going to start to deteri-
orate, but because it doesn't
leave a thick, gestural brush-
stroke, the—

R If we stay here long enough, we
may be able to witness the
event. It's fugitive paint.

L Yeah. I mean, but I can—
S It'll sit there in puddles. If you
don't care, I don't care either.

F So these [paintings] don't mat-
ter.

L Yes, I think eventually, if some-
thing starts to happen—I mean I
don't mind a certain level of
deterioration; I can just go back
in with the silver, because it's
flat, it's not like a thick gestural
work, I could touch it up if I had
to.

F Trying to put conservators out of
business?

L Yes.
F These are the sort of paintings
they live for.
L Yeah.
F So next time, answer, "Yes, I
want them to deteriorate."
L Yeah. "Rapidly."

Here he accommodates himself, impro-
vising an explanation.

The second panelist puts it in dramatic
terms. The imaginary drama—of every-
one standing around, watching paint
fall—makes it more explicit that what
has just been happening is a drama,
and it opens the way for less decorous,
more directly destructive comments.

She repeats the ironic bid for friendship:
"We can be friends if you'll agree the
paintings are going to be puddles." At
this point, the seduction (or proffered
friendship) can proceed only with the
sacrifice of the object of attention it-
self—which both parties know is not
possible.
Another panelist joins in. When this
happens, the critique can become a
one-on-one dialogue: one student and a
unified antagonist.

The first conciliatory comment comes
without any reason—and it's still fairly
belligerent.

The intimacy is partly restored by this
joke, which is still at the expense of the
paintings.

S No, it's a little embarrassing to
have somebody call you after
they've owned a painting for
four or five years, and say, "The
goddamn thing is falling off the
wall."

L Yeah.

*The student is joking along, taking pun-
ishment.*

S Especially if they've given you
twenty-five, thirty or forty thou-
sand dollars for it.

*This is the second conciliatory remark,
since it implies the work may have val-
ue—and again there is no rational con-
nection to what had been said before.*

L Well, I'm not in that position
yet, so . . . If they're willing to
pay that, I'd be glad to come
back and touch them up.

That ended the confrontational portion of the critique. As in a seduc-
tion, it is not always rationality that rules the day. The student's willing-
ness to make jokes at his own expense, and to stop arguing back, might
have saved the day. But these things are ineffable, as they are in relation-
ships. The nascent argument did poison the well, and the remainder of
the critique was conducted under a double shadow: on the one hand, once
this level of antagonism has surfaced it remains possible that it could re-
surface, and possibly more quickly and violently than before; and on the
other hand, all succeeding positive comments are tainted by the panel's
tacit agreement that the paintings are going to fall apart anyway.

I have suggested a sexual metaphor in order to help explain the vio-
lence that sometimes accompanies critiques. In particular I would say that
when untoward emotion rises to the surface, it can sometimes be assigned
to a problem in the half-hidden script of wooing and refusal. When things
go well and the critique is productive and inspiring, the script is running
smoothly. The seduction theory has pragmatic consequences, because stu-
dents and panelists can repair some problems by distinguishing the emo-
tional from the analytic components of a nasty or unproductive comment.

Thinking of panelists and students as jilted lovers can explain highly
emotional, provocative responses, but it is not necessary when the cri-
tique is running smoothly, at a lower emotional level. It would take a
separate book—or better, a novel—to rehearse all the emotions that can
take place during critiques. This exchange I have just quoted contains
betrayal, coyness, insinuation, and slander—four elements of the classi-
cal repertoire of love.[27] And I would also say that there is nothing demean-

ing or irrelevant about seduction as a model for critiques: after all, sexuality is a central fact of life, and it is always possible that critiques may be at their best, or purest, when they are most like successful seductions.

When the work itself has sexual content, these themes are likely to be more explicit, and the critique is more likely to go out of control. In my experience, people have a great deal of difficulty looking at sexually charged work and not using sexual metaphors in their thinking, and when such metaphors are successfully repressed, the sexual content may rise to the surface in the form of bizarre images, disconnected statements, and non sequiturs. In one critique, a panel saw life-size photographs of women's bodies and closeups of women's crotches and other body parts. My transcription of that critique is full of images that were not in the photographs: panelists talk about things like pulling up a little girl's skirt (proposed by one panelist as an example of what men "naturally" want to do), and they use words like sticky, glossy, cheesy, dirty, "big, white, and clean," and other fleshy metaphors. One panelist expresses his ambivalence about the images by saying that he wants to be "slapped and patted at the same time." The conversation is ribald and very entertaining, and to some degree sensual metaphors are both inevitable and expressive of the work. The difficulty, I think, comes from the fact that ordinary judgments get put in such strange ways that their meaning is skewed or they become unintelligible, as in this excerpt:

C What begins to operate for me in these [larger pieces], is that there is a bombastic quality, like you don't earn the bombast. But what I find myself going to, which is sort of interesting, is like the crinkle in the nipple . . . the sort of detail . . . which I'm not supposed to be . . . but which I find myself thinking about.

She means something like, "Smaller artworks are more interesting," or "All pictures need a certain amount of detail," but the example of the crinkled nipple is so bizarre (even by the standards of the works themselves) that it distracts from that idea.

When she says she knows she's not supposed to be thinking about things like that, she almost chastises herself for her original judgment, nearly contradicting the initial idea.

W That's what it does . . .

X They don't have red in them and I wonder if—

This is another strange—and sexually charged—image, since the photographs were monochrome, and no one had mentioned color. Like the crinkled nipple, it may be hiding a perfectly ordinary judgment.

E Well, I wanted to have just . . . a way that you could just enjoy the image, without texture, so there's space.

C Well, to go back to the notion of private parts, because [in the smaller photos] there's a sense of privacy. The peep show thing is interesting for me to think about, because there, there's attention to private parts that I love in that piece.

I hate the word "affirmation," but there's something about these that says, "Oh, yes."

Whereas, I was thinking about the way people were talking about these pieces, and you're talking about the female body, you're talking about my body. And the fact that these pieces spark this kind of discussion . . . You haven't reached that point in the work.

I don't know, I'm just sort of groping my way around to what I'm trying to say, but the fact that we're discussing . . . it was the way in which the female body was being discussed in these pieces . . . in my mind I was comparing it to Barbara Kruger's work, and I don't mean that to be [negative], but in a way this would never happen [in her work], because she's so aggressively taken . . . the conversation, she's mapped the territory where you don't go to, how

The artist would rather not talk about her images that way. She mentions space, cleanliness, coolness, and similar metaphors.

Speaker C tries again, finding a way to admit she likes "private parts." The problem is that her taste leads her to accept the idea that the works are like a peep show, which the panel had earlier decided was a device that serves prurient male interests.

This is a nearly incomprehensible thing to say. "Affirmation" by itself has the connotation of naïveté or sentimentality, but the phrase "Oh, yes" makes it sexual. Why should the two be related?

She feels a personal relation to the images, as if they are representatives of her body. That makes the issue even more difficult to resolve, since she has to talk about the work and her body at the same time.

She is vacillating between her sensual interest in women's bodies (which she would have trouble enunciating, since it would sound like she was promoting peep shows) and her desire to say something about how the work doesn't succeed.

Of course it doesn't help to be "groping" when you're looking at photos of women's bodies.

Here Barbara Kruger is someone who does not run into these difficulties because she controls her position, her voice and her audience. By implied contrast, the panelist's position and voice are fluctuating.

she's displaying the female body
[. . .], how she works to the ad-
vantage of the feminist culture.

The tribulations of this speaker are typical of the critique of sexual work in general: such work throws people off and they pepper their conversation with sexual innuendo and sexual tropes. It seems to me that behind the speaker's tangled thoughts are some relatively straightforward ideas: for example, that large works are difficult to control, and that to some degree a spectator will always identify herself with a depicted body. The pressure of sexual thoughts renders the dialogue somewhat opaque. I think there may be a larger lesson here as well, since we routinely borrow our verbal images from what we're seeing. In front of a landscape painting, we talk about airiness, brightness, and depth, and in front of an iron sculpture we talk about hardness and durability. I don't mean that viewers describe the objects in these terms (though they do that also), but that they let the images suggest their argumentative strategies and judgments. So it stands to reason that even outside the sexual arena, where things are less emotionally charged, our conversation is slurred or skewed by the metaphors that the works provide to us. In the present of sexually charged work, even simple judgments become inscrutable because they are overburdened or tossed around by whatever metaphors happen to be at hand.

7. CRITIQUES ARE LIKE MANY OTHER THINGS, INCLUDING BAD TRANSLATIONS

Seductions are only one kind of metaphor for critiques. Here are some others; each is useful in a limited way, though none is as generally applicable as the seduction model.

1. A critique can be imagined as a problem in translation, because for practical purposes the teacher may be speaking a different language from the student. Say a Netherlander speaks to a German, and they each know only their own language. Each will understand a little of what the other says, but neither will be quite sure they have been understood. Miscommunication is a trait of all communication, but it can derail art critiques in a way that does not happen in ordinary speech. Sometimes the "languages of art," in the philosopher Nelson Goodman's phrase, have names: philosophy, psychoanalysis, literary criticism, artspeak.[28]

Some theoretical terms can be especially effective in establishing the dominance of one or another critical language: once a teacher mentions

Abraham Bloemaert, <u>A Cow, a Palette, and a Maulstick.</u> From Bloemaert, <u>Oerspronkelyk en vermaard konstryk tekenboek</u> (Amsterdam, 1740). Photo: author.

This is one of several title pages to parts of Bloemaert's textbook for painters. This one introduces part 8, on the drawing of various animals. It's meant to be a good engraving of a cow, showing the techniques and the sense of proportion and detail that are explained in the book. But it also looks oddly like a self-portrait—<u>The Artist as Cow</u>—complete with brushes, palette, rag, cloth-tipped maulstick, and jar of linseed oil. Books like Bloemaert's are still published, but they aren't taught in serious art classes. You can find them in large bookstores and art-supply stores, off in a corner of their own: <u>How to Paint Young Animals; How to Paint Barns; Successful Marine Painting;</u> or <u>Painting Weathered Textures in Watercolor.</u> The art world has moved far away from the notion that artists need instruction in depicting specific kinds of objects. If there were standard textbooks for college and university art classes, they would have titles like <u>How to Think About Minimalism; The Limitations and Possibilities of Surrealism;</u> or <u>Twenty Good Reasons to Give Up Painting and Make Videos.</u>

the "parasite," "reaccession," or the "abject," it is likely that the remainder of the conversation will be infected even if the other teachers or the student don't recognize the "languages" those terms come from. Some critiques can be read as being more dependent on theoretical terminology than others—critiques of architecture, film, and painting come to mind. There are also fields where a *lack* of critical terminology can result in improvisatory critiques that wander among many "languages." Performance art is an example. A student might be given an acting critique, and then the conversation may switch to fashion, music, or the movies. I was in one critique where the artist, a young woman, had done a kind of confessional monologue. Afterward she was sitting with me and four other teachers, discussing the lighting and props. Then one teacher said, "You know, you have very hairy legs." I remember thinking I should leave as soon as possible, to avoid a lawsuit—but the woman responded cheerfully about how her sisters and her mother also had hairy legs. After a few minutes, the conversation turned to dramatic criticism, and then back to technical problems of lighting, and then on to confessional novels and poetry. It was a multilingual critique.

A few kinds of art have their own languages. Painting has formal analysis and iconography, and film has film theory. It's also possible that a few metaphors can dominate discourse, without being part of any particular critical "language." In fiber art, metaphors of skin, of the inside and outside, and of softness or pliability can dominate discussions without tying them to any specific theoretical platform.[29] Fiber, I'd say, is not yet an *ideal method*, and so it leans on other discourses.

To the extent that panelists are trying to build theoretical edifices, and to the extent that they are speaking with each other in mind, their critical "languages" will likely be less than crystal clear. This is particularly marked in certain fields such as film and architecture, where the current discourse is particularly abstruse. Some architects use varieties of poststructuralism, and some filmmakers use a kind of criticism derived from writers like Jacques Lacan, Barbara Rose, Jonathan Crary, and Kaja Silverman. From a student's point of view, such critiques require specialized learning that is not always available, especially to undergraduates. Critiques can become places where a student scrambles to translate a teacher's language into her own:

— Rebecca, I think that the question of projection is entirely open here. Instead of the external subject, you have an unmediated co-

presence <u>in</u> the work, and instead of the mediating plane, you have—what do they call it?—the screen, the Lacanian screen.

— Lacanian screen?

— That's the place where the subject is inverted, its normal relation to the world is inverted, so that the subject—you—are caught there, "like a stain," like this portion here, or those marks in the center. It is a kind of anti-projection, a "chiasmatic inversion" is what it's called in film theory.

— Wait, let me write that down.

— These marks subvert the innocuousness of the projective gesture, the gesture of pure projection, like in the Renaissance. They are all about the failure of the unified field of objectivity, a kind of late-capitalist sense of attention or perception.

Of course, this dialogue is a parody—it's a collage of different critiques—not because conversations like this do not take place, but because teachers are usually a little more careful to explain whatever theory they are bringing to bear on the work. Unfortunately not all teachers also function as their own interpreters. The usual situation is that the instructor is not using any particular jargon and may not even realize that he is speaking in a way that is dependent on some theory. After a few years' exposure to postmodern discourse, the majority of people begin to speak in ways that seem habitual but are really only fully comprehensible for people with analogous exposure to the theory. Then the problem is compounded: first the student has to realize that something is in need of explanation, and then she has to decide if it is a good idea to try to read the theory first, or ask for a direct translation.

It's one thing to translate from some theoretical discourse into another way of talking, and it's another to translate the teacher's particular kind of theory-speak back into its original versions in philosophy. The versions of deconstruction and other poststructuralist narratives that are found in architecture journals are significantly different from those in the originating texts. The same is true of the relation of film criticism to its models in feminism and post-Freudian psychoanalysis. There is no easy way to describe these differences. They are not usually unproblematic adaptations or applications of primary texts. Instead they are like provincial dialects: from the point of view of the original philosophers, film theory and architectural theory (among others) can appear misguided or just incomprehensible. That means that as a student, even if you take the trouble to study Lacan or Derrida, you may not be able to understand your advisor.[30]

2. Critiques can also be seen as exchanges of stories, or collaborative storytelling. If you set out to tell a story about your work, you'll quickly find it becomes a collaborative venture, because your teacher or teachers will pipe in, changing your story so it becomes a group effort. Critiques are the intersection, or battleground, of different stories about art.

A story about yourself and your work is a kind of artwork in its own right. Where I work, students' stories are called "spiels" and "performances." Good stories weave the artworks, the studio itself, and the panelists together into one narrative. In that sense a story is also a work of performance art, or even of installation art. Sometimes panelists interrupt the critique to tell stories about their own lives, and sometimes those stories are in belated response to stories proffered by the student. If you open your critique with a narrative about how difficult life has been for you in the last semester, the panelists may respond by being kinder about their criticism, and that in turn will meliorate your story. Panelists also initiate stories, though they are less commonly based on literary modes and more often reminiscent of scientific or scholarly texts—panelists provide analyses, discussions, evaluations, "anatomies," "dissections," and other kinds of drier, less-voiced narratives. Like the model of seduction, storytelling is a rich analogy for critiques, and it sometimes helps to listen to the kinds of narratives that are being traded in critiques. One student's story might be romantic or confessional, and another student's lyric, comic, tragic, or epic. When all goes well, a sob story may become a comedy, or an epic may be shortened to a poem. There are different *genres*— epic, confessional, scientific paper—and within each genre are various *conventions*. In the Homeric epic, there are catalogs of ships and warriors, and in the Artistic epic, there are catalogs of works:

> — First I did that large piece, the one with the red, and that was the beginning of the semester. Then the two smaller pieces came, one after another, and then I was stuck. Bill helped me a lot then, and I did that large yellow one, and the three little purple things, and that little "hairy ball" over there. That was very quick, about a week.

In the *Iliad,* the Homeric catalog supports a reader's sense of the narrator's historical accuracy and underscores the political power of the various nation-states, and it gives the poem a certain measured pace. The lists also seem to reflect Homer's desire to defer or anticipate the issue at hand—in this case, warfare. The student's catalog of works has analo-

gous functions. Listening to it as a narrative helps us to hear its underlying meanings, to understand its place in the larger succession of topics of conversation, and to get a sense of its limitations and potential. A student who is cataloging her works is also in control of the pace of the critique, and so the catalog is a way of saying that she will not let the critique get out of hand. The catalog also bolsters the panelists' sense of the student's veracity and her control of her work.

Some philosophers think of narrative as a kind of fundamental condition for human experience. The idea is roughly that unless you can form a rudimentary narrative about an experience, you cannot understand it at all. Every thought, in this way of looking at things, is a story.[31] A story is not only something that a student or panelist might identify as such, but it is *any sentence* or sequence of sentences. People are sometimes aware of telling stories, and the catalog is an example of something that might be recognized as part of a story. But in this view there are many other stories running throughout a critique: stories that people construct to help them understand themselves, stories that panelists tell themselves about how they usually go about explaining artworks, stories that students use to help understand their relation with faculty. The narrative model of critiques is potentially deeper than a list of specific stories. If the narrative model has a limitation, it is that there is not always much that can be said once the deeper narratives are uncovered. From a teacher's point of view, if a student has a story she tells herself about how she will eventually be misunderstood, it may not help to talk directly about that story in the context of the critique. It may be unproductive to say, "I think you should think about this story you tell yourself—perhaps you won't always be misunderstood." In my experience people tend to become less interesting when I can understand their stories. I loved my grandmother's stories about growing up, but I didn't particularly want to hear them once I realized they were her way of rehearsing her unhappiness— of saying, in effect, "I was unhappy." In a way, what's interesting is listening to the stories, rather than classifying them.

3. After the Homeric catalog of ships, the battle itself gets underway, and a battle is a particularly tempting metaphor for a critique. The hatred, the fear, and the confusion of a battle are sometimes parallel to what happens in critiques, but critiques are much more controlled, more low-key. Students and teachers can become determined adversaries, out to get each other, "sparring" and "fighting." It seems promising, but I am not going to expand on the battle metaphor, because I am not sure how

it would shed light on critiques. Does it help to notice that the aggression of a teacher is like the aggression of a soldier?

4. There is another major analogy for critiques that I like much more, and that is the legal proceeding. Again, though, there are big differences. A serious trial, like a murder trial, is final (it can't be repeated), and that has no parallel in the art world. It does not help to compare a critique to moot court, a hearing, or a deposition since the legal system is built around the idea that final decisions *are* reached, even if they may take years. Art critiques end with many opinions, so they are more like hung juries or mistrials than ordinary court cases. We do say "the jury is out" on an artist—thereby implying that artists do get a final judgment—but we don't say it to students during critiques. (In art history, artists are effectively judged for the last and definitive time after their own lifetimes. A few artists—Giorgione, Vermeer, Piero della Francesca—have been revived, but the majority are judged irrevocably. Art classes aren't like that.)

The legal metaphor is a very good way of thinking about the exercise of power in art critiques. A critique can be like the trials in Kafka's novel of that name: the defendant's attorney is either incompetent or absent, and either the jury is absent or the judges do double duty as jurors. Often enough the student has to decide whether it is wise to speak in her own defense. The defendant, like Kafka's Joseph in *The Trial*, is never quite sure what he is being accused of, but he knows that judgment is in the air. The judges' knowledge is mostly secret, and their methods and rules are difficult to perceive. In Kafka, the principal differences between Joseph and the world of the Law are power and control: Joseph loses a bit more freedom each time he enters a courtroom or lawyer's office. Like an art student in the middle of a critique, Joseph never knows quite what is happening.

Art critiques can have a heavy courtroom atmosphere. Imagine this dialogue between advisors, with the student keeping quiet like a defendant:

— Well, Jane, I just don't know.
— Hmm.
— Okay, well, I'll say this, that your work is very intriguing.
— Mm.
— Yes, that idea about the witches is very nice.
— Yes, I like that too.
 [Silence.]
— But there's a great deal going on here, you know.

— Oh, yes.

[Silence.]

— There are things that can be controlled, and other things that can't be.

— Yes. An artwork is not something that just "goes right," all at once.

— Sometimes it takes years.

There is much to be said for the legal model, but I choose to leave it here, since it is also rather seriously misleading (students do not have their throats cut at graduation, like Joseph's is cut at the end of *The Trial*). Critiques are like courtrooms in that they are formal meetings bent on judgment, and they borrow some of their sense of control and power from the law, but they aim *away* from clear, unambiguous judgments and from punishment itself. In their place they put ongoing conversations, shifting and heavily qualified verdicts, and increasing equality of defendants and judges—all as in *The Trial*. Perhaps critiques are more civilized versions of trials.

The parallel with the law brings the total of allegories for critiques to five: amorous, linguistic, narratological, warlike, and legal. Critiques can be understood as allegories of all of these—which is another way of saying their confusions are multiple. No one model will do. It would have been possible to build this chapter around these and other possibilities, but each is limited by the fact that it is artificial, and the metaphors quickly become strained. As I said in considering the model of seduction, these allegories do not become explicit unless the critique develops problems. Allegories like the five I have named are the substructure of the critique: they give it direction and shape but normally remain out of sight—and conversely, when they are on everyone's mind, it is a sign that something unusual is happening.

In the broadest sense, these allegories all have to do with the different purposes that bring students and teachers to critiques. A student's purpose in a critique is to increase her own understanding of what she has made, to achieve some "distance" from it. On the other hand, panelists are usually out to build explanations. (Including the explanations I am proposing in this book.) "Distance" is not at stake in what the faculty do, since they begin and end at a comfortable intellectual and emotional distance from what they see. Instead they want to say something insightful, partly because they feel an obligation to the student, and partly because they know their colleagues are listening.

Hence one way to control a critique is to be aware of the differing

purposes of students and teachers. For their part, teachers can bear in mind the closeness that students have to their work when it has just been done—an intimacy that can border on complete incomprehension or radical misunderstanding. That way a teacher will know when it is not appropriate to say something abstract like "These marks subvert the innocuousness of that gesture," and when it is better to say instead, "Well, don't worry, the first semester is always the worst." Students, on the other hand, can appreciate the teachers' interest in explaining everything. That way they will know when it is better to say "I think that's too intellectual," instead of "What do you mean, the marks 'subvert the innocuousness'?" On both sides a cognizance of the differing agendas can meliorate differences of "language," purpose, and narrative.

8. TEACHERS WASTE TIME GIVING TECHNICAL ADVICE

Another aspect of critiques that can be confusing is the alternation of technical advice and suggestions about meaning. Some panelists want to talk only about meaning, and others are happy to talk about media. At first it may not seem that this is confusing, as much as it is simply annoying or distracting. Students often complain that panelists or advisors spend all their time on technical advice, and they rarely complain that too much time is spent on the analysis of meaning. Often it is true that giving technical advice is easier than analysis, and faculty members can fall into the habit of talking about media and materials when they don't feel like struggling with meaning.

Talk about technique and talk about meaning have very tangled relations with one another. A teacher might be talking about a medium and thinking about its meanings, or vice versa. One person might assume that meanings come out of media, and another person might think the opposite. The trick is to learn to listen: to hear how symbolic and expressive meanings are implied in technical talk, and how media and formal problems are implied in talk about meaning.

In one critique, panelists saw photographs done with liquid emulsion on glass. A large fraction of the critique was devoted to apparently technical concerns having to do with printing on glass. At one point the artist said:

> A Again, this is just the beginning and I've just started, so I can't really say, "This is the end, this is all I can think of with glass." I mean, I'm beginning to think about other glass; glass with wire inside, pebbled glass, layers of glass and making the same image

and having it recede in space. There are a lot of possibilities and
I'm just at the beginning.

Two panelists kept trying to turn the conversation back to meaning, but
the student was more interested in the possibilities of glass. There were
some brief mentions of historical and expressive meaning toward the end
of the critique. Someone thought of microscope slides, and the artist
mentioned nineteenth-century stereo viewers; and one person mentioned
the "ominous awkwardness" of prints made on wrinkled acetate. But most
of the critique seemed to have little to do with meaning. At one point
everyone was staring up at the skylight, wondering how *it* could be paint-
ed with photo emulsion:

K But don't be too clean about it either, you know. I mean look at that
[pointing at the glass skylight] . . . And it's got pieces of wire in it,
and it's cracked, and it's got fifty years of grunge on it.
W I bet it would take emulsion.
A No, I don't think so at all.
K It's got a tooth to it.
A No. You have to polyurethane glass before you can ever put emul-
sion on it, so there's—
W —Or power etch it, or blast it. You need just a little bit of tooth for it
to grab.

The assumption in this kind of dialogue is often that meaning is some-
thing that is best discovered through technique. The student wanted to
experiment with media and let meanings come out of that process: she
said that a new technique might help "draw the meaning out."

As I read it, this way of speaking about technique is sometimes itself a
technique to avoid thinking about meaning. The more time she spent on
technique, the less she had for pondering her subject matter (which was
photographs of syringes and of arms being injected). To put it in psycho-
logical terms, technique may have become a way to avoid thinking about
herself and her personal interests. The media "led" her from one exper-
iment to another. One sign of this assumption is the notion that some
media will prove to have meaning and others won't. At one point a pan-
elist says this directly:

A There are a lot of reasons to use glass (the practical reason is that it
is transparent), and I can expose liquid light on it, but I'm not sure
. . .

K I just think that if it was used metaphorically it would be much
more interesting than to use it for any practical reason.

Though it is commonly assumed that some media might have metaphor-
ic meaning and others might be just practical, the assumption does not
stand up to scrutiny. Technique and meaning are inseparable, and there
is no medium that does not have symbolic connotation. The canvas that
oil painters use is soaked with historical associations. It recalls painting's
aristocratic past, it alludes to its full European heritage, it refers to the
museum world, and more recently to minimalist notions about support
and surface. Every medium is prone to metaphor. Every artist knows how
engrossing—"seductive" is the word they used in this particular critique—
technical problems can be, and that is because no technique is without
meaning. I think the idea that some techniques are merely techniques, and
others have meaning, is connected to the idea that some talk about tech-
nique is a way of not coming to terms with one's self. If you believe that
techniques are separate from meaning, then you can go on experiment-
ing with them and not be impelled to think consistently or directly about
yourself, and the meanings you want or need. Conversation about tech-
nique *is* conversation about meaning: it is just a special way of talking
about meaning that does not allow the speaker to acknowledge as much.

The problem is how to address talk that is obsessed with technique. If
panelists talk insistently about technical matters, it might mean they are
being lazy. But it might also mean that they have decided—consciously
or not—to avoid thinking about symbols or other expressive meanings.
Perhaps they want to avoid those issues for personal reasons, and they
have become accustomed to thinking "through media" rather than
through ideas. Or they may want to avoid bringing up questions of mean-
ing if they don't think the student has achieved much meaning, or if they
don't like what the student has achieved. They may interrupt a conver-
sation about meaning to talk about technique, and they may interrupt
themselves to talk about technique. In each case, the question is why. I
think the difficult thing about critiques that seem to be overly technical
is trying to listen between the lines, to hear what people are saying about
meaning, or what they are trying not to say about meaning.

9. SOME TEACHERS ARE JUDICATIVE, AND OTHERS DESCRIPTIVE

Judicative and *descriptive* are terms from ancient rhetoric, and they name
two fundamentally different ways of talking about an object. Judicative
statements pass judgment. They value or devalue the work, or some

**Men's life-drawing class. 1905.
Chicago, School of the Art Insti-
tute. Photo: author.**

This is 1905, the year when so
much of modernism got started
in Paris. Meanwhile, in America
(as in much of the world) art
instruction kept to the ideas of
the French Academy. The École
des Beaux-Arts had only recently
allowed women into life-draw-
ing classes, and the issue of
equality of the sexes—not to
mention the problems of sex-
ism—was not yet on the horizon.
These students would all have
been happy to produce acadé-
mies—academic-style nude stud-
ies—which were preparatory ex-
ercises for large oil paintings.
They wouldn't have even noticed
the oddity of posing a female
model surrounded by male stu-
dents. Notice the pompously
posed instructor with his thick
moustache, and the very earnest
young student at the lower left.

151

element of it, and they can either present themselves as subjective ("I don't like that green") or objective ("That green is no good"). Judicative commentary includes anything that urges, persuades, or cajoles. ("But why use so much green?") It wants to change something about the work. Most advisors will suggest possible avenues to explore, and some will prescribe certain ideas. ("Don't use green, use blue.") Thus judicative commentary can appear subjective, objective, prescriptive, or suggestive, and in various combinations of these modes it accounts for the majority of what is said in art schools. On the other side is descriptive commentary, which does not try to change the artwork itself, but rather to translate it into words. (In chapter 2, I advocated a descriptive approach to mediocre artwork.) As in judicative criticism, some examples present themselves as objective ("That's a very bright green") and others as subjective ("To me that looks like a bright green"). Descriptive statements are also sometimes questions: "Is that a horse?"[32]

As the rhetoricians knew, there is no sure way to separate judicative and descriptive analysis. Saying "I think that green is very bright" (a descriptive statement) is also saying "I think that green is *too* bright"— a judicative statement. In practice, descriptive and judicative comments are always mixed. There is no such thing as a neutral observation or a neutral fact. Even naming something is valuing it. If a panelist asks, "Is that a horse?" the idea of "horse" and of the difficulty of identifying the horse are both planted in people's minds. They become terms in the ensuing exchange. When instructors claim they are "only describing what's there," or they "don't mean anything" by a remark, they are making inadequate excuses for judicative statements that failed to disguise themselves as descriptive statements. And this in turn indicates how often teachers make judgments that are couched as neutral description.

There are two ways to deal with this distinction in conversations about art. When you make a statement, you can frame it so that it is clearly either descriptive or judicative; and when you hear a statement, you can categorize it as primarily descriptive or judicative. The question, "Is that a horse?" can be understood in two ways: either it is meant to gather information, or it means something more like "Is *that* a horse?" In the former case, you can take it as primarily or initially descriptive, and in the latter, as primarily or initially judicative. A "rhetorical question" is an ironic or self-evident judicative statement. If the work is a huge bronze horse, and someone asks, "Is that a *horse?*" they may mean it's too obviously a horse, that it suffers because it is too horsy. Even instructors who are genuinely interested in gathering information or in learning more

about the work have judgments that they hold in abeyance. But that doesn't mean it is best to search for the hidden judgment behind the ostensibly neutral description. The fiction of purely descriptive statements also provides the possibility of more equitable exchanges between students and teachers, where the main purpose is just to learn about the artwork. Whenever mutual learning and discovery are goals, it is best to assume that the primary force of a statement is descriptive rather than judicative.

When I am talking about art, I often mean my own statements to be primarily descriptive or primarily judicative. I might have other ends in mind, and my unconscious intention might be different. But I usually imagine myself either as judging, or else as just looking for information. Sometimes I am aware that my more-or-less disinterested search for the truth does not extend very far, and that I am really just gathering information to enable me to judge more effectively. But I have also been at a number of critiques where I have just been trying to understand what I see. In either case I try to make the distinction clear to the student.

It is rare for teachers to intend to be purely descriptive. Art teachers are supposed to point out possibilities and to encourage change and experimentation. Teaching and critiquing are often equated. In one critique, a student showed some prints of human figures in rigid, hieratic poses against dark backgrounds. The figures were slightly smaller than life size, and the frames pressed close to their heads and feet. The result was an impression of rigidity and crowding. The student received a wide range of judicative criticism: try larger figures, try smaller figures, try fragmenting your figures, try brighter colors, make more drawings, try getting away from figures altogether. The assumption in such cases is often that the student will "be herself" no matter how her technique or subject matter changes. But the qualities of murky closeness and formality—qualities that would be the subjects of a purely descriptive critique—could easily have been lost if she had taken some of the advice. Often enough, judicative criticism is thought to be the only mode of criticism, and it comes to seem as if the instructor's job is to inspire change. Here is an imaginary critique of a well-known artist, where every comment is judicative:

— Well, Rembrandt, these are really wonderful paintings. But you know, I like the backgrounds as much as I like the faces. What would happen if you just left out the faces?
— I'm interested in faces.
— But I think you say a tremendous amount in those backgrounds. In a

way, they <u>express</u> the faces. I think you could do without the faces. Those backgrounds are very, powerful.

— I like faces.

— I think you should try more things. Get away from that gluey paint. Use more turpentine. Use color. I want to see bright colors. And bigger paintings. And smaller paintings. And sculptures. Why don't you do sculptures? You know, it won't hurt to experiment. That's why you're in school.

— Okay.

— You know, in five years you won't be doing this same stuff, nobody works the same after they get out of school. So you might as well change now.

In such a case, descriptive criticism would seem to be more sensible, since—as we know—there is a great deal in Rembrandt's work that is worth learning about. But the assumption is often made that the artist will be the same, or that the work will take care of itself, no matter what strategies are adopted. Judicative criticism can be naïve, since it is aware of what the work is *not*, rather than what it *is*. The imaginary teacher speaking to Rembrandt is not thinking of the virtues and expressive power of Rembrandt's chiaroscuro, his amazing muddy paint, or his investigation of psychological portraiture. Judicative criticism can be an unwitting chronicle of the things that are not seen in a work. Judicative critics are like reluctant explorers who map the boundaries of a country and never explore its interior. Perhaps the boundaries are placed incorrectly, and the student needs to think about expanding or adjusting them. But the territory itself is usually just as interesting.

On the other hand, there are several problems with descriptive criticism that do not often apply to judicative criticism. One of the potentially confusing traits of a descriptive approach is that the speaker might be trying to make theories about other teachers' statements rather than responding to the work. To most teachers, what counts is the work: what they can get from it, how it affects them. (I will call that *primary analysis*.) To someone bent on describing and understanding the critique format, rather than bent on understanding the art, what counts is *anything* that happens in the critique. To some extent this always happens, but when a person fixed on descriptive criticism enters the fray the artwork is only one fact in a larger situation. Instead of analyzing the work, such a person might turn her attention to her own reactions to the work (what I will call a *secondary analysis*), so that she will end up commenting on a whole series of her own previous comments. Sometimes the comments

are directed at what the other speakers say, in an attempt to construct a theory of all responses (*tertiary analysis*). The game of descriptive analysis can get entirely out of hand when it is not reined in by the underlying purpose of helping the student.

Here is an excerpt from such a critique, where speaker A is practicing descriptive criticism. (He was a philosopher, visiting the studio department.) The panel of teachers has just seen a film containing some funny social satire along with some experimental camera technique.

A What seems interesting here is that when the film ended, we all laughed—and it <u>was</u> a very funny film.

This is a secondary analysis: *an account of the panelist's own previous reaction.*

B Thank you, I meant it to be.

A But I think that is absolutely unimportant, it is absolutely not the point of the film. I don't think anyone here would argue with the idea that the film is <u>purely formal,</u> that none of that makes any difference.

This secondary analysis is made possible by the time that has elapsed since the panelist was watching the film. He is now attempting to describe the way his thoughts have changed since the film ended. He cares more for the transition between laughter and sober commentary than for the way the humor was created to begin with.

C What? No . . . to me, this was a comic film, and it had some very funny moments, little epiphanies.

Like the other panelists, this speaker is still trying to understand the film itself, and especially the reasons it made her laugh.

A Surely you don't believe that the narratives make any difference? It's just a vehicle, so he can give his . . . so he can make formal points.
The very idea of an "epiphany" is that it is transitory, it leaves, and it leaves you . . . and it makes you think of other things, your shopping, your errands, what you're going to have for dinner. You resent it, maybe, but that's life.

This is a tertiary analysis: *the speaker is now trying to account for the other speaker's reaction. What he wants is a general theory of the transition from humor to analysis, and as he works on his theory, he moves further from anything that might be helpful to the student.*

The dialogue I quoted in the introduction to this book is of the same type. (The teacher, in that dialogue, was endlessly analyzing his own embarrassment that the student's work was so poor.) As a student, you can recognize runaway descriptive criticism and learn what you can from it. Descriptive criticism may be disruptive; in my experience it is not a source of confusion. The difficulty is in trying to get firmly descriptive observers to provide judgments. To a confirmed descriptive theorist, personal judgments are irrelevant. I have seen students become enraged when such instructors refused to say whether or not they liked a work. "Just tell me if it's good!" one student screamed, and his advisor replied, "Well, that's just not my place."

Usually judicative and descriptive analyses are sources of confusion because panelists who aim to provide one or the other can produce conflicting accounts of the work. In the following example a critique panel has been considering paintings that depict mythological scenes. After a short pause, one teacher asked these questions:

A What year is it?
B What?
A What year?
B You mean now?
A Yes.
B 1990.
A What year is it in your paintings?
B It's the years that my mind inhabits, and that seem most important and relevant to me.
A Because to me, that's the problem with your painting. It's that you are ... the paintings are such a fantasy about the nineteenth century that you scramble into the paintings to get emotionally connected to them.
B Well, I don't think it's quite accurate to say that they are fantasies about the nineteenth century, it's more the Renaissance and Baroque.

This sets the terms for a debate about the possibility of retrieving the past. If this conversation had continued, it could have developed the concepts of "fantasy," "relevance," and how the mind "inhabits" periods. But instead the panelists made those concepts dependent on the metaphor of *space:*

C But if you were to describe the imaginary space of your paintings, how would you do it? I know it sounds sort of corny to ask you this,

because everybody, in talking about the space in paintings, includ-ing yourself, has been using this notion of the nature of the space. And in some ways, that _is_ the question. What _is_ the nature of the space you use?

B Well, it varies from painting to painting, and in some paintings I'm really not particularly interested in space . . . because space didn't seem very important for what I wanted to say, but—

D How can you make a painting without being interested in space?

C But she has a very particular space.

B No—not _very_ interested in space, it's not the _highest_ thing on the hierarchy—

D No, but no matter what you do, you're going to have some kind of space. I mean, you can paint—

B Yes, you are.

D —I mean it's unavoidable.

C That's the reason I'm asking if you imagine the space in your paint-ings. What would be the nature of that space?

B Yes, space is unavoidable, but it's whether, when you look at a painting as a spectator, the space announces its presence. . . .

And at last the critique veers off in another direction:

A Well, before when I talked about the sense of time, I thought it con-nected to the sense of space. That's the reason I brought it up. To me, these paintings have a real _strong_ urge to be incredibly corny.

This dialogue is fundamentally judicative, because the panelists are trying to impress the student that it's futile to paint in the style of a past century. The vehicle for that is the term "space," which means something quite different to the student and to the panelists. To the student, it is partly an irrelevancy, since she also wants to talk about "fantasy" and narrative. To the panelists, it is the key, the way to drive home the con-cept of anachronism. It is typical of judicative exchanges that a single overdetermined concept serves as a fulcrum, tilting the critique one way or another.

Late in the critique this largely _descriptive_ dialogue took place between the artist and an art historian:

E Catherine, as long as I've known your work, it seems that the crux of one of your processes is that when you deal with landscape you are able to be generous with the space. You use the space in a different way: in fact you use panoramic views. But your basic method has always been to be very much a literary painter, in the sense that your figurative elements are very important.

B Yes.

E And once that happens, you lose the space. And a part of that (and I remember we said this one time, in the distant past) is that you come out of the British tradition of literary painting, where the theme and the story is very important, where those things are very relevant.

Yet you also come out of the other British tradition, the landscape tradition, and [they are merged in your work]. . . .

That, again, if you think about Baroque painting, which has always been important to you, that the dialogue in Baroque painting is a dialogue of dualities, which is what you're really trying to bring about here, with the contrasts between the foreground and background. So that's certainly one thing which is a parallel.

The other thing is, that, remember, in the Baroque, the narrative picture, with few exceptions, used the horizontal. That was considered to be the narrative mode.

The art historian's comments also revolve around fictive space, but his intentions were to describe and to provide new meanings and terms that the artist might use. He sees no problem in making "Baroque" paintings in the year 1990, and so his comments about space are not judicative—they are not used to support judgments. The sense of "space" in the earlier passages is confrontational and polemic. This panelist's use of the word "space" is classificatory: to him, every mention of space is an opportunity to expand upon the possibilities of the painting. To the other panelists, the concept of space is an opportunity to demonstrate that the artist paints anachronistically. The historian and the other panelists did not talk together in this critique, and it is difficult to see how they could have done so. The different senses of space are also incommensurate from the artist's viewpoint. Different purposes—descriptive and judicative—may have prevented a higher-level synthesis of opinions.

These are only brief excerpts from a more involved conversation. In the full text, there is a sense of hopelessness as the panelists continue to veer off in different directions. It is conceivable that a secondary analysis—such as the comments I have been interpolating—might have been helpful. At least it would have given everyone the opportunity to think about *why* their conversation was so much at loggerheads.

The polarity between judgment and description can also be imagined in moral terms, and sometimes it makes sense to do so. The intention to describe is good in an ethical sense, because the speaker imagines herself to be undeceptive and neutral. A descriptive statement is aimed at increasing knowledge. By the same token, a judicative statement that

masquerades as a descriptive statement could be said to be "evil," because it sets up the artist for a judgment. Ulterior purposes, rhetorical questions, and dishonest judgments are not uncommon in critiques. It is not judgment in itself that is "evil," whether it is positive or negative, but the underlying intentions. There are many reasons why panelists might have axes to grind in critiques, and since critiques are avowedly on the side of good, destructive impulses have to be hidden. Descriptive statements make an effective cover. Critiques are *agathokakological*— that is, they mix good with evil, deception with sincerity, the destructive with the constructive. A critique can even become an *agon* (a battle) between good and evil, and at times it is not at all unhelpful to think of it that way.

10. THE STUDENT'S PRESENCE CAN BE CONFUSING

An artwork implies a creator. As viewers we construct—often without trying, or being aware of what we are doing—entire personalities for artists based on what we see of their works. It's not that we try to picture how the artist works or what kind of a person she is when she's at home: it's that our response to a work involves a fiction—a viewer needs to have an idea of the artist's intention. Otherwise the work will not make sense. Art without *some* sense of the artist's intention will seem random, irresponsible, or unaccountable. Some aestheticians say that an artwork without a notion of the maker's intention cannot even appear as an artwork—it will look like a random configuration of marks. Whatever idea we have of the artist's personality and thoughts is a fiction, but it is not to be dismissed simply because we have invented it. On the contrary: our habits of understanding create that fiction, and it is an essential part of our response because it enables interpretation.

What I mean to emphasize here is that a version of the artist is *already* present in every teacher's mind when she looks at an artwork, even if she hasn't seen the student who made the work. The situation is complicated when the teachers on a critique panel *see* the artist, because it is a natural human reaction to form an idea of the person you see even before that person has spoken. The panelists have a sense of the student as a person, and even a vague notion of what kind of work the student might make; and then they have to square that notion with the sense of the artist that they get from the artwork itself. There are two implied personalities that have to be correlated: the one implied by the work, and the one projected by the student herself. (It is simpler, by comparison, to look at art in a museum, because then you have only one kind of intention to think

about, the one apparently embodied in the work. The artist isn't usually around to confound your assumptions.)

All this is automatic, of course, and it doesn't often become a matter for conscious reflection. A few years ago I was in a critique with a very quiet, neatly dressed student, and I thought I had a kind of idea about the work he did. I had seen some of his pictures based on paint-by-numbers kits, but they didn't prepare me for the work he showed, which was Polaroids of toilets in the men's rooms of gay bars. He hadn't even taken those pictures himself—he had loaned his camera to men who were on their way into the washroom, telling them to photograph whatever they chose. When there is a strong disparity between the student himself and the kind of person implied by the work, it can be hard to get a good critique started. Unconsciously, we all require at least a minimal sense of a single, coherent personality—an "agency," in philosophic terms—behind the work.

So it's enough of a problem when the student doesn't seem to *look* or behave like the person who could have made the artwork. In addition students usually *speak* in critiques. The moment the student says a few words the critique is decisively changed. The panelists then have *three* versions of the artist to contend with: the reconstructed intention implied by the works, persona implied by the artist's appearance, and explanatory narratives that the artist offers. When the critique gets underway the situation is compounded by the teachers' growing awareness of the versions of the artist that have been constructed by other panelists. Whatever the student says has to be judged in relation to the work and the setting—it cannot be taken as neutral information, the way we listen to the news or read a phone book. Does the artist mean to say that her work is about what she says it is? Does she even really believe herself, or is she saying it for the panel? Is her insouciance real or pretended? Why does she stand in that corner? All these things influence the teachers' understanding of the work, and normally teachers do not have time to think about *how* their understanding is influenced. A shy artist, for example, might make panelists gentle and earnest in their reading of the work, or it might make them think the work itself is antisocial or mute. An artist who speaks about family relationships will make panelists think of their own family relationships, and might prompt them to bring in themes and images from family life. I had a student a few years ago who painted lovely landscapes, interiors, and vases of flowers. One of his paintings was a lesbian couple making love. It was obviously lifted from a pornographic magazine. The student insisted it wasn't pornographic, but just a lovely composition with two blondes. When he said that, my whole idea about

him fell apart: I realized I had to rethink my idea of him—as a person—and also my interpretations of his other paintings.

For a teacher it can be hard enough to achieve a coherent sense of the student and the work. When the student speaks, adding her own stories to the mix, it can become nearly impossible. The usual advice students get about critiques is that they should talk as much as they can, to try to control the situation and explain their work. I am arguing the opposite. Talking adds information that confuses an already difficult situation. A critique where the student is silent is more likely to be honest. Once a student begins to speak, the teacher or teachers are in a relationship, and both sides are hampered by politeness. A critique can easily be ruined by the panelists' inability to say something rude, and the dynamic of critiques is frequently determined by the effort it takes to find other things to say. When the panelists are "alone" with the work, they tend to be more free-wheeling and outspoken.

This isn't a hard and fast rule, and critiques can be much more interesting when the student speaks. In addition to what's actually said, there are all the subliminal accompaniments of speaking—the offhand gestures, the sighs and nods, the student's pose and attitude. They all enrich the critique—after all, they're nonverbal elements of communication, just like the visual art that is under consideration. Still, the purpose of a critique is to address the work, and everything else is ultimately a distraction.

In some situations it is definitely a good idea for the student to speak, in order to keep the critique on track, steering it toward important topics and away from wild interpretations. That's the standard line about critiques: control them, and they will go better. But I often wonder if the student has a legitimate claim to know which issues are most important in the work. History would seem to indicate that artists have been consistently misguided about what they do, and even if the student happens to know what is most interesting about her work, it does not follow that other readings are irrelevant. I think the strongest argument in favor of the student's speaking is also the least rational: a critique that is effectively guided by the student can be exhilarating, inspiring the student to do more work. Such a critique can promote the kind of self-confidence that is often helpful in making interesting works. Of course I've been arguing that inspiration and enthusiasm aren't learning, and I am not at all sure that what seems like a well-controlled critique really *is* controlled. A critique that seems to have been effectively led by the student is usually just a critique where real interpretation has been shut down: the student ends up hearing what she had hoped she'd hear.

So if you're a student, you might consider not talking in your next critique; or if you do talk, you might consider the fact that what you say may not succeed in producing better criticism, and that *anything* you say will make the teachers' jobs harder. Every once in a while it even makes sense for the student to be absent altogether. A critique without the student can be thought of as a rehearsal for the everyday situation in galleries and museums, in which critics and historians aren't distracted by the artist's presence. If you want to get a sense of how your work will play in public, when you're not around to defend it, you might consider staying away from your own critique—or just standing in the back without speaking. In "real life" after art school, artists can sometimes stand in the back while people talk about their work: it happens at gallery openings. But it isn't common, and if you want to anticipate the way that art critics might discuss your work, then consider keeping out of sight or at least remaining silent. On the other hand, if you're interested in making the most of the very unusual situation offered by critiques, then by all means speak as much as possible—just don't expect that your speaking will control anything, produce better criticism, make things clearer for your teachers, or help you to make more interesting work.

11. ARTWORKS ARE USUALLY UNORIGINAL

In chapter 2 I considered the issue of mediocre art—the art that is actually made in art classes, as opposed to the masterpieces that teachers continuously hold up for comparison. I also touched on the question of provincial art, and the fact that many art schools and smaller art departments look to the major centers to see what's new. Both of these issues bear on critiques whenever the work is derivative or seems "behind the times."

The time lag between students' works and the avant-garde is much less today than it has been in the past, but it still exists, and the lag is a fact of schools and academies and will always be with us. But to say that students' works are closer than they have been to what is being made in New York or Berlin ignores the fact that the majority of art students are not out to follow the latest trends. The bulk of art students practice older styles of artmaking. As I write this, in 2000, those styles include various kinds of naïve realism, neo-expressionism, late Romantic landscape painting, various returns to the Baroque and Rococo, collage forms derived from Rauschenberg or from dada, fantasy art derived from fin-de-siècle Symbolism, types of abstract expressionism, "post-minimalism," late 1970s-style conceptual art, and late-surrealist figural abstractions. In the early

Demonstration outside the Armory Show. April 1913. Chicago. Archives of the Art Institute of Chicago, folder 9010FF1. Used with permission.

In 1913 the famous Armory Show, including Duchamp's <u>Nude De-scending a Staircase</u> and Matisse's <u>Blue Nude,</u> came to Chicago from New York. The students in the School of the Art Institute, who were being trained in the very conservative manner of the French Academy, staged a protest. They made a straw effigy of Matisse, which they called "Hen-

Avenue in front of the Art Institute. The effigy is presumably the black silhouetted form on the right. Notice the student with the rifle; perhaps it had a bayonet to stab the effigy. The school's French-trained director, William French, had made plans to be away at the time. One year later he had died, and the school was on its way—very slowly—into the twentieth century.

1920s the styles included nineteenth-century-style academic studies, history painting, imitations of Toulouse-Lautrec and illustrational art, and work in the style of Picasso's "blue period." In the 1850s, academy students produced works in the eighteenth-century academic style of David and his followers. There have been time lags between students' works and avant-garde works ever since there were academies.

The reason that such works pose problems in critiques is that the instructors are likely to feel that they have seen them before. As an art student I never suspected that an instructor might be less than interested in what I was making, but as a teacher I am familiar with the feeling of walking into a studio and seeing something that reminds me of an endless series of similar works by other artists. I find I can usually become interested in the peculiarities of the work at hand, but it is not possible to entirely forget that initial judgment. When this happens in critiques the result can be disastrous. The story I recounted in the introduction to this book is one such example, and it is not uncommon for teachers to castigate students for being mediocre or unoriginal. Less extreme versions of this problem are endemic in critiques, simply because it is rare for a panel to encounter something that seems entirely new. (And by the inexorable law of the avant-garde, when teachers *do* encounter something genuinely new, they won't recognize it and they'll usually dislike it.)

Students and teachers alike remark on the low energy level of some critique panels, and students often complain about the silence of some teachers. Both phenomena are related to this issue: if the panelist sees something that she thinks she's seen a thousand times, she loses interest. She's been through it so many times before—the speech on the problems of continuing to paint neo-expressionism, or the speech on the limitations of conceptual work. To take an extreme example: if a panelist sees work that looks very old-fashioned she may want to say something like, "Why do you work this way at all? Don't you know that international abstraction died out after the Second World War? Don't you care that hundreds, maybe thousands of artists have done this exact same kind of work before you?"—but only the rudest instructors are likely to say such things. If the panelist is not given to rudeness, she may just fall silent. So silence results from boredom or annoyance, but either way, it usually means the teacher does not think the work is original. (It may also be that the work appears confusing, but in my experience confused panelists usually talk *more* than unconfused panelists.) The student then faces a double challenge: to admit the possibility that her work might provoke such a reaction, and to find a way to jump-start the silent teacher. A responsible

teacher can think along the same lines: Is there a way to talk about this work that can rekindle my interest?

One of the few effective strategies here is to change the terms of the disapproval. If a panelist is thinking, "This is just kitsch," the word "kitsch" may be functioning as a log jam, stopping the flow of thought. "Sexism," "commercialism," and "decoration" are other words that can work this way. They are like the legend "THE END" that used to conclude movies: words like "kitsch" and "decoration" and "unoriginality" give the teacher permission to stop looking. Critique panels can get stuck on those words like a record needle stuck in a groove. The difference between a critique that is making headway and one that is not is not the animation of the panelists, but the conceptual distance that has been traveled. When a word like "kitsch" is ruling the discussion (even when it is implicit, because no one wants to say it), the conversation will not build and progress but hammer on the same point again and again. What is needed is a way around the word, a way to associate the work with some other, more flexible term.

It can help to break the word apart into its component concepts. For "kitsch" you can substitute "lightness," "immediacy," "camp," or "aesthetic distance," or you can quote Clement Greenberg, or Hermann Broch's useful distinction between "sweet" and "sour" kitsch.[33] If you're a student, you might ask something like this: "Let's leave 'kitsch' aside for a moment. I think it's too general a term, and I'd like to talk about a certain *quality* of kitsch that applies here: its 'lightweight' nature, the idea that a work has to be 'heavy' to be interesting."

A critique stuck in the doldrums of boredom can be revived by introducing specific terms. That helps, even if it won't fix the fundamental problem, which is the teacher's sense that she's seen it all before. There is no easy solution, and it is good to keep in mind that this kind of dissatisfaction might be a hidden subtext throughout a critique. The underlying fact is that if your teacher liked your work without reservation, she would try to make it herself. There is always *some* disapproval—that's only natural. The challenge is to keep enough interest going, and enough honesty, so you can figure out why your teacher isn't talking.

−/−/−/−

Those are my eleven reasons why critiques are confusing. Critiques are amazing institutions. Each one of the eleven reasons makes me more interested in critiques. How boring tests are by comparison. I have taken, and graded, enough tests to know that they measure very limited

properties. An IQ test, an Iowa Test, a GRE, and SAT, a Leaving Cert in Ireland, an A-level or an O-level in England, or any multiple-choice test in an American college is a dreary affair. It tells me next to nothing about myself, if I'm taking it—and if I'm administering it, tells me nearly nothing about the student. It is only a set of little puzzles, like a wheel for a hamster or a maze for a mouse. Tests have the virtue of ensuring that everyone in the class is on the same page. They promote the accumulation of systematic knowledge. At higher levels, as in medical or law boards, they ensure that people who make important decisions are competent in their fields. But what does any of that have to do with living an interesting life, or being an interesting person?

Critiques are an entirely different matter. They are unbelievably difficult to understand and rich with possibilities. All kinds of meanings, all forms of understandings, can be at issue. Critiques can be like real-life situations: they can mimic seductions, trials, poems, and wars. They can hold nearly the full range of human responses—and that is only appropriate, because artworks themselves express the widest spectrum of human response. But the price critiques pay for that richness is very high. Critiques are perilously close to total nonsense. They just barely make sense—they are nearly totally irrational. In the final chapter I will make a few proposals about running critiques, and I will return to the central theme of this book: the incoherence of art instruction, and the reasons why I think it can never make sense to say you learn or teach art.

t is every author's duty to balance negative criticism with positive proposals. In this chapter I am going to suggest some ways to rethink critiques, to make them more effective and clear. I am not saying that these ideas should replace current practice. As I argued at the close of chapter 3, I'm interested in observing what happens in art classes, not in replacing one curriculum with another. The ideas I will describe in this chapter are tailored to allow students and teachers to understand what happens in critiques. They are topical medicines or clinics for specific problems, rather than plausible substitutes for critiques in general.

TINKERING WITH CRITIQUES

Most of this chapter will be occupied with an idea I will call the *chain of questions*. But before I start, I want to propose a few whimsical ideas. I don't mean these to be too serious, although I think there are places where they might be just what is needed.

Suggestions ----- 5

First, here are a few suggestions for things to do with critiques, from the student's point of view:

— Take an artwork done by someone else, and place it among your own. See what kind of stories the critique panelists come up with in order to explain how that work is one of your own.

— Have a friend stand next to you in a critique. Don't tell the panelists which of you is the artist—tell them that at the end of the critique, you'd like them to guess.

— Have someone play your part at the critique, and listen in the background without identifying yourself. Note how the teachers react differently to the actor. If you're a man, ask a woman to play your part; if you're white, ask a Latino or an African American.

— Present someone else's work. Choose someone whom you don't know. Do your best to represent that person's work as your own.

— Present work that you dislike (old work, for example) as if it
was your newest. See if you can convince the panel that you
think it's good work.

— Present the chronology of your works in reverse order. See if
you can convince yourself, and your teachers, that you're
going forward with your work.

— Borrow your opening speech from someone else. Present
that person's concerns to your teachers, as though his or her
interests were your own interests.

Some of these suggestions might need a little help from the faculty,
especially if you're in a small department and most people know you or
your work. I don't think it's a particularly good idea to make fun of the
faculty (that would tend to break down conversation, which I am assum-
ing is not a good idea). Each of these suggestions can be arranged so that
it is not belligerent. The idea is to learn more about how you and your
work are seen, by changing something about yourself or your art. If these
strategies work, they will tell you something about how to control view-
ers' responses—always an important thing to know if you're serious about
becoming an artist.

Second, here are some ideas from the point of view of the faculty:

— Try saying the opposite of what you think: anytime you have
an opinion, instead of saying it, formulate its opposite.

— Try speaking as if you loved Andrew Wyeth, or Norman
Rockwell, or some artist you don't like. Don't name the art-
ist (that might make it too simple to argue against you),
but try to make a convincing case for the artist's sensibility.

— Try speaking as if you were Pollock, or Picasso, or some art-
ist you know well. Don't necessarily pretend you <u>are</u> the art-
ist, just try borrowing the artist's language.

These ideas, too, are tools for understanding other people's responses,
and they can also help illuminate your own habits of thinking. You'll learn
something about your own habits and judgments by taking on someone
else's. (And of course you can always tell the student afterward.)

It is also possible to think of alternate critique formats. In this book I
have been thinking mostly of standard M.F.A.- and B.F.A.-style critiques,
in which one or more teachers (the "panel") talk to one artist. Sometimes
the room is filled with other students, and sometimes it's private. There

WHY ART CANNOT BE TAUGHT

are also larger class discussions in which each student takes a turn saying something about her work—but those are not really full critiques. Here are some suggestions for new kinds of critiques, which could work in undergraduate or graduate settings:

- A critique in which the panelists are allowed only to ask questions about the work and are not allowed to pass judgments or tell stories.
- A critique in which the panelists cannot see the work until the student has discussed it for ten minutes.
- A critique in which the panelists must look at the work for ten minutes without speaking.
- A nonverbal critique, in which panelists have an hour to create a work of their own, in response to what they see. (At the School of the Art Institute, we once had a painting teacher who never spoke: she just took the brushes from the students' hands and painted over their paintings.)
- A critique in which panelists are not allowed to see the work until the student decides they are ready for it.

Any of these could throw light on the usual critique format. If you try them, you'll want to make sure that you can control the situation enough to assure that it uncovers new meaning, rather than just demonstrating some obvious truth—for example, that it's frustrating to keep quiet for ten minutes. You might also use these suggestions as topics for conversation—they can be mentioned during critiques, rather than implemented. (As a student, you might ask, "Would you have rather stayed quiet for a few minutes, to give you a chance to think about the work?")

All these suggestions—for students, for teachers, for alternative critique formats—are ways of increasing control. It is also possible to deliberately relinquish control. The teacher, or the head of the critique panel, can tell everyone to say whatever comes into their minds. People can tell anecdotes, or say whatever the work reminds them of, as long as they say something. I call this kind of critique *free association*. At its purest, with no discernible leadership and no questions in response to what other people say, a free-association critique is indistinguishable from an informal conversation. Some students resist it, thinking that it is not teaching, or that it is not a proper way to respond to art, but others speak highly about it, saying that it leads to all kinds of unexpected insights. It may seem that this would be a particularly bad idea, since it eschews all con-

trol and makes rational analysis impossible. But it mimics the way we naturally think about art, mingling private associations with irrelevant thoughts and sudden inspiration. Certainly a great deal of contemporary art criticism is essentially free association, in that it isn't tied to a single line of inquiry. Because it is so fiendishly difficult to control a critique—and so hard to know what control *is*—it sometimes makes sense to tell everyone *not* to make sense, not to follow a line of argument or pursue a given subject, but to speak freely about anything and everything.

THE CHAIN OF QUESTIONS

Most conversations about art alternate between dull and creative, repetitious and insightful, superficial and deep. Occasionally someone will say something out of the blue that's really interesting, and everyone will fall quiet for a moment thinking about it. This is the art of conversation. It's pleasureful to vary the speed and difficulty of the conversation, and if they aren't sufficiently varied, it gets dull. The free-association critique (or conversation) acknowledges the natural human tendency to want to wander. From Montaigne onward, undirected thinking has had a special place in the arts. It makes sense because it is what we usually do, and it is often what art provokes.

Things are different in academia, where everyone is dedicated to straight, hard thinking. Inspiration counts, but so does the insight born of a protracted inquiry directed at a single topic. This is—to reprise a term from the first chapter—the ancient art of dialectic: you ask, you think about the reply, you ask again, you rephrase the question, you go on, pushing and inquiring, without changing the subject. Essentially, the difference between this kind of questioning and a typical art critique is that dialectic questioning explores a series of questions on one topic, rather than a list of questions on different topics. (This is also closer to the original meaning of "critique," as Kant used it.) Though it is artificial and sometimes difficult to manage, a dialectic inquiry is an optimal way to make sense of the world.

Later I will propose a kind of critique that is entirely based on dialectical questioning. First, however, I want to suggest how dialectical inquiries can function in normal critique settings. In particular, a concerted attack on a single issue can redress a problem that is endemic to critiques: teachers say things just once and then drop the subject before anyone has a chance to follow up on what they've said. Instructors try to provide as many insights as they can during a critique, and that means that many of them will not be developed. There is a serious drawback

to statements that are just "thrown out there": the student does not always know *why* the statements were made in the first place. "You might want to try more blue," or "That seems a little odd," are typical statements in critiques: they are judgments with no explanations. Almost any statement that occurs in a critique has this characteristic: it does not include its rationale.

Sometimes a teacher will know her reason for saying something and will be able to produce it if the student asks. "You might want to try more blue because the green is a bit overwhelming." But notice—and this is the crucial point—that even this is not a complete explanation. It remains to be said why blue is better, and why any one color should *not* be overwhelming. There is an important difference here between the *reasons for statements*, which are the explanations that the teacher comes up with when she is asked, and the *unexamined assumptions* or *dogmas*, which are deeper explanations that the teacher has never thought about. In this example the *reason* is that green is overwhelming, and the *unexamined assumption* behind the reason might be something like this: "Single colors should not be allowed to dominate."

As a student, you can get at your teacher's reasons and unexamined assumptions by asking what I'll call a *chain of questions.* It seems to me that our natural habit of making judgments without giving reasons, and without searching for the underlying assumptions, is the single most important source of confusion in critiques. After a lifetime's experience with art a teacher has an arsenal of ideas about what makes art good in general and what makes certain kinds of art good. Most teachers are largely unaware of these ideas: they know a few of them, but the vast majority go unnoticed. So when a teacher says something about a student's work, chances are very good that the student will not understand quite why the teacher said what she did, and that the teacher herself will be unaware of the assumptions that led her to make the judgment.

The typical things people say about art do not just pop into their heads, but are suggested by unconscious assumptions about what constitutes good art. (In Freudian terms, these assumptions are not unconscious, but *preconscious;* that is, they're not instinctual drives, but things of which we are temporarily unaware.) The reasons for statements are usually easy to explain, but the assumptions may be hard to get at. It is helpful to look at the relation between judgments, reasons, and unexamined assumptions a little more closely.

Judgments are what normally occur in a critique. After a few questions, a panelist may say,

— I think that this film has too much playfulness about it, it's goofy.

Let's say the student or another instructor questions the judgment, in order to elicit a *reason*. There are many ways to bring out reasons, but the best is just to behave like a two year old and ask "why":

— Why is that bad?
— Well, because it starts out seriously, but then it ends up careless.

Often this is where things end, both because the critique moves on to another topic, and because the speaker may not be aware of any further explanation. The judgment that has been made is this:

The film is too playful.

1. JUDGMENT

It is possible to generalize a little and to restate the reason for this judgment as follows:

Films like this should not start out serious and end up playful.

2. REASON

Note that the reason is not the end of the line. There is an *unexamined assumption* behind it, something that drove the speaker to believe that films like this should not turn playful. To evoke it, the student might ask another "why" question:

— Why is it bad that the work begins seriously and ends silly?

As a rule, assumptions are usually unexamined—that is, the speaker has never thought about them—and so this kind of question can be difficult to answer. The response might be a disguised elaboration of the first answer. The teacher might say:

— I think the work promises to take itself seriously and then ends up flippant.

That does not explain why it's undesirable to have the work turn silly, and so it is necessary to rephrase the question and ask again. In this case another teacher might ask the question, instead of the student:

— So does that mean you mistrust the artist?

And let us assume the answer is simply:

— Yes, I suppose so.

Then you might guess that an unexamined assumption behind the reason might be:

A film like this should not be devious.

3. UNEXAMINED ASSUMPTION

Like many unexamined assumptions, this one is ambiguous. The assumption might also be:

— **Any film** should not be devious.
— **Any work of art** should not be devious.
— **This one film** should not be devious <u>in this way.</u>
— **Any work of art** should not be devious <u>in this way.</u>

Or perhaps openness is really the issue, and the assumption should be something like:

— A work of art should not hide its intentions.

Or:

— A work of art should not lie.

Or it may be a more personal issue:

— A work of art is bad if it succeeds in tricking me.

These alternatives could be explored after the critique. At this point, however, there is enough information to conclude that the speaker dislikes being tricked, and that consistency, seriousness, play, trust, and intentionality are all concepts that need further exploration.

The principal difficulty in going further is that evoking deeper, unexamined assumptions is like pulling teeth. Even when the teacher doesn't resist the "why" questions—after all, they can seem rather rude—she may not answer in a helpful way. Let's say that the student, or the other teach-

173

ers, continues to press the issue, and a teacher finally offers this explanation:

— I like things that are flip, I just don't like the way it's done here.

In that case, the exchange might continue this way:

— What seems wrong about the way it's done here?
— It's done without thinking, too quickly.
— Do you think that work which changes from serious to unserious should do it seriously, or carefully?

Notice that it's getting more difficult to frame the questions. Say the answer is yes. Then the instructor believes something like this: "Work should change moods from serious to underserious in a serious or careful manner." This is another unexamined assumption. And what lies behind *it?* Again we have a number of choices:

— Seriousness takes precedence over silliness, and seriousness should control both what is serious and what is not serious.
— Seriousness is fundamental, and playfulness is dependent on it.
— You need to be very careful where silliness is concerned.

The deeper unexamined assumption may be any of these, or several others. Say the assumption was "Seriousness is fundamental, and playfulness is dependent on it." (This is, incidentally, a very common assumption.) Does anything lie behind *it?* Maybe; it could be something like this:

— Seriousness is part of sanity, and silliness can be destructive of sanity. And so the deepest of the unexamined assumptions would be:

Sanity is an ultimate good.

4. FINAL ASSUMPTION OR AXIOM

This final assumption could better be called an *axiom,* since like the axioms of mathematics it cannot appeal to a higher authority for justification. (You can't argue sanity is good, because you can't argue from the opposing point of view of insanity.) Philosophers also call statements like this dogmas, unexamined terms, givens, and postulates. Here I define "axiom" as a statement that stands without justification, not because the speaker is unwilling to think further but because she *cannot* think fur-

ther. Axioms are usually less interesting than reasons or unexamined assumptions because they are things known to everyone. They are sometimes *endoxa*, universal trivial truths, akin to "Don't go out in public without clothes." Typically they are applicable outside of art—they are principles that apply to art and to life. For these reasons, axioms are usually not as much help as unexamined assumptions.

Though I find the four-step sequence of judgment-reason-assumption-axiom is widely useful, the process does not always involve four steps. In particular, assumptions and axioms can be effectively the same. Any of the "ultimate terms" of criticism that I listed in chapter 4, such as "interesting" or "powerful," could also be put as assumptions or axioms. When people say work is interesting, powerful, moving, authentic, inventive, compelling, gorgeous, or stimulating, the assumption is that interesting work is good, or moving work is good, and so forth. These might be axioms, because people would be hard-pressed to say *why* a good artwork is compelling, or *why* it's good to be moved.

It also happens that the judgment and the axiom can be one and the same. Many things about the chain of questions can be questioned. But it's helpful to begin with it in mind, since it provides a very helpful reference for discussion. Here are the four links, then, with their salient points:

Judgment	A statement made in the course of a critique
Reason	The justification given when someone asks for it
Assumption	The unexamined or uncognized principle behind the reason and the judgment
Axiom	The endoxa, the general truth that supports the assumption. Often axioms have little to do with art

THE FOUR-STEP CHAIN OF QUESTIONS

Thinking about the chain of questions clarifies a couple of things. First, the chain can be followed to a final link. There is no circularity or infinite regression. Instead, almost everything that is said in art critiques ultimately depends on unexamined assumptions and axioms. I like to think of this as a stream: the individual judgments are like little rivulets, and they con-

verge into streams, which finally converge into rivers, and empty into the very large and common oceans of axioms. The chain of questions also shows that the number of assumptions and axioms in art teaching, like the number of large rivers, is not infinite. People in the art world sometimes assume that visual art has an infinite number of meanings, but in practice it turns out that our thinking runs in a relatively small number of channels. Art discourse is more limited and conventional than we might wish.

Unexamined assumptions and axioms can be collected the way one might collect stamps. There are a large number of them, but I suspect that in any given art department or "interpretive community" there are really not that many. Here are some that were listed by one of my students, Kirsten Lindberg Benson; they dominated the discussion in two painting critiques, without every being mentioned or questioned directly:

Paintings should be primarily concerned with space.

A painting should have unity.

It is helpful to use other painters as sources.

History is archaeology (and therefore not useful).

One can never be sure when a painting is finished.

Disruptive qualities are good in a painting.

Sensuous paintings are good.

Spontaneity is good.

Old styles of art need new zest to keep them going.

UNEXAMINED ASSUMPTIONS IN PAINTING

One of the interesting things about pursuing the chain of questions is that the assumptions are often real surprises. An artist who thinks of herself as postmodern might also make judgments that depend on some very old-fashioned assumptions. This particular list has some entries that seem dated, like "Sensuous paintings are good." It is the nature of axioms and assumptions to catch us unaware (they are, after all, "unexamined"), and it stands to reason that the general operative principles of our intellectual lives should be older, more dated, than the neologisms we have picked up from the latest art magazine.

I have taught a number of classes on critiques, in which students practice finding assumptions and axioms. In one class a student said he thought one of his assumptions was "It is good to put effort into artworks." But that can't be the final term in a chain of questions, because it is not apparent *why* effort should be good. I suggested that effort might be moral, and he said perhaps that was it. But then his axiom would be

something like "Good art is moral"—an unsettling thing for a postmodern artist to say. Another common assumption is that good art can hold our attention for more than a few moments. But if that is pressed, it sometimes turns out that the underlying axiom is that we should be entertained, and then the axiom might be something like "Art relieves boredom." Again, the axiom is unexpected, and it throws light on the teacher's habit of asking students to make works that hold the viewer's attention.

In practice, it is not usually a good idea to press teachers for assumptions and axioms. People make judgments, and they are usually aware of their reasons, but they often don't know much about the assumptions that are behind the reasons. As Nietzsche said, Socrates was one of the most annoying people who ever lived, because his ultimate purpose seemed to be demonstrating that everyone, including himself, really knows nothing. Talking about the chain of questions can be annoying in the same way because it reveals how little of our reasoning we really understand. Luckily there are ways of studying assumptions and axioms without being too frustrating or insulting.

TRANSCRIBING CRITIQUES

My first suggestion is to study critiques after they have happened: tape them, transcribe them, and then study them at leisure. That is how I generated the various excerpts of critiques in this book. Taping is very helpful, but it has to be done carefully. Most important, you have to preserve anonymity: instructors are not apt to talk naturally if they know that everything they say is going to be scrutinized afterward. In my experience the best solution is to have the student tape the critique, and then change everyone's names when the transcripts are made. The students in the seminar who read the transcript should not know who the speakers were; they should never hear the tape, and all the names should be expunged from the transcript. (If someone says "he said," that can be replaced in the transcript by "[speaker X] said.") When the artist is present in the seminar, he or she should be cautioned not to give any clues about the identities of the other people in the transcription. The best transcripts, therefore, are those that are several years old, so that the artist and most of the panelists are not known to the students. (Most of the critiques I have excerpted in this book were made between 1990 and 1995. They're still just as valuable as when they were made, and the identities of the speakers are now nearly impossible to guess.) Anonymity doesn't hinder analysis, and it helps assure everyone in the department or the school that the instructors are not being critiqued behind their backs.

It may seem that the loss of the nuances of speech would impair the usefulness of the transcripts, but it turns out that virtually everything having to do with content can be retained without knowing about gestures, body language, and untranscribable mumbles and hrumphs. I think it is best to use italics and quotation marks for emphasis, to transcribe words such as "sort of," "um," and "kind of," and to put in ellipses when speakers hesitate; but in general I have found that the nonverbal parts of speech have less meaning than I had thought. (This is an interesting disproof of the common notion that spoken nuance and body language are all-important.)

Sometimes it is difficult to make sentences out of what the speakers say. Panelists in critiques are usually trying to express the most difficult thoughts that come to their minds, and it can be truly surprising to find how seldom they speak in complete sentences. It is my experience that people speak in complete sentences only when they have very little to say. A paragraph's worth of information virtually never comes out as a string of grammatically correct sentences. Yet we are oblivious to syntactical transgressions in everyday speech, and we automatically edit what we hear into subjects, verbs, and predicates. In this respect, the project of transcribing can be an illuminating lesson in the difference between the spoken and written word. What should be done, for example, with the following speech?

> K You could also be printing on plexiglass or any other support that is not that doesn't have one of the main connotations that I can think of about glass is fragility or breakability.
>
> So I mean how do you justify its use maybe given your ideas given that aspect of that particular material because it's not a handheld object and you don't you know you don't impose any of these qualities about the material on the viewer I mean then I would question the use of that as a support.

This is not at all unusual—in fact, I chose it almost at random. The question is how much is read into the passage when it is punctuated. If I edit it in the way given below, am I imposing a sense that was not intended?

> K You could also be printing on plexiglass or any other support that is not, that doesn't have one of the main connotations that I can think of about glass is fragility or breakability.
>
> So I mean, how do you justify its use? Maybe given your ideas, given that aspect of that particular material because it's not a

hand-held object and you don't, you know, you don't impose any of
these qualities about the material on the viewer. I mean, then I
would question the use of that as a support.

I have found that the best strategy is to transcribe the critique, and then
give both the transcript and the tape to the student and to whichever
faculty members are willing to participate, so they can check it. In gen-
eral this issue, like the problem of transcribing grunts and body language,
is significantly less important than it might seem. Most punctuations will
not radically affect the sense.

There are other practical difficulties. When a panelist says, "I like that
one there," the transcript needs to have a bracketed interpolation iden-
tifying the work, and it needs to be keyed to a slide of the work. For that
purpose it is essential that the student review the transcript and identify
which works the panelists were discussing. All in all, transcribing takes
time. The tape machine has to be good quality, since a low-quality mi-
crophone will miss a great deal of dialogue. It takes me an average of five
or six hours to type out a forty-five-minute critique: not because I type
slowly, but because the transcription requires numerous decisions about
punctuation. Slides have to be taken of the artworks, preferably soon after
the critique before they are dispersed or altered. Then the transcription
has to be given to the artist to be checked. The slides have to be labeled
to correspond with the way they're referred to in the critique.

All that takes work, but then the transcript can be studied in a class-
room setting. Members of the class can read the parts as if the transcript
was a radio play, with someone showing the slides at the same time. In
doing this it needs to be made clear that the purpose is not to continue
the critique by adding more judgments to those the panelists have made.
There needs to be a vigilant separation between the judicative statements
in the critique and the descriptive statements in the analysis. A good way
of putting this is that the function of analyzing transcriptions is to un-
derstand the critique, not the artwork.

It can be tempting to disparage or make fun of panelists who are, after
all, thinking on their feet. Most things that most of us say sound stupid
when they are analyzed too carefully. So although it is sometimes useful
to say that a given panelist had no particular idea in mind, or that a giv-
en statement was particularly obvious, unproductive, or confused, it is
essential not to assume that any member of the class would do better.

The main advantage of going to all this trouble is that it slows down
the critique. If a seminar class reads a critique like a play, it is possible

to pause after every speech and analyze it according to any of the topics I introduced in the previous chapter, or according to the chain of questions. In general, the panelists' unexamined assumptions become much more apparent than they were in real time, and so their judgments will be easier to understand.

When a critique is confrontational or disjointed, reading it slowly can show how one person might be trying to build bridges to another person, or evading the possibility of responding directly, or inadvertently obstructing the dialogue. Sometimes reading transcriptions makes everyone in the class into a critique doctor, with proposals for how the critique could have been salvaged or improved, or what people should have said at any moment.

In my classes we read critiques very slowly: we get through a half-hour critique, which is about eighteen typed pages, in a three-hour class. It might seem that at that pace it would be possible to make a great deal of sense out of the dialogue, and sometimes it is. But often it doesn't help much, and it seems that *no matter how slowly* we read, the critique remains incomprehensible. Sometimes there is no way to understand a person's train of thought, and no way to see why people respond to each other in certain ways. Why does speaker X say this to speaker Y at this moment? Why doesn't speaker Z listen? Often there is no answer to that kind of question.

Studying transcribed critiques is fascinating, but it is not a panacea: it takes a great deal of effort and preparation, and sometimes the only moral that can be drawn is that the critique was somehow doomed from the beginning, or that it will never make sense, no matter how carefully it is studied. At the same time, transcription is the best tool I know for examining how art is taught.

THE EXPLORATION OF MEANING , exp. assumptions

Here is another idea. It is possible to organize a special kind of critique that is ideally suited to dialectical questioning. In this kind of critique, which I call the *exploration of meaning*, people are allowed to speak only about meanings: it's the opposite of the disorganized free-association critique. Exploring meanings is intensive and exhausting, and it needs to be done in a carefully supervised forum. In the example excerpted below, a class of twenty-five people looked at a single work for three hours, trying to name and understand every single meaning that occurred to them. No discussion of anything except meaning was permitted, and to simplify things the artist did not talk. (In other sessions, the artists con-

tributed their own analyses, talking about the meanings they saw and their own intentions, but it is simpler to begin with a session where the artist doesn't speak.) No one in the class was allowed to suppose that the work was not finished, or to bring up questions of display or the marketplace. No one was allowed to advise the artist; the discussion was purely descriptive. There was no talk about technique unless it bore directly on meaning.

When a critique like this is announced, there are generally two reactions: either people say it will be impossible to talk about a single work for three hours, or else they think that three hours is nowhere near long enough, because meanings are infinite and one could go on forever. What actually happens is that three hours is just about enough to satisfy everyone in a class that they have explored every meaning that they could think of or that is worth exploring. That result is unexpected, and it is sometimes exhilarating: for the first time, students feel that they really understand a piece of art. Needless to say, that feeling is an illusion, but the discovery that meanings are not infinite is real. As I suggested in regard to the chain of questions, viewers normally think along very conventional lines, and it is possible to find most or all of those lines in three hours. Students and teachers can then see what appears to be, for that particular class, as the sum total of a work's meanings.

I have found that the best way to organize one of these explorations of meaning is to divide the class into three stages. First is a half hour or an hour in which students are encouraged to say any meaning that comes to mind. This avoids the imposition or appearance of inappropriate rigidity. The instructor and several volunteers write down everything that is said. At the end of the half hour there is a break, and in the second stage the instructor and some of the more involved students get together and try to classify the various things that have been said. A provisional outline or list of topics is then used to direct the inquiries in the third stage, which again involves the entire class. Sometimes stages two and three need to be repeated. Ideally, the critique should not end until everyone has said everything they can think of—and it is especially important not to end when people become exasperated, exhausted, or bored.

Though this is a very artificial way of talking about artworks, I find it is a productive opposite to the habitual ways of responding to art, which are unorganized, undirected, and can operate at a relatively low energy. The shortcomings of this method are a lack of pleasure in the process and a certain narrowness (because advice, formal analysis, biography, anecdote, and friendly small-talk are excluded). Its payoff is a sense, rare in

art history or art criticism, of having at last *understood* everything about one's reactions to a work, from the first few seconds of confused impressions to the wall of boredom that is reached after an hour or so.

In this example, the class saw three large, quasi-abstract monoprints that formed a triptych. The *first stage* is when everyone is encouraged to list whatever meanings come to mind.

A Okay, let's get started. I think that we should start the way we always do, with some free association. Anyone have any comments on what you see, positive or negative?

B Well, I see those two round forms in the one on the right as two suns.

A Okay, let's just take this one on the right first, and go through it looking for symbols. Afterward we can do the other two, and then after that I'll ask for other kinds of comments. But as long as we've started, let's keep going on this one, in this way.

"In this way" means, for example, that if someone says that it's misguided to look for symbolism their comment will be deferred until the class has exhausted its search for symbols.

E Well, I think that purple form is a pair of calipers.

A Does anyone agree with that, or with the observation about the suns?

It is always important to see what consensus the reading has, to distinguish perverse or idiosyncratic comments from those closer to the "interpretive community's" position.

The next twenty minutes were spent adding symbolic meanings. At the end I opened the floor to any kind of reaction other than symbolic meanings.

C I don't know, I just think these pictures are a little boring.

The idea of boredom is tricky: it is partly induced by the critique format, and partly inherent in the work.

A Uh-huh. Let me just say paren-
thetically that that's an entirely
different kind of reaction, and
maybe we might want to think
whether or not it belongs—how
it belongs—with that list we
have just been making.

So anyway, I'd like to know if
you just thought that recently,
or from the very beginning.

C Yes, at the beginning, but much
less. This is maybe just too
much time to spend on one
print.

*The question is intended to distinguish
the student's idea from the boredom
that was beginning to settle on the
class.*

F Yes, I see some of the symbols,
but I really don't . . . I really
wouldn't see them unless we
had been looking for them.

*This comment also has to do with how
long the prints can hold a viewer's at-
tention.*

A So now I think we have another
"theme," to go along with our
dictionary of symbols, and that
is how long the work holds at-
tention. Any comments on that?

We went on another twenty minutes exploring the themes of boredom,
the importance of symbols, the existence of forms that were not symbol-
ic, the possibility that the prints were not meant to be "read" at all. Dur-
ing the *second stage*, the topics have to be arranged in the best way pos-
sible. In this case we began with an unorganized list of topics, including
"landscape symbols," "kinds of abstraction," "issues of unity and dis-
unity," "color problems," "boredom," and several others. Some were
placed under larger headings. "Boredom," for instance, went under "psy-
chological responses," which also included "fascination," "exasperation,"
and "mistrust." The outline was about three pages long.

The *third stage*, when the class reconvened, began with the question
of boredom that had come up in the first stage. (I read the list of mean-
ings that had been arranged during the break.) In general the purpose
of the third stage is no longer the collection of meanings but the analysis
of unexamined assumptions.

183

A Why did you say this was boring?

C At first it seemed like a kind of mysterious landscape or a cityscape, and I liked that. It seemed as if it could have been abstract or figurative.

This is then the reason behind the judgment; actually it is two reasons together. The first might be: "I like mystery, and without it I am bored," and the second "I like ambiguity, and without it I am bored."

A So do you think that mystery is good in a work, or a good thing here?

Making sure that the first reason really was a love of mystery.

C Yes, well, it's good <u>here,</u> or it would have been . . .

This is the reason behind the initial judgment, but it still requires explanation.

A So why is it a <u>negative</u> thing to stop being mysterious? You don't mean that any work that is not mysterious is less interesting? Can't a work be straightforward and also successful?

It is not clear why mystery and ambiguity are positive values, or why boredom is not.

C No, no, it's that I get the impression that the panels are supposed to be mysterious—

A —that they're intended to look mysterious—

C Yes, and so, when I see that it is not mysterious, the work, quote, "fails."

This may mean that he thinks that the artist's intention has to be carried through in order for a work to be successful.

D I think sort of the opposite here. I like the piece very much, and I think what I like is that it is <u>not</u> ambiguous after all, after a while. It is . . . it says, "I am abstract," and that's good.

(This student had been speaking in favor of straightforward work earlier in the critique.)

C Well, not for me.

A Yes, that's interesting.

Let me just stop for a second and sum up the assumptions in these statements (and you can argue with me about them in a moment): that boredom is bad, that mystery and ambiguity are good,—or, as [speaker D] said, bad—, that it is important, or necessary, that the artist should

These three unexamined assumptions should probably remain unexamined for a while, since they are difficult to think about. In a few minutes they can be brought up again.

follow through on their inten-
tion (and if they mean some-
thing to be mysterious, it should
be). I'm not so sure about that
last one. Why can't it just make
the work more interesting when
it "fails" in that way?—but let's
leave that for a second. I want
to go back to something [speak-
er T] said . . .

The critique continued until we had talked about everything on the out-
line and about several new topics that had come up en route. Twice dur-
ing the discussion I read the outline aloud so it could be questioned, and
the idea of an outline also became a topic. (In particular, students won-
dered if the work was inimical to any outline.)

Typically students end in a state of perplexity. They run aground on
the assumptions that they are surprised to learn they hold, and they are
concerned to discover they cannot understand thoughts that are clearly
their own. "Why," a student might ask, "do I dislike ambiguity?" Con-
fusion is sometimes a goal of art instruction. In general it does not seem
to me that provoking confusion is a good teaching strategy, but unan-
swerable questions are not the purpose of this kind of analysis—instead
they are a byproduct. The fundamental insight is that inquiries into
meaning can be directed and finite. The question, "Why do I dislike
ambiguity?" might resonate without answer for some time: but it is a clear
question, important and illuminating.

COMPARING CRITIQUES

One last idea. In addition to transcribing critiques and holding special-
purpose critiques, it is also helpful to compare critiques in different fields.
Even within the visual arts, sculpture critiques are generally different from
painting critiques, and there are differences between critiques in differ-
ent media. Outside the visual arts the differences only become greater—
and, I would argue, even more informative. I have mentioned the unemo-
tional nature of architecture critiques. The expressive function of the
architecture can be entirely bypassed in favor of abstract, historical, or
technical considerations such as the relation to the site, the program, the
restrictions on building, and the theoretical platform and methodology.
In this respect architecture critiques come closest to critiques in non-art
fields. The oral examination for the Ph.D. degree is an apposite parallel,

185

since the candidate is not likely to be asked about the expressive force or stylistic function of her dissertation, or about her own emotional reasons for investing so much of her life in her chosen topic. The dissertation advisors ask about the content of the dissertation and about its veracity, and they may engage the candidate in heated and even aggressive discussion of its merits. But I do not know any instances in which the committee spoke about the dissertation as an expressive document—as something that expresses the personality of the student. From the point of view I'm taking in this book, that omission is curious, and it illuminates how different art instruction is. I find the exclusion of psychological inquiry in these cases equally unsatisfactory, though it is deeply ingrained in architecture critiques and in Ph.D. examinations. It only seems stranger in architecture because we continue to think of architecture as one of the fine arts, and hence as an expressive activity.

Another kind of critique that is largely unknown to people in the visual arts is the music critique, and especially the "master class," which represents the closest parallel to what happens in the visual arts. In master classes the students, faculty, and a visiting "master" listen while a student performs a piece in part or in whole, and then the master critiques the performance. Often enough the critiques also involve some performance, since the master might take up the baton, sing, or play an instrument to give her own version of what the student had done. That kind of criticism-by-doing is widespread in music and rare in the visual arts. In an ordinary class in the visual arts a teacher might take up a brush to change a portion of a painting, but that does not happen in critiques. Another difference between master classes and art critiques is the relative unimportance of verbal criticism in music. Teachers and conductors sometimes hum or beat out the passages they are critiquing instead of playing them properly. That kind of criticism cannot be reproduced in print. A master class instructor may say something like this:

> — I like the part where you go "dum, dum, dum, <u>dee,</u> dum, da, dum dum," but I would put more <u>bite</u> into that last beat, like "dum, dum, dum, <u>dee,</u> dum, daaah, dum <u>dum!</u>"

The disadvantage of untranslatability is compensated by the extreme *specificity* of the critique. It pertains to a single passage, and it seeks to emend a particular way of understanding that passage. The equivalent level of specificity in painting would be a description of a square inch of canvas:

— I like the way the yellow goes up here [squinting at a tiny patch of canvas], and this kind of sloppy mixing with the green, and the little scrap of thinness there, and the bit of gloss from the medium . . .

But visual arts critiques rarely get that specific, because past a certain level of detail, nothing can be effectively put into words. (It would be interesting to try critiques in which instructors made their own versions of students' works, since that is the analogue to the maestro humming or playing his own version of what the student had just played.)

Music critiques are occasionally open, and with the consent of the faculty anyone can observe. Master classes are the easiest to attend, and some are advertised in department fliers. Ph.D. oral examinations are ordinarily closed, but under special circumstances they can be attended, with the permission of everyone involved. Short of that, it is always possible to attend critiques within the visual arts but outside of your accustomed medium—and it is always possible to visit a neighboring college or university and attend their critiques. (Just call the chairperson in advance; I have never encountered any problems.)

The principal thing to be gained by comparing critique formats is a sense of the conventions of your own department, school, or medium. What may appear to be unproblematic or inevitable ways of dealing with artworks can begin to seem like restrictive rituals; and then you're free to ask whether or not other rituals might not be better.

S ense is something that has to be made. It does not exist naturally, and it is especially hard to find in art teaching. At several places in this book I have said that I do not think that we can make too much progress in understanding what is done in art classes, no matter how much we try. I called that attitude both skeptical and pessimistic, and I drew three provisional conclusions. Here they are, as I set them out in chapter 3:

1. The idea of teaching art is irreparably irrational. We do not teach because we do not know when or how we teach.
2. The project of teaching art is confused because we behave as if we were doing something more than teaching technique.
3. It does not make sense to propose programmatic changes in the ways art is taught.

The first of those conclusions is the one that answers the title of the book. The second points to the principal reason why art instruction is irredeem-

Conclusions

ably irrational. The idea of the third is that if a practice is so far from rational, then it doesn't make too much sense to plan major revisions in the practice: that would be like letting a child operate on a patient. (It could work, but the child's simple ideas probably won't correspond with the patient's complicated anatomy.)

There are still grounds for optimism, I said, because we can always try to learn more about what we do, and we can always hope that what we learn might be of some benefit. Even if most of what happens in art classes is irrational, it still makes sense to think about them. But there is another way of looking at that. One can also ask if it is a good idea to keep trying to make rational sense out of art teaching. The unexamined assumption—or perhaps, the axiom—behind the three numbered claims is that the pursuit of rational knowledge is a good thing. But can we ever know whether it makes sense to try to make sense? That question, though it sounds silly, may be the most disruptive question that can be asked in this context. The more I understand about what happens in art classes, the more I want to understand; but I also know that what I understand does not provide evidence that understanding improves teaching or learn-

ing, or even that it makes them more interesting. Indeed, there is some evidence that it makes teaching *less* interesting.

For example, say you're a student, and you go into your next critique listening for descriptive and prescriptive commentary. You will probably pick up on some teachers who make descriptive comments, and you will be able to distinguish them from judicative comments. Your critique may well appear in a new light: it may seem to be split down the middle, going in two directions at once. There is a measure of clarity in that observation. But is it better than the confusion that existed originally?

In most subjects clarity and sense are ultimate goals, and it is not sensible to criticize them. To "get clear" or "achieve clarity" about a troublesome issue is to understand it thoroughly, to grasp it, to know it perfectly. The principles of physics are best when they are clear (even if they are about uncertainty or probability), and the principles of car mechanics are best when they make sense, so that theoretical mechanics applies to everyday repair problems. But is the same true of art classes? Teaching in an art department or an art school is the most interesting activity that I know, because it is the furthest from anything that makes sense—short of psychosis. Even though I have written this entire book on the assumption that it is a good idea to try for some measure of clarity, I am not sure that is ultimately such a good idea. There is no way to know if it is a good idea to understand something that works by not being understood. This could be put as a formal claim, the last one in my list:

4. It does not make sense to try to understand how art is taught.

−/−/−/−

There is a cave chamber in Sarawak so large that it could hold five football fields—the largest single subterranean chamber in the world. When it was first discovered, the spelunkers had no idea what to expect. They were walking up an underground stream when the walls diverged and left them staring into darkness. The room is so large that their headlamps could not pick out the ceiling or the walls, and they spent the next sixteen hours working their way around the room, keeping close to the right-hand wall, intending to keep going until they got back to the entrance. At times they were fooled by "house-size" boulders that they mistook for walls of the chamber, only to find that they were giant boulders fallen from the ceiling. At one point one of the cavers panicked, but eventually they all got out. Pictures taken on later surveying expeditions show the spelunkers' lights like little fireflies against a measureless darkness.

I think of this book in the same way. Like the people on that first exploration, we are not about to figure out very much of what takes place in art classes. There is still a good probability that we will get badly lost thinking about art instruction—and I think parts of this book do get lost. Perhaps that's the best way for things to be. The cave will certainly be less interesting when it has electric lights and ramps for tourists. Isn't the cave best as it is—nearly inaccessible, unlit, dangerous, and utterly seductive?

Perhaps some of the things I have written in this book will shed some light on what happens in art classes—but even now, having finished the book, it is not apparent to me how my rational analyses bear on the irrationalities of art teaching. In addition I am fairly certain that the ideas in this book do not make what we do more interesting, except in the negative, limited sense that they show how intricate it is. My evidence for that is this book itself, which I think is ultimately less interesting than an actual critique. In the end, if it were possible to produce a full account of how art is taught it might be a boring, irrelevant, pernicious document, something that should be locked away.

1. There are two prinicipal English-language histories of art academies, but they are for specialized audiences. Nikolaus Pevsner, *Academies of Art Past and Present* (New York, 1960 [1940]), is for art historians (Pevsner leaves quotations in French, Italian, Latin, Greek, and German untranslated), and Arthur Efland, *A History of Art Education: Intellectual and Social Currents in Teaching the Visual Arts* (New York, 1990) contains a history aimed at art educators.

2. The "earliest known theoretical treatise on painting" is by Agatharchus (c. 450 B.C.). J. J. Pollitt, *The Ancient View of Greek Art: Criticism, History, and Terminology* (New Haven, Conn., 1974), 14 and 256–57.

3. The earliest Greek treatise written by a sculptor about sculpture may have been Polyclitus's *Canon* (c. 450–425 B.C.).

4. Aristotle, *Politics* 1337b. For an English translation see *The Basic Works of Aristotle*, ed. Richard McKeon (New York, 1941), 1306–8; and for further information, Eva Keuls, *Plato and Greek Painting* (Leiden, 1978), 144.

5. Keuls, *Plato and Greek Painting*, 145–46.

6. See Henri Irénée Marrou, *Histoire de l'education dans l'antiquité*, translated as *A History of Education in Antiquity*, trans. George Lamb (New York, 1956).

Notes

7. Charles Homer Haskins, *The Rise of Universities* (Ithaca, N.Y., 1957 [1923]), 2. Haskins's account is mostly anecdotal but has a good introductory bibliography. The standard work is still Hastings Rashdall, *The Universities of Europe in the Middle Ages*, ed. F. M. Powicke and A. B. Emden, 3 vols. (Oxford, 1936 [1895]).

8. This was codified by the Roman writer Martianus Capella. See Paul Otto Kristeller, "The Modern System of the Arts: A Study in the History of Aesthetics," parts 1 and 2, *Journal of the History of Ideas* 12 (1951): 496–527 (the reference to Capella is on page 505);13 (1952): 17–46. Kristeller also refers to Capella in his *Renaissance Thought II: Papers on Humanism and the Arts* (New York, 1965), 163–227.

9. A typical thirteenth-century curriculum would have required Aristotle's work on logic, the *Organon*, which was divided into two collections of essays, called the *Prior Analytics* and *Posterior Analytics*. See Philoleus Böhner, *Medieval Logic: An Outline of Its Development from 1250 to c. 1400* (Manchester, Eng., 1952).

10. Books were very expensive since they had to be copied and checked by hand, but many of the classics were available in monastery libraries; the tendencies I am noting here weren't due to economic restraints.

11. Haskins, *The Rise of Universities*, 67, gives a number of entertaining anecdotes about such books and the informers (called "wolves") who reported students who spoke their native language.

12. To get an idea of the kind of text that would have been studied, look at Justinian I (483?–565), *Institutiones*, a standard Roman law text. A recent translation is *Justinian's Institutes*, ed. Peter Birks and Grant McLeod (Ithaca, N.Y., 1987).

13. It is not irrelevant that the medieval schemes that associate an art with each of the nine muses omit the visual arts and associate poetry and music with the sciences. See August Friedrich von Pauly, *Paulys Realencyclopädie der classischen Altertumswissenschaft*, 70 vols. (Stuttgart, 1894–1972), especially vol. 16 (Stuttgart, 1935), 680 and 725, cited in Kristeller, "Modern System of the Arts," 506 n. 68.

14. See Emile Levasseur, *Histoire des classes ouvrières en France depuis le conquête de Jules César jusqu'à la révolution*, 2 vols. (Paris, 1959), especially vol. 1, 204, cited in Albert Boime, *The Academy and French Painting in the Nineteenth Century* (New Haven, Conn., 1986 [1971]), 2.

15. Kristeller, "Modern System of the Arts," 507. (At the time, armorers were skilled in engraving and in the construction of house-sized machines, so Hugo's classification isn't entirely arbitrary.)

16. For Renaissance academies see Charles Dempsey, "The Carracci Academy," *Leids Kunsthistorisch Jaarboek V–VI (1986–87)* ('s-Gravenhage, The Netherlands, 1989), 33–43; K. E. Barzman, "The Florentine Accademia del Disegno: Liberal Education and the Renaissance Artist," ibid., 14–32; and Zygmunt Wazbinski, *L'Accademia Medicea del disegno nel Cinquecento: idea e istituzione* (Florence, 1987).

17. The best-known academies of language began somewhat later than the earliest academies of art. The Florentine Accademia della Crusca was founded in 1582 and brought out its dictionary in 1612. The Académie Française, founded in 1635, published its dictionary in 1694 (but did not complete its grammar until 1932).

18. Pevsner, *Academies of Art*, 4–5 n. 1, lists seven meanings of "academy" current around 1500, including "semi-secret astrological societies," others devoted to Platonic philosophy, and still others to Ciceronian skepticism and "genuine (not scholastic) Aristotelian philosophy." Inscriptions found in catacombs in 1475 were left by academicians in secret meetings.

19. Pevsner, *Academies of Art*, 1.

20. This was first discussed by Frances Yates, *The French Academies of the Sixteenth Century* (New York, 1988 [1947]), and then by Carl Goldstein, "The Platonic Beginnings of the Academy of Painting and Sculpture in Paris," *Leids Kunsthistorisch Jaarboek V–VI (1986–87)* ('s-Gravenhage, The Netherlands, 1989), 186–87. Goldstein's views are collected in his *Teaching Art: Academies and Schools from Vasari to Albers* (Cambridge, 1996).

21. See Trissino, *Epistola* [and other works], edited by R. C. Alston (Menston, Yorkshire, Eng., 1970).

22. Pevsner, *Academies of Art*, 8.

23. One sign of diversity is the proliferation of science academies. Among the most famous is the Accademia dei Lincei, founded in Rome in 1603, whose members included Galileo. Others are the Royal Society of London, founded in 1645,

and the Accademia Scientiarum, founded in 1700 on the insistence of Leibniz. See Martha Ornstein Bronfenbrenner, *The Role of Scientific Societies in the Seventeenth Century* (Hamden, Conn., 1963 [1928; the Hamden edition is from the third edition, 1938]).

24. This figure is from M. Joannis Jarkii, *Specimen historiae academiarum eruditarum Italiae*(Leipzig, 1729), quoted in Pevsner, *Academies of Art*, 7.

25. See C. E. Roman, "Academic Ideals of Art Education," in *Children of Mercury: The Education of Artists in the Sixteenth and Seventeenth Centuries*, exh. cat. (Providence, 1984), 81. Roman's essay is a commentary on the early pictures of ideal academies.

26. Pevsner, *Academies of Art*, 7, 11, 12–13. Pevsner also cites Wilhelm Pinder, *Das Problem der Generation in der kunstgeschichte Europas* (Berlin, 1926), 55.

27. The academy is still operating, under the name Academy of the Fine Arts, although its curriculum has no resemblance to its Renaissance original.

28. Charles Dempsey, "Some Observations on the Education of Artists in Florence and Bologna during the Later Sixteenth Century," *Art Bulletin* 62 (1980): 552. See also Zygmunt Wazbinski, "La prima mostra dell'Accademia del Disegno a Firenze," *Prospettiva* 14 (1978): 47–57, and Wazbinski, *L'Accademia medicea del disegno*.

29. See Elizabeth Cropper, "On Beautiful Women, Parmigianino, *Petrarchismo*, and the Vernacular Style," *Art Bulletin* 58 (1976): 374–94; Marco Rosci, "Manierismo e accademismo nel pensiero critico del Cinquecento," *Acme* 9 (1956): 57–81.

30. It is possible to use the drawings assembled in Bernhard Degenhart and Annegrit Schmitt, *Corpus der italienischen Zeichnungen, 1300–1500* (Berlin, 1968–82), as a general indication of what went on in fifteenth-century Italian workshops.

31. Barzman, "The Florentine Accademia del Disegno," 19. Barzman reports that the mathematics program at the Academy of Design was so successful that professional mathematicians were brought in to teach it, and later the mathematics chair at the University of Florence was transferred to the academy.

32. The fundamental text here—though it is not easy reading—is Erwin Panofsky, *Idea: A Concept in Art Theory* (New York, 1968 [1924]).

33. Among the primary sources see Ignazio Danti, *Trattato delle perfette proporzioni* (Florence, 1567), a treatise on proportions which was to be the first of fourteen books on design (*disegno*). Michelangelo had plans to write an anatomy text that would have stressed movement.

34. Among many sources here, see Rudolph Siegel, *Galen on Psychology, Psychopathology, and Function and Diseases of the Nervous System: An Analysis of His Doctrines, Observations, and Experiments* (Basel, 1973), and Galen, *Galen on the Passions and Errors of the Soul*, trans. P. W. Harkings (Columbus, Ohio, 1963).

35. For examples of poses once thought to express mental states, see my *Pictures of the Body: Pain and Metamorphosis* (Stanford, 1999), chapter 2.

36. Barzman, "The Florentine Accademia del Disegno," 24.

37. For art historical examples of drapery studies, see Eva Kuryluk, "Metaphysics of Cloth: Leonardo's Draperies at the Louvre," *Arts* 64, no. 9 (1990): 80, and her *Veronica and Her Cloth: Sources, Structure, and Symbolism of a "True" Image* (Cambridge, Mass., 1991).

38. The best translation of Vitruvius's treatise is Vitruvius Pollio, *Vitruvius: Ten Books of Architecture*, trans. Ingrid Rowland (New York, 1999). The list is given in I.i.3, but it is augmented by things Vitruvius mentions throughout I.i.

39. The Accademia degl'Incamminati, as it was called, was founded in 1582 and lasted until it encountered financial troubles in the second decade of the next century. See Dempsey, "The Carracci Academy," 33 and 35, and Dempsey, *Annibale Carracci and the Beginnings of the Baroque Style*, Villa I Tatti Monographs 3 (Glückstadt, 1979). A summary of earlier work on the Carracci is available in Pevsner, *Academies of Art*, 75. Among the primary sources are Giovanni Battista Armenini, *De veri Precetti della Pittura . . . Libri tre* (Ravenna, 1587), translated as *On the True Precepts of the Art of Painting* (New York, 1977), trans. Edward Olszewski (Armenini provided part of the theoretical basis on which the Carracci formed their Academy); Carlo Cesare Malvasia, *Felsina pittrice* (Bologna, 1841); and Giovanni Pietro Bellori, *The Lives of Annibale and Agostino Carracci*, trans. Catherine Enggass (University Park, Pa., 1968).

40. The best recent assessment is Dempsey, "Some Observations." See also Dempsey, *Annibale Carracci*; Denis Mahon, *Studies in Seicento Art and Theory* (Westport, Conn., 1975 [1947]); Mahon, "Eclecticism and the Carracci: Further Reflections on the Validity of a Label," *Journal of the Warburg and Courtauld Institutes* 16 (1953): 303–41; Mahon, "Art Theory and Practice in the Early Seicento: Some Clarifications," *Art Bulletin* 35 (1953): 226–32; Carlo Ragghianti, "I Carracci e la critica d'arte nell'età barocca," *La Critica* 31 (1933): 63; and M. J. Levine, "The Carracci: A Family Academy," in *The Academy*, Art News Annual, vol. 33, ed. Thomas Hess (New York, 1967), 19–28.

41. See, for example, Lionello Venturi, *The History of Art Criticism* (New York, 1964 [1936]), 116, for the claim that the Carracci's interests "could not be an artistic programme."

42. See, for example, in Karel van Mander's biographies (the *Schilder-boeck*, published in Haarlem in 1602–4 and reprinted in Utrecht in 1969). See also H. Meidema, "Over Vakonderwijs aan Kunstschilders in de Nederlanden tot de zeventiende Eeuw," in *Leids Kunsthistorisch Jaarboek V–VI (1986–87)* ('s-Gravenhage, The Netherlands, 1989), 268–82, with English summary; and E. van de Wetering, *Studies in the Workshop Practice of the Early Rembrandt* (Amsterdam, 1986). The term "studio-academies" is from Pevsner, *Academies of Art*, 73.

43. On Baroque academies see: Jonathan Brown, "Academies of Art in Seventeenth-Century Spain," *Leids Kunsthistorisch Jaarboek V–VI (1986–87)* ('s-Gravenhage, The Netherlands, 1989), 177–85; J. H. Rubin, "Academic Life-Drawing in Eighteenth-Century France," *Eighteenth-Century French Life Drawing*, exh. cat. (Princeton, 1977); W. Busch, "Die Akademie zwischen autonomer Zeichnung und Handwerkdesign. Zur Auffassung der Linie und der Zeichen im 18. Jahrhundert," in *Ideal und Wirklichkeit der bildenden Kunst im späten 18. Jahrhundert*, ed. Herbert Beck, Peter Bol, and Eva Maeck-Gérard (Berlin, 1984), 177–92; Gottfried Bammes, *Das Zeichnerische Aktstudium. Seine Entwicklung in Werkstatt, Praxis und Theorie* (Leipzig, 1973).

44. On the Royal Academy in London, see Sidney Hutchinson, *The History of the Royal Academy, 1768–1968* (London, 1968); Hutchinson, "The Royal Acade-

my of Arts in London: Its History and Activities," *Leids Kunsthistorisch Jaarboek V–VI (1986–87)* ('s-Gravenhage, The Netherlands, 1989), 451–63.

45. See the list of academies in Pevsner, *Academies of Art*, 140. Most academies lack thorough histories; an exception is John Turpin, *A School of Art in Dublin since the Eighteenth Century: A History of the National College of Art and Design* (Dublin, 1995).

46. Chu-Tsing Li, *Trends in Modern Chinese Painting* (Ascona, Switzerland, 1979), 5–7.

47. The text is Baldassare Castiglione's *The Courtier*, which was influential in the sixteenth century. See Kristeller, "Modern System of the Arts," 507.

48. These are sixteenth-century English opinions, noted by I. Bignamini, "The 'Academy of Art' in Britain before the Foundation of the Royal Academy in 1768," *Leids Kunsthistorisch Jaarboek V–VI (1986–87)* ('s-Gravenhage, The Netherlands, 1989), 434.

49. See, for example, Michel de Montaigne, "On Pedantry" (1572–78) and "Of the Institution and Education of Children: To the Lady Diana of Foix, Countess of Gurson" (1579–80), in *The Complete Works of Montaigne*, ed. D. M. Frame (Stanford, 1967 [1948]), 97–104; Rabelais, *The Most Horrific Life of the Great Gargantua*, trans. S. Putnam (New York, 1964 [1946]), 124–32; and Jan Amos Comenius [Komensky], *The Great Didactic*, trans. M. W. Keatinge (New York, 1967). Further references are listed in R. J. Saunders, "Selections from Historical Writings on Art Education," in *Concepts in Art and Education: An Anthology of Current Issues*, ed. George Pappas (London, 1968), 4.

50. Ludovic Vitet, *L'Académie royale de peinture et de sculpture: étude historique* (Paris, 1861); Goldstein, "The Platonic Beginnings of the Academy," 186–202; Pevsner, *Academies of Art*, 82.

51. The first two are called drawing from *modèles de dessin* and drawing *à la bosse* (from casts).

52. M. Missirini, *Memorie per servire alla storia della Romana Accademia di S. Luca* (Rome, 1823), 32, and Leonardo, *Treatise on Painting (Codex Urbinas Latinus 1270)*, ed. A. Philip McMahon (Princeton, 1956), vol. 1, 45 and 65, cited in L. O. Tonelli, "Academic Practice in the Sixteenth and Seventeenth Centuries," *Children of Mercury: The Education of Artists in the Sixteenth and Seventeenth Centuries*, exh. cat. (Providence, 1984), 97. Leonardo is also the first to have advocated a sequence of drawing: first from other drawings, then from reliefs, and finally from live models. See *The Notebooks of Leonardo da Vinci*, trans. Edward MacCurdy (New York, 1958), 899.

53. Pevsner, *Academies of Art*, 174.

54. See M. Baker, *The Cast Courts* (London, 1982), and Francis Haskell and Nicholas Penny, *Taste and the Antique: The Lure of Classical Sculpture, 1500–1900* (New Haven, Conn., 1981).

55. In 1990, it was in a side room and missing an arm. See Pauline Saliga, "Plaster Casts, Painted Rooms, and Architectural Fragments: A Century of Representing Architecture at the Art Institute of Chicago," in *Fragments of Chicago's Past*, ed. Saliga (Chicago, 1990), 52–67.

56. For the case of Michelangelo, see my "Michelangelo and the Human Form: His Knowledge and Use of Anatomy," *Art History* 7 (1984): 176–86.

57. Benvenuto Cellini, *Sopra i principii e 'l modo d'imparare l'arte del disegno*, in *Opere di Benvenuto Cellini*, ed. Giuseppe Guido Ferrero (Turin, 1971), 829 ff. For Vasari see the excerpts from the *Vite* published as *Vasari on Technique*, trans. Luisa Maclehose (New York, 1960), 206 ff. For secondary sources, Tonelli, "Academic Practice in the Sixteenth and Seventeenth Centuries," 97; Roman, "Academic Ideals in Art Education," 84; and Anthony Blunt, *Artistic Theory in Italy, 1450–1600* (Oxford, 1970), 96.

58. Gropius's instructional plan for the Bauhaus includes the injunction to draw heads, models, animals, landscapes, plants, and still lifes from "fantasy." See his "Programm des Staatlichen Bauhaus in Weimar," reprinted, for example, in H. W. Wingler, *Das Bauhaus* (Bramsche, Ger.: Rasch, n.d. [c. 1962–69]), 41.

59. Saul Baizerman, "The Journal, May 10, 1952," edited by Carl Goldstein, *Tracks* 1 (1975): 17, quoted in Goldstein, "Drawing in the Academy," *Art International* 21 (1977): 42–47.

60. These terms are translations of more exact French and Italian words. "First thoughts" renders *première pensée* (Italian *primo pensiero*), and sometimes *croquis* or *mise en trait*. There followed various kinds of drawings, *dessins* (Italian *disegni*), also called *esquisses* (Italian *schizzi*), and *pochades; études* (Italian *studi*) were anatomic and other detailed studies, leading to the *ébauche* (Italian *abozza*), the finished mockup or monochrome underpainting. See Boime, *The Academy and French Painting*, 26, 80–82, 150–53; Charles de Tolnay, *History and Technique of Old Master Drawing* (New York, 1972 [1943]); and David Karel, "The Teaching of Drawing in the French Royal Academy," Ph.D. diss., University of Chicago, 1974.

61. Tonelli, "Academic Practice in the Sixteenth and Seventeenth Centuries," 103.

62. The Baroque era was also the time of the first systematic art treatises. The earliest French treatise is Abraham Bosse, *Sentimens sur la distinction des diverses manières de peinture, dessein et graveure* (Paris, 1649); see Goldstein, "The Platonic Beginnings of the Academy," 190. The eighteenth century saw the proliferation of handbooks, manuals, popularized explanations, and textbooks of all sorts. Students, dilettantes, connoisseurs, and the idle rich could learn watercolor, engraving, perspective, color theory, anatomy, and drawing.

63. See Sir Joshua Reynolds, *Discourses on Art*, ed. Robert Wark (New Haven, Conn., 1975). In the literature on the *Discourses* see B. A. C. van Brakel-Saunders, "Reynolds' Theory of Learning Processes," in *Leids Kunsthistorisch Jaarboek V–VI (1986–87)* ('s-Gravenhage, The Netherlands, 1989), 464 ff.; E. H. Gombrich, "Reynolds's Theory and Practice of Imitation," *Burlington Magazine* 80 (1942): 35–40; Charles Mitchell, "Three Phases of Reynolds's Method," *Burlington Magazine* 80 (1942): 35–40; and "Sir Joshua, P.R.A.," in *The Academy, Art News Annual*, vol. 33, ed. Thomas Hess (New York, 1967), 39–46.

64. The most important are: André Félibien, *Entretiens sur les vies et sur les ouvrages des plus excellents peintres anciens et modernes: (Entretiens I et II)*, ed. René Démoris (Paris, 1987 [1666]); Roland Fréart, Sieur de Chambray, *L'Idée de la perfection de la peinture* (Paris, 1662), translated as *An Idea of the Perfection of Painting*, trans. J. E., Esquire [initials only] (London, 1668); Charles-Alphonse

Dufresnoy, *De arte graphica liber,* translated as *The Art of Painting of Charles Alphonse Du Fresnoy,* trans. William Mason, with an introduction by Sir Joshua Reynolds (York, Eng., 1783); Roger de Piles, *Balance des peintures* (Paris, 1708); de Piles, *The Art of Painting* (London, 1706), and later translations; and Giovanni Pietro Bellori, *Vite de'pittori, scultori, et architetti moderni,* 2d ed. (Rome, 1728).

65. Until the mid-seventeenth century, art theorists still used Lomazzo, Armenini, and Zuccari; see Pevsner, *Academies of Art,* 93. The primary sources are: Federico Zuccari, *L'idea de'pittori, scultori ed architetti* (1607), reprinted in Zuccari, *Scritti d'arte,* ed. Detlef Heikamp (Florence, 1961); Giovanni Paolo Lomazzo, *Idea del tempio della pittura* (Hildesheim, 1965 [1590]) (for which there is an old translation, *A Tracte Containing the Artes of Curious Paintinge . . . ,* trans. R. H. [Oxford, 1598]); and Armenini, *On the True Precepts of the Art of Painting.*

66. The best way to understand this mentality is to study examples of such analyses. See in particular Donald Posner, "Charles Le Brun's 'Triumphs of Alexander,'" *Art Bulletin* 61 (1959): 237–48 (discussing *Alexander at the Tent of Darius* [1661] in Versailles); and André Félibien, *Les reines de Perse aux pieds d'Alexandre, peinture du cabinet du roy* (Paris, 1663).

67. The authors of these lists are Roland Fréart, Sieur de Chambray; Roger de Piles; and André Félibien, respectively; de Piles's scores are repeated in Pevsner, *Academies of Art,* 94 n. 2. The beginnings of the hierarchy of genres can be seen in Pliny, who mentions a painter named Piraeicus who was called *rhyparographos,* "painter of low things." See Stephen Bann, *The True Vine: On Visual Representation and the Western Tradition* (Cambridge, 1989), 37, quoting from *Textes Grecs at Latins relatifs à l'histoire de la peinture ancienne,* ed. Adolphe Reinach (Paris, 1985), 390.

68. See Albert Boime, "The Prix de Rome: Images of Authority and Threshold of Official Success," *Art Journal* (1984): 281–89.

69. Pevsner, *Academies of Art,* 168–69.

70. After 1748, winners were also housed in the Louvre for three years before they went to Rome.

71. There is some evidence that increasingly, there was a longer period between the winning of the Rome Prize and election to the academy. At first, artists could become "academicians" in their twenties and thirties. Later, as the bureaucracy grew, the average age of an academician was fifty-three. Harrison White and Cynthia White, *Canvases and Careers: Institutional Change in the French Painting World* (New York, 1965), 17, quoted in Boime, *The Academy and French Painting,* 4.

72. Generally speaking, the imbalance continued until the resolution of the "Querelle des Anciens et des Modernes," which disputed the relative importance of design and color from 1671 to 1699. See Jacqueline Lichtenstein, *La couleur éloquente: rhetorique et peinture à l'age classique* (Paris, 1989).

73. For attempts to connect Baroque academic theory with practice: Gombrich, "Reynolds's Theory and Practice of Imitation"; and Carl Goldstein, "Theory and Practice in the French Academy: Louis Licherie's 'Abigail and David,'" *Burlington Magazine* 111 (1969): 346–51.

74. There are some schools that carry on these traditions. Until very recently,

Shanghai University taught an essentially Baroque curriculum, mixed with principles taken from nineteenth-century Russian models. After c. 1980, some elements of the Bauhaus curriculum were added. As of c. 1987, Baroque-style classes were still in effect. In the United States there is Atelier Lack (in Minneapolis), which offers a rigorous Baroque-style curriculum without the social realist flavor of Shanghai.

75. The best book to read in preparation for this is Boime, *The Academy and French Painting*.

76. These invectives are collected in Pevsner, *Academies of Art*, chapter 5.

77. If you want to see the German work, look up the Nazarenes, including Franz Pforr, Friedrich Overbeck, and Peter von Cornelius. See, for example, Keith Andrews, *The Nazarenes* (Oxford, 1964).

78. For discussion of the split, see J. Thuillier, "The Birth of the Beaux-Arts," in *The Academy*, Art News Annual, vol. 33, ed. Thomas Hess (New York, 1967), 29–38.

79. See T. Burollet, "Antidisestablishmentarianism," in *The Academy*, Art News Annual, vol. 33, ed. Thomas Hess (New York, 1967), 89–100.

80. Landscape painting in the academy, as opposed to landscape drawing, began in the 1830s in Germany. Pevsner, *Academies of Art*, 232–33.

81. I am currently examining the spectrum of opinions in my "Failure in Twentieth-Century Painting," a study in progress; see also Thomas Crow, *Modern Art in the Common Culture* (New Haven, Conn., 1996), chapter 1.

82. Pevsner, *Academies of Art*, 236.

83. Ibid., 252.

84. See Rudolf von Eitelberger von Edelberg, *Gesammelte kunsthistorische Schriften* (Vienna, 1879), vol. 2, 121; Pevsner, *Academies of Art*, 257–58. On the history of the *Kunstgewerbeschulen* see also Stuart MacDonald, *History and Philosophy of Art Education* (London, 1970). (MacDonald's book is principally concerned with British nineteenth- and twentieth-century art instruction.)

85. See R. F. Zeublin, "The Art Teachings of the Arts and Crafts Movement," *Chautauquan* 36 (1902): 282–84.

86. See the accounts of instruction in Breslau, Weimar, and Leipzig in Pevsner, *Academies of Art*, 274–75.

87. The original words for the three stages are, respectively, *Vorkurs*, *Werklehre*, and *Baulehre*.

88. In 1923 Moholy-Nagy took over, and Albers taught from fall 1928 to 1933. For an analysis of Itten's teaching see Marcel Franciscono, *Walter Gropius and the Creation of the Bauhaus: The Ideals and Artistic Theories of Its Founding Years* (Urbana, Ill., 1971), 178; and Johannes Itten, *Design and Form: The Basic Course at the Bauhaus and Later*, trans. John Maass (New York, 1966). Material on the first-year course is also available in Laszlo Moholy-Nagy, *Vision in Motion* (Chicago, 1947), and Gyorgy Kepes, *The Language of Vision* (Chicago, 1944).

89. The *Vorkurs* was different under other instructors. See *Experiment Bauhaus: das Bauhaus-Archiv, Berlin (West) zu Gast im Bauhaus Dessau*, exh. cat., ed. Magdalena Droste et al. (Dessau, 1988).

90. See Clark Poling, *Kandinsky's Teaching at the Bauhaus: Color Theory and Analytical Drawing* (New York, 1986).

91. See Herbert Bayer, Walter Gropius, and Ise Gropius, eds., *Bauhaus 1919–28* (Boston, 1959), 34; and Hans Maria Wingler, *The Bauhaus: Weimar, Dessau, Berlin, Chicago* (Cambridge, Mass., 1968), 64. Howard Dearstyne, who attended Albers's foundation course in 1928–29, thought that the exercises were "without reference to established art conventions." See Dearstyne, *Inside the Bauhaus* (New York, 1986), 91; and compare the description in *Experiment Bauhaus*, 10.

92. For the *Rudiments of Painting* (not *De pictura*, translated as *On Painting*), see the discussion in my *Poetics of Perspective* (Ithaca, N.Y., 1994).

93. *Friedrich Froebel's Pedagogics of the Kindergarten: Or, His Ideas Concerning the Play and Playthings of the Child*, trans. Josephine Jarvis (New York, 1904). See also John MacVannel, *The Educational Theories of Herbart and Froebel* (New York, 1905), and Arthur Efland, "Changing Conceptions of Human Development and its Role in Teaching the Visual Arts," *Visual Arts Research* 11, no. 1 (1985): 105–19.

94. See Johann Heinrich Pestalozzi, *ABC der Anschauung* (Zurich and Bern, 1803); Pestalozzi, *Leonard and Gertrude*, trans. Eva Channing (New York, 1977 [1785]); and Kate Silber, *Pestalozzi: The Man and His Work* (London, 1960). For Dewey's laboratory school see John Dewey and Evelyn Dewey, *Schools of Tomorrow* (New York, 1929 [1915]), and Katherine Mayhew and Anna Edwards, *The Dewey School: The Laboratory School of the University of Chicago, 1896–1903* (New York, 1966 [1936]).

95. Pevsner, *Academies of Art*, 287–93. Pevsner cleverly reproduces the letterheads of three leading art academies in Berlin, London, and Paris, to show how conservative they were (fig. 28).

96. Foster Wygant, *Art in American Schools in the Nineteenth Century* (Cincinnati, 1983), reproduces many drawing books of the time. Efland, *A History of Art Education*, chapters 3–6, puts these developments in European contexts.

97. For material on German education before and after World War II, "Art Education and Artists' Training in the Federal Republic of Germany," ed. W. von Busch and O. Akalin, in special issue of *Bildung und Wissenschaft* 7–8 (1985): 1–99. The monograph also contains information on the state of German art education at all levels.

98. Edmund Burke Feldman, "Varieties of Art Curriculum," *Journal of Art and Design Education* 1, no. 1 (1982): 21–45, argues there are four kinds of curricula: those based on technique, on psychology, on anthropology, and aesthetics. Bernard Dunstan, "A Course of Study," *Artist* 95, no. 1 (1980): 10–13, suggests there are only three legitimate subjects in art schools: technique, drawing from nature, and art history.

99. Thanks to Prof. Dr. Karl Schawelka, Bauhaus–Universität Weimar, for this information. The Bauhaus in Weimar can operate at this distance from the original Bauhaus pedagogy only because it teaches very little painting and drawing. The emphasis on objects and design makes the problem of specifically fine art, with its attendant dogmas, less visible.

1. See—among many other examples—Carol Kino, "The Baddest of Bad Art," *Atlantic Monthly*, April 2000, 113–19, concerning the Dahesh Museum in New York City. For background, see Carl Goldstein, "Towards a Definition of Academic Art," *Art Bulletin* 57 (1975): 102.

2. This list of four ideas is drawn, with modification, from Goldstein, "Towards a Definition," 103.

3. E. C. Baker, "Is There a New Academy?" in *The Academy*, Art News Annual, vol. 33, ed. Thomas Hess (New York, 1967), 141.

4. For twentieth-century examples see my review of Steven Mansbach, *Modern Art in Eastern Europe*, in the *Art Bulletin* 82 (2000): 781–85.

5. See Thomas Hess, "Some Academic Questions," in *The Academy*, Art News Annual, vol. 33, ed. Hess (New York, 1967), 8–10.

6. For the general idea of linear progress in history, see Frederick John Teggart, *Theory of History* (New Haven, Conn., 1925), 87 ff., and Teggart, *The Idea of Progress: A Collection of Readings*, ed. George Hildebrand (Berkeley, 1949). One of the most thoughtful essays having to do with art is E. H. Gombrich, "The Leaven of Criticism in Renaissance Art," in *The Heritage of Apelles* (Oxford, 1976), 118.

7. Marshall Brown, "The Renaissance Is the Baroque: On the Principle of Wölfflin's Art History," *Critical Inquiry* 9 (December 1982): 394, is an interesting deconstructive approach to a linear art history.

8. This is also emphasized by Hess, "Some Academic Questions."

9. For further reading see my *Why Are Our Pictures Puzzles? On the Modern Origins of Pictorial Complexity* (New York: Routledge, 1999).

10. Frederick Rudolph, *The American College and University* (New York, 1965), 395.

11. N. Boothby et al., "The Present Status of the M.F.A. Degree: A Report to the Midwest College Art Conference," *Art Journal* 24, no. 3 (Spring 1965): 244.

12. Dempsey, "Some Observations," 569.

13. The author of this scheme is Charles Perrault, *Le Cabinet des beaux arts* (Paris, 1690), quoted in Kristeller, "Modern System of the Arts," 527.

14. See the abbé Charles Batteux, *Les Beaux arts réduits à un même principe* (Paris, 1746), quoted in Kristeller, "Modern System of the Arts," 21.

15. Theodore Greene, *The Arts and the Art of Criticism* (Princeton, 1940), 35, cited in Kristeller, 497 n. 4.

16. Robert Zimmerman, *Aesthetik*, part 1, *Geschichte der Aesthetik als philosophischer Wissenschaft* (Vienna, 1865).

17. See the discussion of the history of software in my "Art History and the History of Computer-Generated Images," *Leonardo* 27, no. 4 (1994): 335–42.

18. See my article "Why There Are No Philosophic Problems Raised by Virtual Reality," *Computer Graphics* 28, no. 4 (1994): 250–54.

19. Rudolph, *The American College and University*, 412.

20. See, for example, Tom Venable, *Philosophical Foundations of the Curriculum* (Chicago, 1967).

21. The opposition is discussed in Robert Maynard Hutchins, *The Conflict in Education in a Democratic Society* (New York, 1953).

22. See Robert Maynard Hutchins, *The Higher Learning in America* (New Haven, Conn., 1978 [1936]).

23. See John Dewey, *Democracy and Education* (New York, 1916).

24. See Carol Gilligan et al., eds., *The Relational Worlds of Adolescent Girls at the Emma Willard School* (Cambridge, Mass., 1990).

25. See, for example, Robert Efron, *The Decline and Fall of Hemispheric Specialization* (Hillsdale, N.J., 1990), reviewed in *Science* 251 (1 February 1991): 575–76.

26. *St. John's College, Statement of the St. John's Program, 1990–1991* (Annapolis, c. 1990), 23. The graduate program is outlined in *St. John's College, Graduate Institute in Liberal Education, 1991–1992* (Annapolis, c. 1990), 5–8.

27. For some of the debate about Stanford's curricular changes, including a letter from Carl Shorske, see *Chronicle of Higher Education*, 13 April, 27 April, and 1 June 1988.

28. An article that looks at this from the liberal arts viewpoint is J. D. Morse, "Viewpoints: What About Art among the Liberal Arts?" *American Art Journal* 6, no. 1 (1974): 72–74.

29. The image of the wheel is from E. H. Gombrich, *In Search of Cultural History* (Oxford, 1969); for further discussion see my "Art History without Theory," *Critical Inquiry* 14 (1988): 354–78.

30. See my "La Persistance du 'tempérament artistique' comme modèle: Rosso Fiorentino, Barbara Kruger, Sherrie Levine," *Ligeia* 17/18 (October 1995–June 1996): 19–28.

31. This idea made its way into academia as early as 1956. A report on the visual arts at Harvard counters this notion, arguing that artists can be intellectual, and so they do have a place in the university. See *Report of the Committee on the Visual Arts at Harvard University* (Cambridge, Mass., 1956), 44.

32. Pevsner, author of the study *Academies of Art* that I have been referring to throughout this book, says he was impelled to write by noticing the way that artists in Dresden were "painfully severed" from the public. But his concern is principally economic and institutional, and his solution has to do with changes in art school curricula.

33. Michel Serres, "Literature and the Exact Sciences," *SubStance* 18, no. 2 (1989): 4–5.

34. See Carol Becker's untitled essay in *New Art Examiner* 18, no. 6 (1991): 15–17.

35. E. H. Gombrich, "In Search of Cultural History," in *Ideals and Idols: Essays on Value in History and Art* (Oxford, 1979), 190.

36. Easily best meditation on this problem is T. J. Clark, *Farewell to an Idea: Episodes from a History of Modernism* (New Haven, Conn., 1999).

37. The ideas here are the central subject of my current study in progress, "Failure in Twentieth-Century Painting."

38. For more information on the history of oil technique, see my *What Painting Is* (New York, 1999).

39. I explore this in my "On Modern Impatience," *Kritische Berichte* 3 (1991): 19–34.

40. "Academic Planning for 1986–90," Report of the Committee on Academic Planning, Office of the Academic Senate, University of California at Berkeley, 17 June 1986, 45, cited in Charles Sykes, *Profscam: Professors and the Demise of Higher Education* (New York, 1988), 154.

41. Ihab Hassan calls the list a "catena" in "Pluralism in Postmodern Perspective," *Critical Inquiry* 12 (1986): 503.

42. For the dynamic of high and low, see especially Crow, *Modern Art in the Common Culture*. For an example of a critic who believes that high and low have become entangled, see Dave Hickey, *Air Guitar: Essays on Art and Democracy* (Los Angeles, 1997).

43. See especially Clark, *Farewell to an Idea*, chapter 7.

44. E. H. Gombrich, *The Sense of Order: A Study in the Psychology of Decorative Art* (Ithaca, N.Y., 1984)

45. Jules Prown, "Mind in Matter: An Introduction to Material Culture Theory and Method," *Winterthur Portfolio* 17, no. 1 (1982): 3.

46. These phrases are from Prown's "affective" theory, "Mind in Matter," 5. See also E. Ferguson, "The Mind's Eye: Nonverbal Thought in Technology," *Science* 197 (1977): 827–36.

47. Gombrich, *Sense of Order*, 217.

48. For an account of gender issues, see Marina Sauer, *L'Entrée des femmes à l'Ecole des Beaux-Arts*, trans. (from the German) Marie-France Thivot (Paris, 1990), esp. 42.

49. See further my *Our Beautiful, Dry, and Distant Texts: Art History as Writing* (New York, 2000), 48, and especially n. 9.

50. See Kenneth Clark, *The Nude: A Study in Ideal Form* (New York, 1965 [1956]).

CHAPTER 3: THEORIES

1. These phrases are taken from a xeroxed flier mailed to prospective graduate students by the Midway Studios, University of Chicago, 1991.

2. I am happy to go along with nearly any of the definitions offered in Noël Carroll, ed., *Theories of Art Today* (Madison, Wisc., 2000); see my review in *Journal of Aesthetic Education*, forthcoming.

3. Aristotle, *Poetics* 1455a. For *mania* in Greek art see Keuls, *Plato and Greek Painting*, 134–35.

4. Goldstein, *Teaching Art*, 5, and see 262 for a description of the Bauhaus manifesto, which was introduced by a print by Lionel Feininger. Goldstein reports Albers was initially confused by the pamphlet, wondering where the art—like Feininger's—would find its way into the curriculum.

5. I pursue the dreaming metaphor in my *Our Beautiful, Dry, and Distant Texts*, 255–97.

6. Howard Conant, "On the Education of Artists," *Art Journal* 24, no. 3 (Spring 1965): 241.

7. Oscar Wilde, "The Critic as Artist," in *Intentions* (1891), reprinted in *The Artist as Critic*, ed. Richard Ellmann (Chicago, 1982 [1968]), 349.

8. Conant, "On the Education of Artists," 241.

9. Kristeller, "Modern System of the Arts," 498.

10. Aristotle, *Art of Rhetoric* I.i. I elaborate this distinction in my *Our Beautiful, Dry, and Distant Texts*, 49.

11. See Pollitt, *The Ancient View of Greek Art*, 14, on Polyklitus's *Canon*.

12. For the term and its use, see Efland, *A History of Art Education*, 240.

13. I am abbreviating. For the full argument, see T. J. Diffey, "Aesthetics and Aesthetic Education (and Maybe Morals Too)," *Journal of Aesthetic Education* 20, no. 4 (1986): 43–44.

14. See B. A. Brueske, *An Annotated Bibliography Dealing with Discipline-Based Art Education* (South Bend, Ind., 1988).

15. Arthur Efland, "Curricular Fictions and the Discipline Orientation in Art Education," *Journal of Aesthetic Education* 24, no. 3 (1990): 67; Efland, "History of Art Education as Criticism: On the Use of the Past," in *The History of Art Education: Proceedings of the Second Penn State Conference, 1989*, ed. Patricia Amburgy et al. (Reston, Va., 1992), 1–11, with further bibliography.

16. Early education movements headed by Pestalozzi and others are the antecedents of DBAE. See Arthur Efland, "Curriculum Antecedents of Discipline-Based Art Education," *Journal of Aesthetic Education* 21, no. 2 (1987): 57–94; C. G. Wieder, "Essentialist Roots of the DBAE Approach to Curriculum: A Critique," *Visual Art Research* 16 (Fall 1990): 26. Wieder points to Elliot Eisner, *Educating Artistic Vision* (New York, 1972), as an essentialist position that influenced DBAE. A seminal early paper is M. Barkan, "Curriculum Problems in Art Education," in *A Seminar in Art Education for Research and Curriculum Development*, ed. Edward Mattil (University Park, Pa., 1966).

17. See C. Stroh, "University Art Programs and the Discipline-Based Art Education Movement: What Prospects?" *Design for Arts in Education* 91, no. 2 (1989): 38–47.

18. For a selection of pertinent essays see *The History of Art Education: Proceedings of the Second Penn State Conference, 1989*, ed. Patricia Amburgy et al. (Reston, Va., 1992), especially Mary Ann Stankiewicz, "Time, Antimodernism, and Holiday Art," in *History of Art Education*, 209–14; also Foster Wygant, *School Art in American Culture 1820–1970* (Cincinnati, Ohio, 1993).

19. This question is discussed in Efland, "Curricular Fictions," 67.

20. The primary text is Empiricus Sextus, *Pyrroneioi hypotyposeis*, trans. as *The Skeptic Way: Sextus Empiricus's Outlines of Pyrrhonism*, trans. Benson Mates (New York, 1996).

21. Philippe de Lacy, "Skepticism in Antiquity," in *Dictionary of the History of Ideas*, ed. P. P. Wiener (New York, 1973), vol. 4, 237b.

22. Aristotle, *Metaphysics* 1008b 26.

23. The skeptic Carneades's three criteria of "probability" (*pithane*, the persuasiveness of an appearance; *aperispastos*, the lack of contradictory neighboring appearances; and *periodeumene*, the presence of a full complement of neighboring appearances) are not present in the unpersuasive, contradictory, limited knowledge we have of art instruction. See de Lacy, "Skepticism in Antiquity," 239a, citing Sextus Empiricus, *Adversus mathematicos* 7. 166–184.

24. The principal authors of "philosophical skepticism" are Eduard von Hartmann and Schopenhauer. See von Hartmann, *Philosophie des Unbewussten* (Eschborn, Ger., 1995 [1860]), translated as *Philosophy of the Unconscious*, trans. William Chatterton Coupland, 3 vols. (London, 1884). For Schopenhauer see, for example, *The Pessimist's Handbook: A Collection of Popular Essays*, trans. T. Bailey Saunders (Lincoln, Nebr., 1964). Writers and poets who were at one time or another pessimists in this sense include Byron, Heine, and Leopardi.

CHAPTER 4: CRITIQUES

1. Gombrich, "The Leaven of Criticism," 118–19.

2. Examples include the designs for the United Nations building in Geneva and the Chicago Tribune Tower.

3. Dempsey, "Some Observations," 36–37.

4. And it is just as difficult to study for. One high school class writes 75-word essays on each of the almost 1,000 illustrations in H. W. Janson's *History of Art* (New York, 1999). See National Endowment for the Arts (NEA), *Toward Civilization: A Report on Arts Education* (Washington, D.C., 1988), 66–67, and further D. W. Schönau, "Nationwide Final Examinations in the Visual Arts in the Netherlands: Practice and Policies," *Visual Arts Research* 15, no. 1 (1989): 1 ff., which augments *Toward Civilization.*

5. NEA, *Toward Civilization*, 98.

6. Most writing about critiques has been done in the realms of educational theory and experimental psychology. See Efland, *A History of Art Education*, 251; E. Eisner, *The Educational Imagination: On the Design and Evaluation of School Programs* (New York, 1979); R. Degge, "A Case Study and Theoretical Analysis of the Teaching Practices of One Junior High School Class," Ph.D. diss., University of Oregon, Eugene, 1975; and Maurice Sevigny, "A Descriptive Study of Instructional Interaction and Performance Appraisal in a University Studio Art Setting: A Multiple Perspective," Ph.D. diss., Ohio State University, Columbus, 1977.

7. W. Schneiders, "Venünftiger Zweifel und wahre Eklektik. Zur Entstehung des modernen Kritikbegriffes," *Studia Leibnitiana*, 17, no. 2 (1985): 160–161.

8. John Dewey, *Democracy and Education: An Introduction to the Philosophy of Education* (New York, 1920); William Frankena, "Education," in *Dictionary of the History of Ideas*, vol. 2, 82–83, and Frankena, *Philosophy of Education* (New York, 1965).

9. For the division into "traditionalist," "social behaviorist" (skill oriented), and "experientialist," see W. H. Schubert, *Curriculum: Perspective, Paradigm, and Possibility* (New York, 1986).

10. Charles Jansen, "The Post-Modern Agenda," a flier distributed at the 1991 C.A.A. conference, n.p. [p. 1]. See also Jansen, *Studying Art History* (Englewood Cliffs, N.J., 1986). For postmodern curricula see also Donald Kuspit, "Postmodernism, Plurality and the Urgency of the Given," in *The Idea of Post-Modernism: Who Is Teaching It?* (Seattle, 1981).

11. H. Risatti, "Protesting Professionalism," *New Art Examiner* 18, no. 6 (1991): 23.

12. For rhetoric see Wayne Booth, *The Rhetoric of Fiction* (Chicago, 1983 [1961]), and Booth, *Modern Dogma and the Rhetoric of Assent* (Chicago, 1980).

13. M. H. Abrams, *The Mirror and the Lamp: Romantic Poetry and the Critical Tradition* (Oxford, 1953). The account that follows mixes Abrams's somewhat simple "orientations" with the "six types" proposed in an outstanding essay by Richard McKeon, "The Philosophic Bases of Art and Criticism," *Modern Philology* 40 (1943).

14. See Batteux, *Les Beaux arts réduits à un même principe.*

15. *Aristotle's Treatise on Poetry,* ed. Thomas Twining (London, 1789), 4, 21–22, 60–61.

16. For the reference to flute playing, see Aristotle, *Poetics* 6.1449b, 14.1453b. For Socrates on imitation, see the *Republic* 10.596–97.

17. Keuls, *Plato and Greek Painting.*

18. Richard McKeon, "Literary Criticism and the Concept of Imitation in Antiquity," in *Critics and Criticism,* ed. R. S. Crane (Chicago, 1952), 173.

19. Abrams, *Mirror and the Lamp,* 35.

20. Here Abrams follows J. S. Mill, "What Is Poetry" and "The Two Kinds of Poetry," *Early Essays by John Stuart Mill,* ed. J. W. M. Gibbs (London, 1897), 208–9, 211–17, 228.

21. See René Wellek and Austin Warren, *Theory of Literature* (Harmondsworth, Middlesex, Eng., 1982).

22. Denis Diderot, *Rameau's Nephew, and d'Alembert's Dream,* trans. L. W. Tancock (Harmondsworth, Middlesex, Eng., 1966).

23. "Nomadic" thought is Gilles Deleuze's term. See Deleuze and Félix Guattari, *Traité de nomadologie,* trans. as *Nomadology: The War Machine,* trans. Brian Massumi (New York, 1986).

24. The most exhaustive text on interpretive communities is Stanley Fish's *Is There a Text in This Class? The Authority of Interpretive Communities* (Cambridge, Mass., 1980).

25. "Evanescent interpretive communities" is an amalgam of Stanley Fish's concept and Nelson Goodman's "evanescent ontology." See Goodman, "The Way the World Is," in his *Problems and Projects* (Indianapolis, 1972), 24.

26. These comments are inspired by Jean Laplanche's Freudian theory and art criticism, which uses seduction as a primary trope. See Laplanche, *New Foundations for Psychoanalysis,* trans. David Macey (Oxford, 1989). An earlier version of this discussion appeared as my article "Studio Art Critiques as Seductions," *Journal of Aesthetic Education* 26, no. 1 (1992): 105–7.

27. The best text here is Roland Barthes, *A Lover's Discourse,* trans. Richard Howard (New York, 1978). Barthes's entire book could be applied to critiques, as a handbook of affects.

28. See Nelson Goodman, *Languages of Art: An Approach to the Theory of Symbols* (Indianapolis, 1976). See also Gerald Graff, "Other Voices, Other Rooms: Organizing and Teaching the Humanities Conflict," *New Literary History* (Autumn 1990), and Graff, *Professing Literature: An Institutional History* (Chicago, 1987).

29. For an attempt to develop skin metaphors into a more extended "language," see my *Pictures of the Body.*

30. I call this problem *metatheoresis* in my *Our Beautiful, Dry, and Distant Texts*, 9–11.

31. See Paul Ricoeur, *Time and Narrative*, 3 vols. (Chicago, 1989).

32. In poetics this "judicative" criticism is called "judicial" or "prescriptive," and "descriptive" criticism is called "aesthetic" or "romantic." See *Princeton Encyclopedia of Poetry and Poetics*, ed. A. Preminger (1990 [1965]), s.v. "Poetics," 637b.

33. Hermann Broch, *Dichten und Erkennen* (Zurich, 1955), vol. 1, 295, discussed briefly in Karsten Harries, *The Meaning of Modern Art: A Philosophical Interpretation* (Evanston, Ill., 1968), 81–83. Commercialism is discussed in J. Morreall and J. Loy, "Kitsch and Aesthetic Education," *Journal of Aesthetic Education* 23, no. 4 (1989): 63.

Index

James Elkins is a professor in the Department of Art History, Theory, and Criticism at the School of the Art Institute of Chicago. He is the author of numerous articles, reviews, and books, including *Pictures of the Body: Pain and Metamorphosis* (1999), *What Painting Is* (1999), and *Our Beautiful, Dry, and Distant Texts: Art History as Writing* (2000).

Typeset in 9.5/15 Bauer Bodoni
with Citizen and Trixie display
Designed by Copenhaver Cumpston
Composed by Jim Proefrock
at the University of Illinois Press
Manufactured by Thomson-Shore, Inc.

University of Illinois Press
1325 South Oak Street
Champaign, IL 61820-6903
www.press.uillinois.edu